ATELIER **ROBERT CAPA**

37, RUE FROIDEVAUX - PARIS (XIV)

TÉL. : DANTON 75-21

Robert Cope

ROBERT

Bernard Lebrun ★ Michel Lefebvre

The Paris Years 1933–1954

In collaboration with Bernard Matussière

Translated from the French by Nicholas Elliot

Abrams, *New York*

6 Preface by John G. Morris
8 Preface by James A. Fox

11 André, Robert, Bob, and Company

ANDRÉ (1933–1936)
41 A Refuge in Paris
43 Trotsky, the First Photo Story
44 An Actor in a Photo Novel
48 Saarland: Friedmann Takes a Credit
50 First Trip to Spain
57 Circle of Friends

ROBERT (1936–1939)
71 The Invention of a Photographer
72 The Reporter in Action
76 Photographer for the Popular Front
80 Capa in Marseille
82 Capa Among the Radical-Socialists
84 Paris Takes to the Streets
86 Barcelona at War
90 Militiawomen in Training
94 Looking for Combat in Aragon
99 Mysteries of an Icon
116 A Lesson in Photojournalism in Madrid
128 Photomontages at the 1937 International Exhibition
132 *Ce soir*, Capa's First Newspaper Job
142 The Man with the Movie Camera
148 The Framing of a Photo
150 Combat Books, in New York... London... Moscow... And Barcelona
172 In China with Joris Ivens
182 On the Way to the Ebro Front
186 Photographers and Brigadiers
190 Leaving France at Any Cost

BOB (1940–1954)
197 The American
200 Waiting for D-day in London
204 With the First Wave
211 On the Front Lines in Normandy
216 Paris, My City
220 Friends at the Scribe Bar
225 Back with the Spaniards
227 Photographing Cinema
230 Capa in the Land of the Soviets
232 Capa Arrives in Tel Aviv
238 The Good Life
243 Memories of the War
248 The Last Mission
255 "It Was 3:10 PM"

257 Traces of a Legend
260 Appendices
261 Acknowledgments
262 Bibliography

"My entire life, through everything that France has endlessly made of me, I've tried to connect with what Spain left in my blood, and what, in my opinion, was the truth."
ALBERT CAMUS (in *Notebook III*)

"I just stayed behind my tank, repeating a little sentence from my Spanish Civil War days, '*Es una cosa muy seria. Es una cosa muy seria.*' This is very serious business."
ROBERT CAPA
June 6, 1944, at Omaha Beach (in *Slightly out of Focus*)

A party celebrating the Liberation of Paris, August 1944, in the apartment of Michel de Brunhoff, editor in chief of *Vogue* France. John G. Morris wrote in his memoirs. "Little did we realize it at the time, but this happy gathering… brought together three of the four principal photographer-founders of Magnum."

From left to right: in somber dress, glass in hand, Robert Capa; behind him, with glasses, John G. Morris; to the left of Capa, who holds his shoulder, Michel de Brunhoff (brother of Jean de Brunhoff, the inventor of Babar, and brother-in-law of Lucien Vogel, the founder of *VU*, then in exile in the United States); close to de Brunhoff, David Seymour, called "Chim"; opposite is an unknown person and Henri Cartier-Bresson; seated in front, in the uniform of a war correspondent, Lee Miller; close to her, kneeling to her left and wearing glasses, Bob Landry, photographer for *Life*.

THE MEMORIES OF CAPA

Incredible! Robert Capa died more than half a century ago, but my memory of him remains more vivid than that of the person I had lunch with yesterday.

Robert Capa is among the most indestructible figures of the twentieth century. I first met him during the winter of 1939–40, when I was a producer-reporter for *Life*. He had just arrived from Paris, preceded by his fame. His photo stories about the Spanish civil war and the Second Sino-Japanese War had propelled him to the top. World War II had just begun, with Hitler's invasion of Poland in September. In the West, the front was calm, and Robert Capa had no conflict to cover. *Life* sent him to photograph Ernest Hemingway at the Sun Valley ski resort, as well as Republican senator and presidential candidate Robert Taft in Florida. He also did short assignments in Chicago and Washington.

We connected immediately. Capa invited me to a reception held in the apartment he shared with his mother, Julia, and his brother, Cornell; I invited him to lunch with my *Life* coworkers at the Rockefeller Center ice-skating rink. He took the arm of the prettiest girl he saw. The two of them started skating around the rink, tripped, and collapsed a few seconds later, setting off an eruption of laughter.

In October 1943, *Life* sent me to London to prepare its coverage of the D-day landings. We knew it would happen sooner or later, but we had no idea when or how. The rumors grew over the months, and after photographing the Italian front, Capa joined us in the spring of 1944. Ernest Hemingway, whom he called "Papa," arrived in the English capital as a correspondent for *Collier's* magazine. Capa decided to organize a party in his honor. It lasted until four in the morning. Papa was offered a ride back to his hotel; the driver crashed into a cistern. Papa was projected through the windshield and wound up in the hospital. Capa and his friend Pinkie visited him at the hospital, where Capa took a delightful shot of Papa after Pinkie opened Papa's hospital nightgown as he was getting up to go to the bathroom. This photo is among my most precious keepsakes.

D-day finally came on June 6, 1944. The story of the London lab accident that ruined three of the four rolls of film Capa shot on Omaha Beach has often been told. I was able to save the eleven pictures that have now become a part of history.

I worked with Capa many times after the war. I had left *Life* to head the photo department at *Ladies' Home Journal*, America's biggest women's

magazine. Capa came to New York in the spring of 1947, shortly after his breakup with Ingrid Bergman in Hollywood. He was considering going to the Soviet Union with John Steinbeck, and I asked him to reserve the first run of their story for *Ladies' Home Journal*. It made the cover of the magazine, which ran sixteen pages of photos with captions by Steinbeck.

One night Capa invited me to a small reception in Greenwich Village to celebrate the founding of Magnum Photos. We celebrated with champagne, of course. A few days later we headed for Iowa to do a story about a typical farming family, the first of a series of articles on the lives of farmers all over the world, largely photographed by members of Magnum. We called it "People Are People the World Over" (1947). I am proud to say that it served as an inspiration for Edward Steichen's famous MoMA exhibition The Family of Man.

In 1952, Capa came to New York for the holidays, as he always did. He asked me to become Magnum's international editor in chief, a position I held for the next nine years. As long as he was alive, it was a magnificent adventure. He cemented Magnum with his incomparable talent.

Our world was rocked on May 25, 1954. My day started in a small town in Missouri. I woke up to learn that Magnum's great Swiss photographer Werner Bischof had been killed in a car accident in Peru. I hurried back to New York. When I got home, I was greeted with the news that Robert Capa had stepped on a mine in what was then called Indochina and was killed instantly. It was too much for a single day.

Over the last few years, the authenticity of Capa's photograph of a Spanish Republican militiaman being struck down by a bullet has been called into question. Those of us who knew Capa know he would never have faked a photo, that that would simply have been impossible for him. Wanting to express myself on the controversy, I wrote a letter to *The New York Times*, but the paper never bothered to print it.

Yes, Capa was making propaganda against Francoism. Just like his friend Ernest Hemingway. Just like the rest of us war correspondents, who would later find themselves in London to cover the D-day landings. We wanted to win the war! Unfortunately, Capa died covering a war about which he was mistaken: the futile Indochina War. My memories are intact. I had to help lower his body into the ground.

Robert Capa witnessed more twentieth-century tragedies than any man I know. "The Falling Soldier" attests to his sacrifice and that of the soldier, two reasons for which there should no longer be any wars.

John G. Morris, April 2011

FORTY YEARS OF DISCOVERIES

Cornell Capa (left) and Jimmy A. Fox (right) at Magnum's Paris office in the early 1980s.

I met Cornell Capa for the first time in New York in May 1966. It was in the Magnum agency's office, which was on Forty-fifth Street at the time. He hired me as an archivist to make an inventory and create an index of the agency's archives. Cornell and his wife, Edie Capa, became my close friends. I worked a lot with Edie, who had a unique method of finding her way through the Robert Capa archives she kept in their Fifth Avenue apartment. In 1976, I became editor in chief of Magnum Paris, where I remained until my retirement in 2000.

One day in September 1986—the agency was on passage Piver then—I received a visit from a Sorbonne professor named Carlos Serrano. He wanted to see photographs of the Spanish civil war and the book *Death in the Making*, which Robert Capa had published in New York in honor of Gerda Taro. Professor Serrano had been recommended to me by Michel Quétin, a curator at the National Archives in Paris, a lover of photography, and a regular at Magnum's exhibitions. It was at one of these exhibitions that Quétin told me Professor Serrano had discovered eight notebooks full of cut-out contact sheets in a series at the National Archives: The contact sheets were of photographs taken by Robert Capa in Spain. Thanks to the negatives in the "Mexican suitcase," we now know that there were also shots by Gerda Taro and Chim—a major discovery.

I wasted no time in getting to the Archives to examine the notebooks. For three hours, I wrote down every possible detail. Then I sent a telex to Cornell in New York to tell him what I had seen. I went back to the Archives to give him more information about each of the pages. For example, in notebook number 5: "November 9, 1938, 4th story: 30 photos including 6 of Ernest Hemingway." My next mission—at Cornell's request and with Mr. Quétin's agreement—was to have the entirety of the notebooks photographed, including the covers. I had Magnum send all the photos to Cornell.

Years later, in 2002, I received the following message from Richard Whelan: "Dear Jimmy, In late 1938, Cornell was getting ready to leave Paris for New York, while Robert was on assignment in China. Cornell was a lab assistant at the Pix agency in New York. Before leaving Paris, he personally made the notebook of his brother's stories shot in China, just as he had done with the Spanish notebooks." In May 2009, the International Center of Photography in New York's archives acquired Robert Capa's China notebook, which Bernard Matussière had found on rue Froidevaux in 1983. On that occasion, ICP curator Cynthia Young wrote me, "I was surprised by what Richard Whelan said about the 'Capa notebooks' allegedly made by Cornell. That isn't possible, because many of the photos they contain were taken after his departure for New York. Cornell probably contributed to them when he was still there, but it was the Capa studio team that continued the work after his departure."

The last task Edie, Cornell, and I carried out together in their apartment on Fifth Avenue was research for a book Magnum published on the fiftieth anniversary of the creation of the State of Israel. There were giant stacks of boxes of photos by Robert Capa, full of vintage prints and negatives, all stuffed into an unforgettable little closet. This is where part of his archive was kept. Edie was the guardian of these treasures. Only one person from Magnum's New York office was allowed to transport documents from the private archives: Allan Brown, the agency's living memory. He had met Robert Capa during World War II. He contributed a great deal to gathering Capa's work and remained devoted to the family.

Though I was living on the other side of the Atlantic in the 1980s, I remember clearly how enchanted Cornell and Richard Whelan were to finally locate the "Mexican suitcase" (then known as the "Spanish suitcase"). The fact that it brings together negatives by Gerda Taro, Chim, and Robert Capa beyond the threshold of death certainly proves the eternal connection and determination that brought this group of friends together in their desire to depict the fight for freedom.

James A. Fox, March 9, 2011

ANDRÉ, ROBERT, BOB, AND COMPANY

Paris: 37, rue Froidevaux in the fourteenth arrondissement. This is where the Robert Capa legend was born. To tell the story of Capa's life and work, we have chosen to focus on this area of Paris and specifically on his Montparnasse studio—an artist's studio—the only apartment he ever rented in his life. Here, in a span of less than three years, he would become "the greatest war photographer in the world," according to *Picture Post* magazine. This book will not offer yet another retelling of the life story of the Hungarian photographer born Endre Ernő Friedmann on October 22, 1913, in Budapest, who died in Indochina on May 25, 1954, at the height of his fame. Instead, it will reveal the all but forgotten "French Capa," nearly edged out of the picture by his American career. From 1933 to 1954, Capa used Paris as a global platform for his photography. It was here that artistically he was born, choosing the surname Capa and the first name Robert and, with his companion and fellow war photographer Gerda Taro, born Gerta Pohorylle, creating a name now synonymous with photojournalism. Even the choice of their pseudonyms, Robert Capa and Gerda Taro, is mysterious . . .

 In the mid-thirties, Paris was the capital of photography. Early in 1937, Capa, who had just become known for his photo stories about the Spanish civil war, moved into the studio on rue Froidevaux. He would work there until his departure for New York in the fall of 1939. That studio is where the 4,500 negatives in the "Mexican suitcase," found in 2007 in Mexico, came from, as did the eight books of contact sheets now in the National Archives

The building at 37, rue Froidevaux, in Paris's fourteenth arrondissement, photographed in 2011. The studio occupied by Robert Capa from 1937 to 1939 is on the second floor.

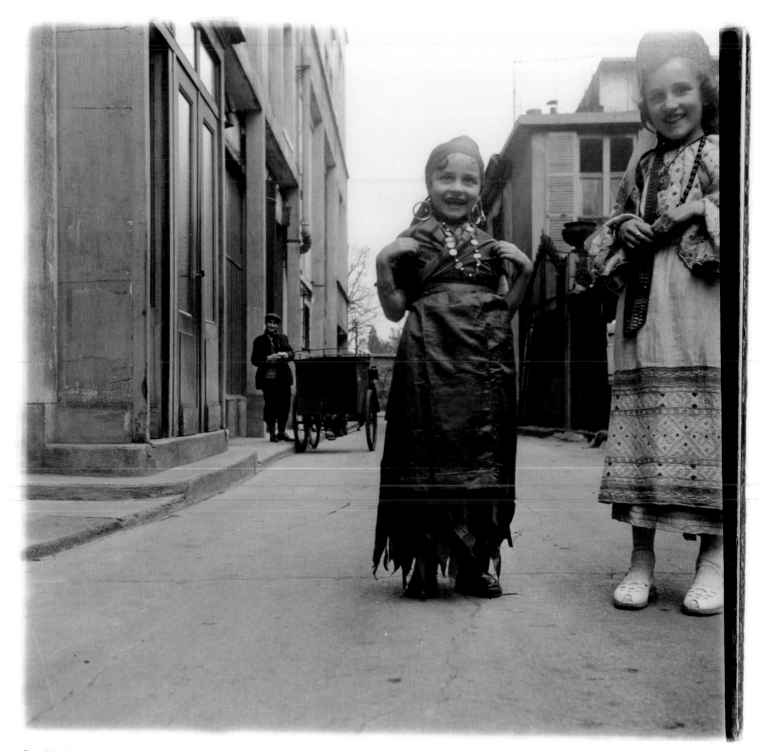

12

Two girls playing dress-up in the alley of
37, rue Froidevaux. This photo was probably
taken before World War II. Behind the
children is the wall of the cimetière du
Montparnasse.

in Paris, and other recently uncovered prints and objects that belonged to him (see pages 28–32). The building still stands, unaffected by time. At number 37, a gate opens onto a cul-de-sac. You have to walk along the facade past the concierge's quarters and two more doors before finally reaching the one that leads to the Capa apartment. Its double doors open onto a steep wooden staircase. Beyond the first landing, another flight of stairs, then a right into a dark hallway. This is the Robert Capa studio. His letterhead: *Atelier Robert Capa, 37, rue Froidevaux, Paris (XIV^e). Tél.: DAN 75-21.* (DAN stands for Danton, the neighborhood, and represents the numbers 3-2-6 on old dial telephones.) The studio door opens into a beautiful space, about 430 square feet with 16-foot ceilings. Light streams in through tall windows. To the right of the front door, a spiral staircase leads to a mezzanine nearly 10 feet wide and running the full length of the apartment—a classic Parisian artist's studio, with a little kitchen on the bottom level and a shower room upstairs. Only one photograph of the studio predating World War II has been found. It shows Ruth Cerf, a friend of Capa and Taro's, sitting in a low armchair, her feet resting on a stove. We do have several photos of the studio in the 1970s, when it was occupied by Ladislas (Taci) Czigany, another friend of Capa's. Today, the apartment is affecting and very quiet. Nothing has really changed since these photos were taken. Oh, if only walls could talk!

Capa is a great subject for study, especially as a jack-in-the-box popping out to thumb his nose from beyond the grave at anyone who tries to fit him back into the box. He is *the* photojournalist, a man who built his own legend. The creator of modern photojournalism and the founder—with his friends—of the Magnum Photos agency. The prototype of the concerned photojournalist (a reference to Cornell Capa's book). The one who covered five wars, inventing just about everything as he went along: conceiving the subject as the picture is being taken, gathering photographers in a cooperative to market their photos and preserve their negatives, controlling how newspapers use images by providing captions. Boastful and charming, brave and rough around the edges, likable and brash, but above all else, brilliant.

Capa arouses passionate devotion, whether from professional researchers, enlightened amateurs, or gold seekers. Some search for the flaw, the fake, the montage, proof that he was a cheat. Others bask in his reputation as a romantic, with his many amatory conquests, poker tales, and champagne-fueled soirees. Still others sing the praises of the fearless prince of reporters, always in the right place with just the right camera angle. Universities could very nearly establish departments of Capa Studies. These would allow us to compile the research of those working to deepen our understanding of Robert Capa, whether in New York, Mexico City, Paris, Barcelona, or San Sebastián. For there are still plenty of discoveries to be made about this great Hungarian, despite the large amount of scholarly research already devoted to him.

From the 1980s to the 2000s, Robert Capa was *the* subject of study for Richard Whelan, an American academic, a lover and historian of photography, and a punctilious guardian of the temple. With his tweed jackets

PHOTO TCHIKI
PARIS

13

Photo taken by Csiki Weisz in the 1930s in Paris. He lived and worked in the workshop on rue Froidevaux, where he took photographs. On the back of the photo, he signed "Tchiki."

ABOVE: Ruth Cerf photographed
by Robert Capa, rue Froidevaux.
This is the only photo of the inside
of the studio before World War II.
A friend of Gerda Taro, Ruth Cerf
worked there in 1938, the year
the photo was taken. "The stove
was not there for decoration but
for heating and the chair on which
I was sitting was purchased by
Gerda, who had little furniture but
all of it very modern."

LEFT: The house occupied by Émile
Muller before and after the war,
photographed from the building
that housed Capa's studio. The
roof allowed access to a terrace
where one could enter an attic
in which negatives and prints of
Capa's were discovered.

OPPOSITE: A view of rue
Froidevaux from number 37, with
the cimetière du Montparnasse
visible across the street.

16

ABOVE AND OPPOSITE, TOP: The door of the building, the stairs, and the landing of the second floor of 37, rue Froidevaux, photographed in 2011. It was the hallway that led to Capa's studio.
OPPOSITE, BOTTOM: A photo and stamp of Rosie Rey, another photographer who lived on the ground floor of the building before and after the war.

and inimitable New York–intellectual style, he affected a gruff exterior at the service of a refined analytical mind. His rigor and standing enabled him to erect a kind of cordon sanitaire around his subject, discouraging all those who had not won his trust. Whelan's role as head "Capalogist" was conferred upon him by Cornell Capa, Robert's brother, and his great advantage was to be a full-time, lifelong specialist in Capa Studies. The first fruit of his work was a thorough, formidable biography published in 1980 that will be difficult for anyone to improve upon. A good biography owes its success to firsthand accounts, archival documents, and talent. Richard Whelan had all three and the time required to take full advantage of them. Most important, he was able to meet people who had known Robert Capa and who are no longer with us, and to consult the correspondence between Capa and his mother, Julia. This model of filial dialogue is essential to achieving an understanding of his character. We can only hope that this exchange will one day be published.

Consequently, rather than attempting to write another biography, we have sought a different way to grasp Capa's character—through successive layers, through the various stages of his life where he was known by different names: André, Robert, Bob. Like Tom Thumb, Capa left white pebbles that

reflect light on the gray zones and shadowy parts of his life. He covered the world—because the world was his hunting ground—with signs, traces, photos, publications, friends, and enemies, but often these clues to his identity lead us right back to Paris.

 The building on rue Froidevaux is at a right angle to the cimetière du Montparnasse, the eternal home of Baudelaire, Maupassant, Beckett, Sartre, Zadkine, and many others. A 1938 André Kertész photo, probably taken from the roof of the house adjoining number 37, shows the entire street and the cemetery. In the 1930s, the neighborhood of Petit-Montrouge felt removed from the bright lights of boulevard Montparnasse, known for its cafés—Le Dôme and La Coupole. Petit-Montrouge was a working-class area of small houses, artisans' workshops, and orchards. Painters, sculptors, and photographers established themselves in Montparnasse early in the twentieth century, moving into studios on the upper floors of apartment buildings or in courtyards. The neighborhood developed a bohemian atmosphere. Formerly a road through the commune of Montrouge, which was annexed to Paris in 1860, rue Froidevaux was originally called rue du Champ d'Asile, which was also the cemetery's initial name. Running parallel to the rue Daguerre, a bustling

PHOTOS
ROSIE REY
37, RUE FROIDEVAUX
PARIS XIVᵉ
TÉLÉPH. : DANTON 92-36

shopping street, it begins on one side of place Denfert-Rochereau, with its statue of the Lion of Belfort, and ends at avenue du Maine.

Number 37 is an unusual building, erected in stages beginning in 1919, as several stories of artists' studios were added. The house belonged to a funeral director, M. Jofin, who stored tombstones and scaffolding at the end of the cul-de-sac. Among those who lived here, we find Marcel Duchamp, the Giacometti brothers, Marie Vassilieff, possibly André Kertész. The memory of Robert Capa lingers, of course, as does that of Gerda Taro. Yet they did not live here; it was their place of business. In the late thirties, the Hungarian photographer Ata Kando lived on the second floor, below the Capa studio, with her husband, a painter. She remembers Capa as such a nice man, sometimes drunk, coming to the studio between two trips to Spain to visit his friend Csiki "Tchiki" Weisz, who was staying there at the time. The writer Philippe Soupault and his wife, Ré Soupault, a German fashion designer and photographer, also lived in the building, on the second floor overlooking the street. Their studio, which was financed by a rich American and decorated by Mies van der Rohe, included the Ré Sports fashion house, where Man Ray photographed the latest collections. The Slovakian Hungarian photographer Rosie

Rey lived on the ground floor. When she died on rue Froidevaux, she left a suitcase of her negatives—another suitcase of negatives!—which was recovered by Bernard Matussière and later by a museum in Bratislava, Slovakia.

Much remains to be explained about how the Atelier Capa operated, about its financing and those who spent time there. There are few firsthand accounts. Yet thanks to Capa's correspondence and a few documents kept at the International Center of Photography (ICP), we can attempt to describe life at the Capa studio. Invoices were sent out from this address to request payment for the use of photographs. This commercial correspondence reveals intense global activity. Mme Garai, the secretary, and Ruth Cerf, Gerda Taro's friend, managed daily operations.

By 1937, the little Capa and Company business was running at full speed. Photos were printed by Capa's friend Csiki and mailed to Amsterdam, London, and New York, where they were published by the biggest magazines, such as *Picture Post* in the UK and *Life* in the US. The various organizations supporting the Spanish Republic were also clients, buying shots for papers, pamphlets, and films. Capa was the photo editor of the daily paper *Ce soir*, launched in Paris in March of that year. *Ce soir* also hired Henri

OPPOSITE, TOP: Capa's studio, seen here in the 1960s, occupied since 1939 by his friend Ladislas Czigany, known as "Taci."
OPPOSITE, BOTTOM: The German passport under the name "Czigany," issued during the war.
ABOVE: The same view of the studio taken in 2011, which shows that little has changed. LEFT: The stamp of Taci Czigany.

L. CZIGANY
Photographe
37, Rue Froidevaux, 37
PARIS-XIV'
Tél. : DAN. 54.37

Le grenier où dormaient les photos de Capa.

ROBERT CAPA:124 PHOTOS RETROUVÉES

Cent vingt-quatre photos et négatifs inédits de Robert Capa, plus un carnet de contacts : telle est la formidable découverte que nous a apportée il y a quatre semaines un jeune photographe, Bernard Matussière. Cent vingt- (suite page suivante)

Cartier-Bresson as a photojournalist. These were the first salaried positions either photographer accepted. Taro, still in Spain, had a deal with *Ce soir* for the exclusive rights to her photos. David "Chim" Seymour, born David Szymin, was also on the scene. Chim had introduced his Hungarian friend to *Regards* magazine, which published Capa's photos starting in 1933. The Spanish civil war provided Capa, Taro, and Chim an opportunity to reveal their talents. As Louis Aragon put it, "the image of the Spanish civil war is theirs."

Other significant figures gravitated to the area. Gisèle Freund lived on rue Daguerre, Pierre Gassmann—a virtuoso photo printer—on boulevard Saint-Jacques, in the same building as Brassaï. Capa crossed paths with them at Le Dôme and at meetings of the AEAR (Association des écrivains et artistes révolutionnaires [Association of Revolutionary Writers and Artists]). Maria Eisner of Alliance Photo, which employed Taro, lived on the other side of avenue du Maine; she distributed Capa's photos. Facing the Atelier Capa's building on the other side of the cul-de-sac was a ragtag house joined to a garage. The second floor was salvaged from a pavilion for a colonial exhibition. It was inhabited by the German Émile Muller, who had been a Communist since 1936 and called himself a mechanic-photographer. André Kertész taught him the rudiments of his trade in a single day. When Capa left in October 1939,

he entrusted Muller with some of his things: a typewriter, prints, negatives, notebooks, boxes. Muller hid them in his attic space above the house, as these were not the kind of artifacts you wanted to be found with during the German occupation. Here the first part of the story of rue Froidevaux comes to an end. To understand how rue Froidevaux fits into Robert Capa's career, we need to move back in time and observe how his circle of friends came together and how these friends, along with his family, would inspire his work and ideas.

In Budapest, there is a small and hard-to-find museum dedicated to the work of Lajos Kassák. This avant-garde Hungarian artist, deeply respected by Capa, knew how to do everything: write, paint, and make theater. In the period when Europe was spiraling into World War I, Kassák argued for social revolution and revolution of forms, but was wary of violence. He was a lifelong opponent of the Hungarian Fascists and the Stalinists who would later take over his country. Kassák was a wanderer; his most beautiful book told the story of a journey by foot from Budapest to Paris. It is a guidebook for all souls driven by wanderlust. Capa would be one such soul his whole life.

Family was also essential, Julia Friedmann especially, a real "mother hen," as Robert's friends would describe her when they met her in New York. Born Julianna Berkovits into a modest bourgeois family, the seamstress Julia

In 1983, the magazine *Photo* published a dossier on the discovery of negatives and prints of Robert Capa from the rue Froidevaux.
LEFT: An overview of the disorder in the attic.
RIGHT: The home of Émile Muller, now destroyed, and Capa's famous "Chinese notebook."

22

A selection of negatives from the 154 recovered in 1983 (and not 124 as the magazine *Photo* reported) at the rue Froidevaux.

They are now kept by the International Center for Photography, New York.

23

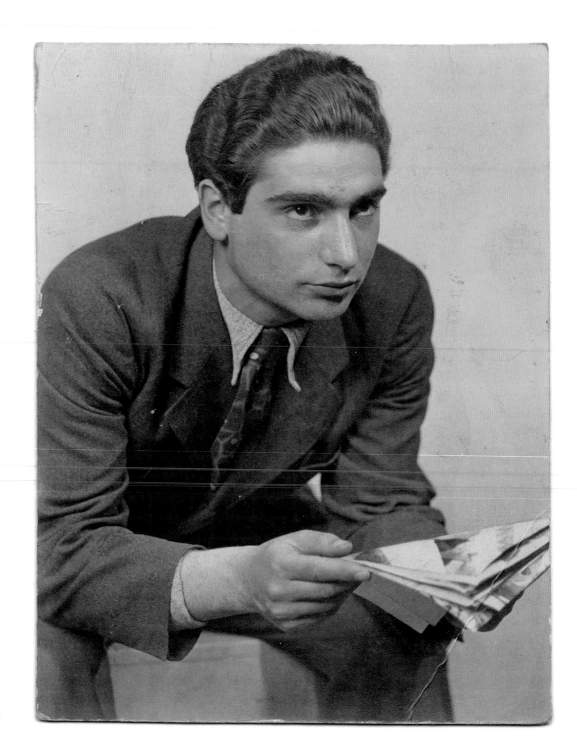

24

Robert Capa photographed by Kati Horna in Budapest, 1933, in the workshop of Jozsef Pécsi. It is one of the rare photos where one can see a young Capa. Friends in Hungary, the two later passed through Paris, Spain, and Mexico, where Kati, after having covered the Spanish civil war as a photographer and graphic designer for an anarchist press, would continue her exile.

married the tailor Dezsö Friedmann in 1910 and founded a fashion house in Budapest shortly thereafter. Business was good, some twenty pairs of hands were at work . . . but the boss was a gambler. He frittered away the little business's profits over the course of memorable card games. In 1931, when the 1929 Wall Street crash hit Budapest hard, the Friedmann fashion house closed its doors. Dezsö and Julia survived by selling made-to-order clothing and dresses fashioned from patterns out of their home. But deeply in debt, the couple separated. Early in 1935, Julia joined her sisters Gladys and Lenke in New York. Robert's brother, Cornell, followed them there in June 1937. Robert Capa was often accused of having a fatally atavistic attraction to gambling, a failing inherited from his father, an affable, elegant, and boastful ladies' man who loved to tell stories on café terraces, while Capa's mother passed on to him her dedication to success through hard work.

While still in Budapest, Endre Ernő Friedmann met Katerine Deutsch, the young daughter of a Jewish banker, who would become the photographer Kati Horna. Like Eva Besnyö, she lived in the same building as the Friedmanns. She was also a disciple of Lajos Kassák, who taught her modernism, as well as social photography and a form of asceticism. Her path would cross Capa's several times. She was a year older than he was, and they would remain very close—according to some sources, lovers. They saw each other in Paris; probably in Spain during the war, which she photographed for anarchist newspapers; and finally in Mexico, where she sought refuge in 1939.

Capa first settled in Berlin. The year was 1931. He had escaped Budapest after being arrested for activism against the authoritarian regime of Admiral Horthy. His goal was to study journalism, write, bear witness. He enrolled in the German School for Political Studies. But this was short-lived, for Endre Ernő Friedmann was a penniless political exile, an eighteen-year-old kid who had to forsake an education to survive. Necessity brought him to the darkroom of Simon Guttmann's agency, Dephot, which gave him his chance by sending him to photograph Leon Trotsky in Copenhagen. Guided by the sage advice of his childhood friend, the Hungarian Eva Besnyö, a highly talented photographer who was already established in Berlin, he began to build a career in photography. At the time, Germany had the best illustrated press in Europe—it was also the most modern and innovative. Photojournalists were shaking up the convention of the posed photograph. The time had come for action, movement . . . life! These innovators included Martin Munkácsi and Erich Salomon. The photos and photomontages of this strikingly designed new press now called out to the reader. This was the Germany that invented the Leica and the use of 35 mm motion picture film for still photography. In 1938, Martin Heidegger would write, "The fundamental event of the modern age is the conquest of the world as picture."

Two years after his arrival in Berlin, Capa went into exile again to escape Hitler's regime. In 1933, Paris was packed with refugees. There were tens of thousands of Germans, of course, who had taken whatever means necessary to escape Nazi Germany. They mingled in the cafés and political

25

The original cover of the book by Lajos Kassák published in Budapest in 1927, a poetic digression on his voyage by foot from Budapest to Paris. For Capa, who was very young at the beginning of the work, the avant-garde Hungarian artist, at the time a poet and a painter, was a role model.

ENTRE LES SOUSSIGNES

—Madame Françoise GASSMANN née DOUAY, épouse de Monsieur Hans Pierre GASSMANN, lequel n'intervient aux présentes que pour autorisation maritale, habitant tous deux à Paris, 21bis Avenue de la Motte Picquet.

ET—Monsieur Ladislas CZIGANY, habitant à Paris 37 rue Froidevaux

Il a été établi, ainsi qu'il suit, les statuts d'une société devant exister entre eux.

STATUTS

TITRE I
OBJET-DENOMINATION-DUREE-SIEGE

ARTICLE I.- FORMATION DE LA SOCIETE

Il est formé, par les présentes, une société à responsabilité limitée qui existera entre les propriétaires des parts sociales ci-après créées et de celles qui pourraient l'être ultérieurement.
Cette société sera régie par le Code de Commerce, par la loi du 7 mars 1925 et les lois subséquentes et par les présents statuts.

ARTICLE 2.- OBJET DE LA SOCIETE

L'exécution de tous travaux de photographie pour professionnels.

ARTICLE 3.- DENOMINATION

La dénomination de la société est : PICTORIAL SERVICE

Dans tous les actes, factures, annonces, publications ou autres documents émanés de la société, la dénomination sociale doit toujours être précédée ou suivie immédiatement des mots écrits visiblement et en toutes lettres: "société à responsabilité limitée" et de l'énonciation du montant du capital social.

ARTICLE 4.- DUREE DE LA SOCIETE

La durée de la société prend cours ce jour pour finir le trente et un décembre deux mil quarante huit.
Toutefois, chacun des associés aura la faculté, pour la première fois au trente et un décembre mil neuf cent cinquante quatre et ensuite à l'expiration de chaque période de 5 ans, de se retirer de la société, à condition de faire connaître sa décision aux autres associés et à la gérance, par lettre recommandée, six mois au moins avant l'expiration de la période en cours. Dans ce cas, les associés restants auront la faculté de racheter, pour leur compte personnel ou de faire racheter par personnes agréées par eux les parts sociales de l'associé qui se

26

Taci Czigany, born October 8, 1908, in Hungary, lived at 11, rue Daguerre, prior to the war. In 1930, he worked as laboratory manager for the photo agency Keystone, but quit two years later to rejoin Fulgur, another agency. From 1934 to 1936, he was a photographer-journalist for *VU*, then, from 1936 to 1939, for *The March of Time*. During the war, he was employed for a time as lab foreman for Hermann Rohrbeck. After the war, he worked for *Life*, as evidenced by his press card.

A very close friend of Robert Capa, Czigany took over the studio on rue Froideaux in 1939, where he lived and worked until his death in the early 1980s. After his death, junk dealers came to the studio and threw away hundreds of boxes of photos. Some documents were saved, including the articles of incorporation of the Pictorial Service—the lab that developed photos from Magnum and of which Taci Czigany as well as Pierre Gassmann and his wife were shareholders—a photo of Pierre Laval, Capa's driver's license, and the papers and photo of the car bought by Capa and driven by Czigany, as Capa was very bad at driving.

TIME & LIFE LTD
21, RUE DE BERRI
PARIS VIIIᵉ

TÉLÉPHONE | ÉLYSÉES 22-46 15-96 CHARLES CHRISTIAN WERTENBAKER
 DIRECTEUR

PARIS, 24th September, 1945

I hereby certify that the car, Ford, B.M.W. 49.122, French licence plates: 65 TT 5 X, registered under my name through the Ministry of Information, will be in the care of LADISLAV CZIGANY, 37 rue Froidevaux. This car, which was put at my disposal through the American Army, for my use as a War Correspondent, will be used to carry out my business while I am in the United States. I would be very grateful if, during my absence, all necessary facilities could be accorded to Mr. Czigany so that he will be able to renew my circulation permit and when necessary pay the customs and all eventual formalities which may arise.

Robert Capa
ROBERT CAPA
War Correspondent

SOCIÉTÉ ANONYME AU CAPITAL DE 140.000 F R.C. PARIS B 562051835

HEADQUARTERS
9875 REPAIR PLATOON

18 July 1945.

TO WHOM IT MAY CONCERN:

1. This is to certify that the car B.M.W.

 Type ------------- 327/8
 Cubic c.m. ------- 1950
 Engine Number ------- 74512

has been sold for the amount of $ 350.-- to Mr. L. Czigany, civilian, correspondent for Time-Life, Inc., 21 Rue de Berri, Paris (8), France, to facilitate in the rapid transportation of news and photographs. The use of this car is necessary in Mr. Czigany's work. This car, found abandoned in Germany by U.S. Army personnel, was partially repaired and sold to Mr. Czigany with the knowledge and approval of all authorities concerned.

For the Company Commander;

Robert L. Stevenson
ROBERT L. STEVENSON
1st. Lt.
Ordnance.

Certified

Luther M. Jackson
Luther M. Jackson
1st. Lt. Ord.

PRESS SECTION
HQ 3ʳᵈ U.S. ARMY
APO 403
U.S. ARMY

N.B. We sold this car with two tires only (instead of five), furthermore the engine is in bad condition and needs repairing. We assume no responsibility for the mechanical performance of this car; all repair work after the date of sale is to be at the charge of Mr. Czigany.

ALLIANCE PHOTO

ABOVE: The German Maria Eisner—a refugee to Paris since 1933—photographed by Henri Cartier-Bresson, and the stamp of Alliance Photo, the agency founded by Eisner which distributed photos by Capa and Chim, as well as those of Pierre Verger, Juliette Lasserre, Denise Bellon, and Emeric Feher. After the war, Eisner joined Magnum, where she was president from 1948 to 1951.
BELOW: A typewriter found at rue Froidevaux, certainly from Capa's studio.

organizations of Montparnasse and spent the rest of their time trying to survive. Capa arrived in Paris with Csiki Weisz. He had to start from scratch again, but family friends would help. There were quite a few Hungarians in Paris, many of them photographers. Soon Capa met André Kertész, then Chim (who became an American citizen in 1943 under the name David Seymour), and Henri Cartier-Bresson. Within three years, he had become a famous photographer, and Paris was his city.

We think we know everything about Robert Capa: his prolific, brilliant, and moving body of work, from the militiaman falling in Spain in 1936 to the Normandy landings on June 6, 1944, and his adventurous, perilous, and romantic personal life. But in fact, beyond the clichés that surround his life, many details remain to be discovered and explained. For instance, we thought we knew the name of that famous Spanish militiaman and of the place where he was shot down. Recent research has shattered our convictions. With even the frame of the shot in question, Capa's most famous photograph remains an enigma. One thing is clear: You are never bored by him. You jump from one discovery to another; new controversies and new questions spring up. No other photographer elicits such keen interest and maintains such deep mystery.

The most recent development to further our knowledge of Capa came late in 2007 when a suitcase of negatives arrived in New York. In the fall of 2010, a major exhibition at the International Center of Photography revealed them to the public. This was the epilogue to a long story inaccurately known as the "Mexican suitcase." In fact, the contents of the exhibition were drawn from three boxes containing 4,500 negatives from Paris. Yet the "Mexican suitcase" was hardly the first discovery. In the last thirty years, several treasures have turned up, revealing entire aspects of Capa's work, each removing one more layer of mystery. Let's look back at these various stages of discoveries, one by one.

First stage. In 1948, during the first session of the United Nations in Paris, Robert Capa is reunited with Émile Muller, whom he hasn't seen since 1939. They fall into each other's arms, but do not discuss the negatives and prints Capa had left with Muller. After Robert's death in 1954, his brother, Cornell, begins searching for the whereabouts of this scattered material. On some unknown date, Cornell goes to Paris to collect what his brother had left in Muller's attic. The attic is in chaos, and Cornell returns to the United States with a few documents, but no specific inventory. Starting then, Cornell Capa devotes himself to recovering his brother's work, particularly from *Life* in New York (where many prints were found), the Pix agency (which distributed Capa's and Taro's work in the United States before the war), and the Black Star agency (an American photo agency that provided images to publications such as *Life*).

Second stage, the late 1970s. Taci Czigany, Capa's friend who had lived in his studio since the end of the war, dies. Over the course of an entire day, the studio is emptied out. Hundreds of boxes of photos are thrown away.

Secondhand goods dealers later recover a few photos and papers, including Capa's French driver's license and a selection of other documents.

Third stage, 1983. The photographer Bernard Matussière, who has moved into Muller's premises, empties the attic and finds 154 negatives and prints of shots Capa took in China and Spain, as well as a book of contact sheets from China. He returns the former to Magnum, which had requested them, and puts the latter up for sale. He later finds nine more negatives of Spain and the Popular Front, as well as different objects from the Capa studio, including a small typewriter. These are presented for the first time in the pages of this book (see pages 28, 30–31).

During the same period, other treasures surface. In 1979, a suitcase belonging to Juan Negrín, prime minister of Spain's Second Republic, who lived in exile in France after the civil war, is found in Sweden. It contains ninety-seven photos from the Spanish civil war, prints of photos by Capa, Taro, Chim, and Fred Stein, some of which are unpublished. In an interview kept at ICP, Csiki Weisz explains that he "had given the photo archives to Juan Negrín in Bordeaux." Another essential discovery is made in the mid-eighties: eight books of contact sheets by Capa, Chim, and Taro (more than two thousand five hundred pictures) are found at the National Archives in Paris. They come from French Ministry of the Interior and Security of the State and thus probably are the result of a seizure by the police. There is no record of police searches at rue Froidevaux, but we know that after the German occupation of France in June 1940, the offices of Alliance Photo were emptied by the Germans, as were those of organizations supporting the Spanish Republic. The contact sheets could have come from one of these sources.

As for the boxes of negatives associated with the "Mexican suitcase," they were entrusted by Capa to Csiki Weisz, who left 37, rue Froidevaux to go to either Bordeaux or Marseille, depending on whom you ask. Csiki was arrested by the French authorities as an "undesirable foreigner" in 1940. Imprisoned in a French camp in Morocco, he owed his freedom to the Capa brothers, who put him on a ship to Mexico in 1942. The suitcase was long out of his hands by then—he had given it to a veteran of the Spanish civil war, who had in turn passed it on to Chilean or Mexican diplomats, again according to whom you ask. The mystery remains whole. The negatives wound up in the possession of a Mexican general, then with his nephew Benjamin Tarver, who contacted Cornell Capa. Negotiations dragged on for more than ten years and finally succeeded in 2007.

All these discoveries have two things in common. First, all the material was made in or came from the Atelier Robert Capa at 37, rue Froidevaux. Second, they show a group effort on the part of Capa, Taro, and Chim, whose negatives were collected and used, often without any attribution, in a vast number of publications defending the Spanish Republic.

To tell Capa's story we must follow the trail of the young Endre Ernő Friedmann, who arrived in Paris in 1933 and quickly became André Friedmann, using that name for the first photographs he published in

29

ABOVE, TOP: Émile Muller poses with his camera.
ABOVE, BOTTOM: One of the photos taken after World War II. "Mechanic-photographer," as he liked to be called, "Mumu" to his friends, he commenced a successful career as a photographer for the French press. When Capa was forced to flee in 1939, he left some of his negatives and prints in Muller's care, which Muller hid in the attic.
BELOW: The logo of the Catherine agency, which Émile Muller ran with his wife.

ABOVE: A storage box filled with negatives and prints, one of those found by Bernard Matussière in Émile Muller's attic in 1983.

OPPOSITE: Nine other negatives—four of Spain, three of a demonstration in Paris, and two of Marseille— found by Bernard Matussière.

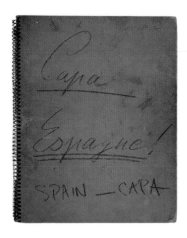

ABOVE AND OPPOSITE: The cover and a page from a notebook filled with cutout contact sheets, found in the apartment of Cornell Capa in 2005. Eight other notebooks are conserved in the National Archives in Paris. A tenth, the first in the series, is lost. These notebooks, made at rue Froidevaux, allowed Capa's clients to order photos by simply specifying a number.

ABOVE: The elegant Vuitton valise of Juan Negrín, found in Sweden in 1979, contained 97 prints by Capa, Chim, and Stein from the Spanish civil war.

newspapers, before becoming Robert Capa. Finally, we follow the man who came to be known as Bob during World War II. Our principal approach is to track down the appearances of his photos in a large array of newspapers and other publications. The search is endless. The 1930s were a blessed era for the illustrated press, which invented the practice of relaying news through images. It is impossible to understand anything about photography of the era without studying the context of its publication. This is particularly true with Robert Capa, whose way of photographing a situation always anticipated the print layout. The papers not only published his photos, but also his captions and sometimes even his texts. Capa did not write much, but enough to make clear his involvement in the conflicts he covered and especially his journalistic approach. His book, *Slightly Out of Focus*, has an undeniable charm. It is imprecise yet passionate. Few photographers have produced such fine writing.

Capa encountered many people who would serve as witnesses to his adventurous life—photographers, writers, and journalists, each of whom contributed a piece to his legend. He has fascinated novelists from Patrick Modiano (*Chien de printemps*) to Romain Gary (*The Roots of Heaven*), who have turned him into a character or an archetype. His life inspired legendary film roles, such as the one played by Clark Gable in *Too Hot to Handle* in 1938 or by James Stewart in Alfred Hitchcock's *Rear Window* in 1954. Many have added chapters to the Capa saga, the life he invented.

Serving as another record of his life are the letters he wrote. Capa wrote to his mother, of course, but also to his friends and business acquaintances. The correspondence paints a picture of a man far removed from the daredevil reporter flying from a love affair to a battlefield with the sole concern of keeping his film from getting damp.

Before the Spanish civil war, his principal concern was merely to survive—to eat, pay for his hotel room in the evening, find a pair of shoes or a hat. Paris was hard on immigrants. A wandering Jew juggling Yiddish, German, and French for whom the ultimate law was a sense of duty toward his friends, he became a Parisian street urchin with an inimitable accent, an expert at finding the few francs necessary for a place to sleep and something to eat. It is said that his mastery of foreign languages was so peculiar that he spoke the "Capalanguage." Yet no one ever forgot his voice and his Hungarian accent. Later he would accede to the rank of American reporter, a rather unusual citizen of the United States who mostly lived in Paris. Indeed, once he was the head of Magnum Photos, which he founded with his prewar buddies Chim and Cartier-Bresson, Capa's preferred office was a café on the Faubourg Saint-Honoré. His worktable and conference room were the pinball machine. It was from here that photojournalists would take off to travel the world with the boss's blessing.

Montparnasse held no allure for him. Longchamp and Auteuil were his favorite postwar hunting grounds. His daily life consisted of croissants, baguettes, champagne, a game of *pétanque* between friends, fashion shows, the Ritz bar, the Hôtel Meurice, and the Hôtel Lancaster near the Champs-Élysées

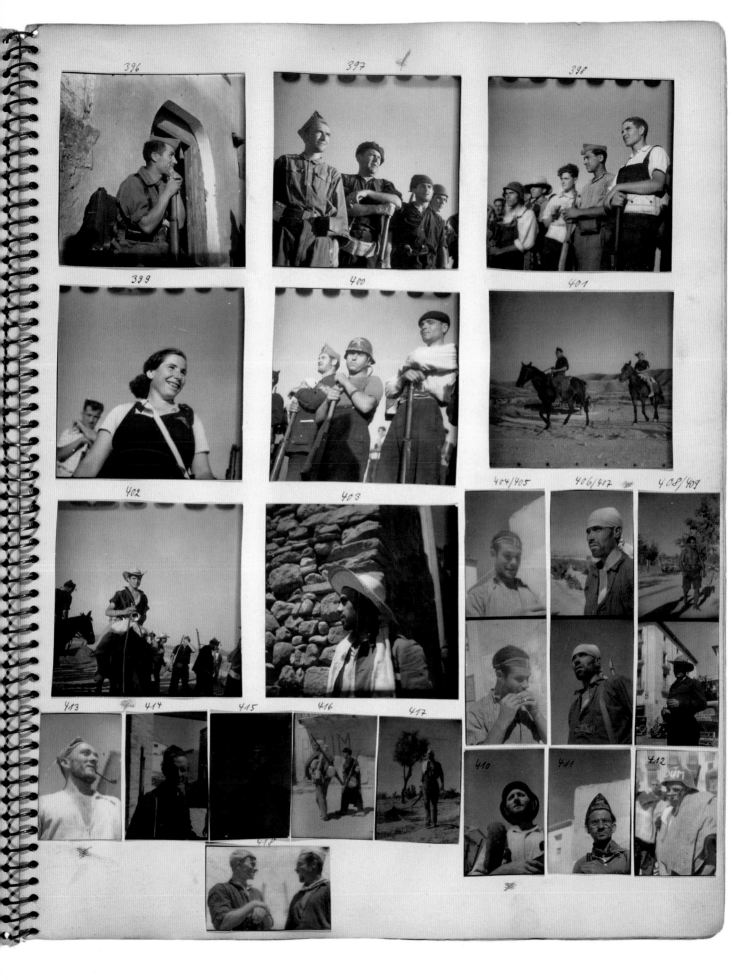

396 397 398
399 400 401
402 403 404/405 406/407 408/409
413 414 415 416 417 410 411 412
418

33

The three boxes, made on the rue Froidevaux and discovered in the "Mexican suitcase" in 2007, contained 4,500 negatives of photos by Capa, Chim, Taro, and Stein. The negatives are preserved today at the ICP in New York.

(his last known residence). According to Pierre Gassmann, "As of 1938, Capa spent in Europe what he made in the United States." New York was his refuge and that of his family, but Paris was "his" city, his world. So for nothing in the world would he have missed August 25, 1944, the Liberation of Paris. He even beat his great friend Ernest Hemingway into the city by being one of the first journalists to cross the Porte d'Orléans, aboard a jeep belonging to Général Leclerc's Second Armored Division!

In fact, he was at home wherever he dropped his bag. He had nothing to call his own save for a few tailored suits, some cameras, his gambling debts, and, most important, those exceptional survival skills.

ABOVE: A curious envelope found at rue Froidevaux addressed to "Monsieur A. Kertész—37, rue Froidevaux—Paris 14e." According to Émile Muller—the Hungarian photographer who lived in the house before him— he took the famous photo titled "Rue Froidevaux" on the roof of the house (or the attached garage). BELOW: A dedication from Henri Cartier-Bresson to Bernard Matussière.

à Bernard
d'un autre habité de
la rue Froidevaux
et en souvenir de Capa
très cordialement
Henri

ANDRÉ

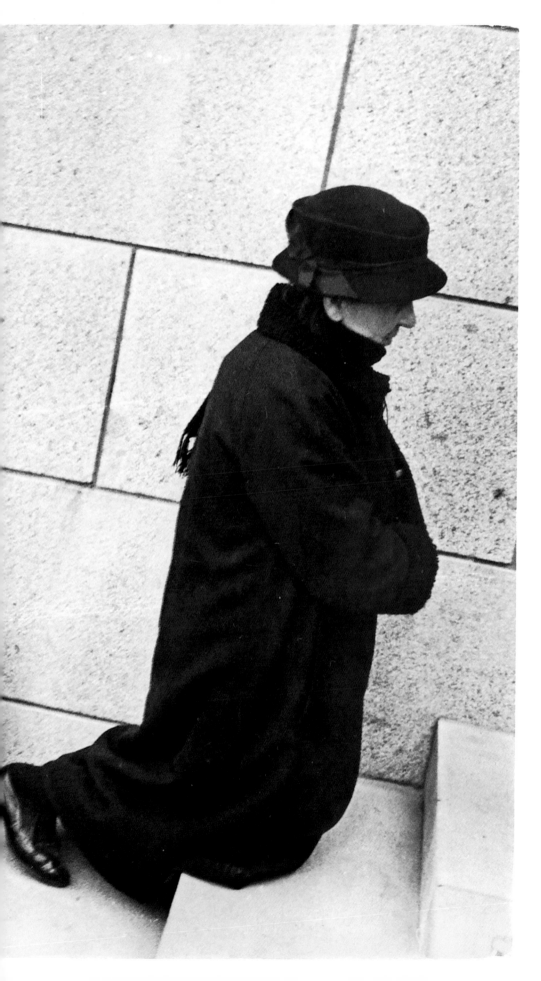

André Friedmann traveled to cover the religious ceremonies of the pilgrimage town Lisieux. The year is uncertain: 1934 or 1935. André had begun working with various agencies—Anglo-Continental and Alliance Photo—and while they distributed his photos of this event, there is no sign of the story in the press.

39

A Refuge in Paris

September 1933, Wien Westbahnhof, the departure point for trains bound west from Vienna, Austria: Endre Friedmann is barely twenty, but he is already going into exile, in France, with his childhood friend Csiki Weisz. Two one-way tickets to Paris. With their bags and their "hobo look and messy long black hair," as fellow photographer Ata Kando would later describe them, the two young men each travel with a single treasure: a camera. Endre's is a Leica I, the basic model, and is already ever at his side. This one piece of equipment had rescued him from precarious circumstances by enabling him to earn the little money he needed to leave. Not particularly glorious work: postcards in Budapest, photos of a Boy Scout jamboree in Hungary (which were never published), darkroom work in Vienna . . . anything to be free! Like thousands of others, Endre and Csiki Weisz are fleeing the sound of boots in Nazi parades, anti-Semitism, and a Central Europe crushed by the economic crisis and unemployment. They are atheists and anti-Fascist activists of Jewish stock and know perfectly well that there is no future for them in Hitler's Germany.

No one awaits them on the platform at Gare de l'Est. They don't speak French and have no place to stay. Endre carries the address of his mother's Parisian cousin and her husband, the Fischers, but for an emergency only. In the early days, the two pals share a hotel room in the Latin Quarter, on rue Lhomond in the fifth arrondissement, but are soon unable to afford it. The struggle for survival is as daunting here as everywhere else, but at least in Paris the threat of suppression does not hang over them—in spite of the fact that in France, the right of asylum is, in Klaus Mann's words, "subject to three obligations: You could not work, depend on public charity, and, especially, not take a permanent address." An impossible challenge. According to the French authorities—who did not want to provoke Germany by welcoming its adversaries—Paris was only supposed to be a way station for émigrés. Yet it became the city of refuge for anti-Nazi Germans and gave Endre an opportunity to use the German he had mastered during his stay in Berlin.

Here, he would come across many old acquaintances, like his former boss from the Dephot agency, Simon Guttmann, often passing through France. There were also his elders from the homeland, starting with the Hungarian photo geniuses Kertész and Brassaï, who would guide and advise him. The first decision made by the now Parisian Friedmann was to Gallicize his first name. From now on he would be André. Then, with five years of relentless work, the "hobo" who arrived at Gare de l'Est would become "the greatest war photographer in the world."

This photo of André Friedmann, the man soon to be known as Robert Capa—kept at ICP in New York—was taken early in his time in Paris, probably in the fall of 1933.

41

Leon Trotsky photographed
by Endre Friedmann, special
correspondent of the Dephot
agency in Berlin, during a
conference in Copenhagen on
November 27, 1932. This was the
photographer's first photo story.
The prewar print was found in the
Capa studio at 37, rue Froidevaux.

Trotsky, the First Photo Story

This photograph of Leon Trotsky is undoubtedly among the most exceptional of the prints discovered by Bernard Matussière in his attic on rue Froidevaux. This small-scale (5.1 × 6.8 inches) vintage gelatin silver print is one of the photos from the very first picture story Capa ever published. The reverse bears the black ink stamp PHOTO ROBERT CAPA, that he began to use in 1936. The photograph was taken on November 27, 1932, in a stadium in Copenhagen, Denmark, during Leon Trotsky's last known public conference. Banished from the Soviet Union in 1929, Trotsky was then living on the island of Prinkipo in Turkey. In the fall of 1932, he accepted an invitation from the organization for student social democrats in Copenhagen. On the day appointed, two thousand five hundred people filed into the sports arena. Dozens of journalists were on the scene.

In Berlin, Simon Guttmann's Dephot (Deutscher Photodients) agency for press photos—which had just changed its name to Degephot—was looking for a photojournalist. Legend has it that since all those available were already booked, Simon Guttmann asked Endre Friedmann, then a darkroom assistant and messenger, to leave for Copenhagen with a writer for the *Der Welt Spiegel* newspaper. Friedmann had been taught the basics of photography by his gifted elders at the agency, and his boss found his first attempts satisfactory. The International Center of Photography now has the contact sheet from the Trotsky conference. There are twenty-nine shots, more than twenty of which are tightly framed, emphasizing the gestures of the great orator at the lectern. This image in which the pointing finger of Trotsky's right hand is held on a level with his mustache is photo number 17.

As usual, Capa would tell several versions of the story of his success that day. Here is one: "Impossible to get a photo. Trotsky would not let himself be photographed. Photographers from the entire world were there with their large-format cameras. None of them could get in. Some workers showed up carrying long steel tubes inside. I joined them. I had a little Leica in my pocket and no one could imagine I was a photographer. My little Leica and I went to see Trotsky."

Four of his photographs—including this one with the pointed finger—were published on a single page in the December 11, 1932, issue of *Der Welt Spiegel* with the credit "Aufnahmen [recordings] Friedmann—Degephot" under the title "Trotsky Takes the Platform."

Fate would set the paths of Robert Capa and Leon Trotsky to cross again in Mexico City in 1940. Capa was covering the Mexican presidential elections for *Life* magazine and *The March of Time*, the Time-Life press corporation's newsreel program. On August 21, the day Trotsky's assassination was announced, Capa hurried to Trotsky's house in Coyoacán but was unable to get in. However, Capa *was* in the cemetery on August 27, the day of the funeral. He telephoned New York and summarized what he had seen for *Time*'s editorial office: Just as the body was being cremated, something happened that caused the coffin to be opened, and Capa saw the great man's hair and beard catch fire. These details were published in the magazine. For months, Capa had been living in the Hotel Montejo, on the Paseo de la Reforma, where he kept encountering a strange guest who never said a word, not even *buenos días* . . . It was later revealed that the man was Ramón Mercader, alias Jacques Mornard, Trotsky's assassin.⊕

The first installment of *Le tueur au boomerang* appeared in the July 4, 1934, issue of *VU* magazine. André Friedmann is featured as a shady lout posing as a threatening mannequin.

44

An Actor in a Photo Novel

André Friedmann launched his career in the press in 1933 as an actor in a photo novel published in *VU*. In the tradition of the French press, Lucien Vogel's photo magazine regularly serialized novels. That year, Fritz Drach, a German immigrant and the magazine's editor in chief, got hold of a detective story called *Le tueur au boomerang* (*The Boomerang Killer*) by Don Pablo, a pseudonym for Paul Bataille, which was yet another pseudonym. This complex story describes the police investigation following the discovery of the body of M. Corton-Viel in his townhouse, lying next to a mannequin holding a boomerang. The mannequin represents Johnny Flosch, an Australian music hall performer. Fritz Drach turned to German journalist and illustrator Ludwig Wronkow to render the story. Together they chose to have photo illustrations made by Marie-Claude Vogel, the daughter of *VU*'s owner, who had her photos credited to "Marivo." Eight of Marie's friends from Le Dôme were asked to appear in the photos. They eagerly accepted, delighted to find a little work. A few costumes were pulled together, and the photos were taken in hotels. The parts of the boomerang killer and Johnny Flosch were nicely handled by an unshaven André Friedmann, who had just pawned his Leica—his only possession—to make ends meet. Ludwig Wronkow played the detective.

VU

7ᵉ ANNÉE. — Nº 329
4 JUILLET 1934
PARAIT LE MERCREDI
PRIX : 2 FRANCS
Direct. : Lucien VOGEL

NOTRE GRANDE
ENQUÊTE :

IL NE DEVRAIT
RIEN SE
PASSER LE
8 JUILLET

LA HAINE RÈGNE EN ALLEMAGNE

NOTRE NOUVEAU ROMAN

LE TUEUR
AU
BOOMERANG

45

ILLUSTRATIONS PHOTOGRAPHIQUES DE MARIVO

Le fameux boomerang, l'arme volante du chasseur australien, qui va frapper la victime et revient dans la main qui l'a lancée.

le tueur AU BOOMERANG

ROMAN DE DON PABLO

M. Corton-Viel, le criminologiste notoire...

Il était rentré de bonne heure, ce soir-là, à l'hôtel où il logeait.

21 Décembre.

J'ai rencontré Johnny Flosch ce matin. Il s'appartait à rentrer chez lui.

le tueur AU BOOMERANG

ROMAN DE DON PABLO

ILLUSTRATIONS PHOTOGRAPHIQUES DE MARIVO

RÉSUMÉ DES CHAPITRES PRÉCÉDENTS

M. Corton-Viel que passionnaient les recherches criminologiques se trouve mort dans la grande galerie de son hôtel auprès d'un mannequin boomerang...

Trois heures après-midi.

Onze heures du soir.

Je me mettais vivement de la lettre.

Je m'avançai vers la fenêtre.

The cover of issue number 329 of *VU*, dated July 4, 1934, features a hilarious montage beneath the title "Our new novel, *The Boomerang Killer*" (see page 45). That's André Friedmann, seen from head to foot, eyes dead ahead, gripping the murder weapon against an eye-catching red background. Inside, the first installment of the serial is published over three pages. The description of the scene of the crime reads: "We see the autographs of many stars of criminal history, objects having belonged to them, a most complete collection of weapons, finally all sorts of souvenirs recalling the knights of the switchblade and the revolver. But the most beautiful ornament in the gallery is the mannequin before which lies the body of the eccentric collector, M. Corton-Viel. It represents a particularly sinister character, a poorly dressed assassin, above the orange scarf surrounding its neck, a swarthy face out of which fierce eyes shine under the black curls of thick, woolly hair."

The novel would appear over ten installments throughout the summer of 1934, three pages a week, always illustrated with four or five photos. With his earnings, Friedmann was able to reclaim his Leica. The serial's text would be published in book form (without the photos, unfortunately) by Sequana éditeur in 1942, in a new series of detective novels known as *La chauve-souris* (The Bat).⊕

The serial's photos are by Marie-Claude Vogel and appear with the credit "Photographic Illustration Marivo." On one of these photos, we find the stamp "Central/Agence photographique, 13 rue de Dantzig, Paris XVᵉ. Téléphone Vaugirard 37-66" (Central/Photographic Agency, 13 rue de Dantzig, Paris, Fifteenth arrondissement. Telephone Vaugirard 37-66). Each of the ten installments (*VU* issues 329 to 338) features four or five photos in which Johnny Flosch, the boomerang killer, aka André Friedmann, frequently appears. The serial would be released in book form much later, in 1942, in a collection of detective novels.

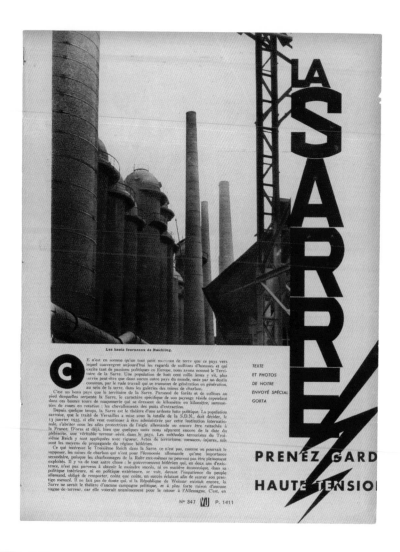

Les hauts fourneaux de Roechling.

C E' n'est en somme qu'un tout petit morceau de terre que ce pays vers lequel convergent aujourd'hui les regards de millions d'hommes et qui excite tant de passions politiques en Europe, nous avons nommé le Territoire de la Sarre. Une population de huit cent mille âmes y vit, plus serrée peut-être que dans aucun autre pays du monde, unie par un destin commun, par le rude travail qui se transmet de génération en génération, au sein de la terre, dans les galeries des mines de charbon.

C'est un beau pays que le territoire de la Sarre. Parsemé de forêts et de collines au pied desquelles serpente la Sarre, le caractère spécifique de son paysage réside cependant dans ces hautes tours de maçonnerie qui se dressent de kilomètre en kilomètre, surmontées de roues en rotation : les chevalements des puits d'extraction.

Depuis quelque temps, la Sarre est le théâtre d'une ardente lutte politique. La population sarroise, que le traité de Versailles a mise sous la tutelle de la S.D.N., doit décider, le 13 janvier 1935, si elle veut continuer à être administrée par cette institution internationale, s'abriter sous les ailes protectrices de l'aigle allemande ou encore être rattachée à la France. D'ores et déjà, bien que quelques mois nous séparent encore de la date du plébiscite, une véritable terreur sévit dans le pays. Les méthodes terroristes du Troisième Reich y sont appliquées avec rigueur. Actes de terrorisme, menaces, injures, tels sont les moyens de propagande du régime hitlérien.

Ce qui intéresse le Troisième Reich dans la Sarre, ce n'est pas, comme on pourrait le supposer, les mines de charbon qui n'ont pour l'économie allemande qu'une importance secondaire, puisque les charbonnages de la Ruhr eux-mêmes ne peuvent pas être pleinement exploités. Il y a de tout autre chose : le gouvernement hitlérien qui, en deux ans d'existence, n'est pas parvenu à obtenir le moindre succès, ni en matière économique, dans sa politique intérieure, ni en politique extérieure, se voit, devant l'impatience du peuple allemand, obligé de remporter, coûte que coûte, un succès éclatant afin de sauver son prestige menacé. Il ne fait pas de doute qui, si la République de Weimar existait encore, la Sarre ne serait le théâtre d'aucune campagne politique, et à plus forte raison d'aucune vague de terreur, car elle voterait unanimement pour le retour à l'Allemagne. C'est, en

TEXTE
ET PHOTOS
DE NOTRE
ENVOYÉ SPÉCIAL
GORTA

N° 347 VU P. 1411

LA SARRE

PRENEZ GARD

HAUTE TENSION

Saarland: Friedmann Takes a Credit

Since the end of World War I and the Treaty of Versailles, the German state of Saarland had been the epicenter of tension between France and Germany. Long occupied by French troops as a defensive position on the right bank of the Rhine, Saarland was scheduled to hold a referendum on January 13, 1935, to either confirm its status quo as a French territory or ratify its reintegration into Germany. The question fueled long debates in the press, and *VU* was no exception. In the fall of 1934, the magazine published two long articles on the subject: the first in the November 7 issue, the second in the November 21 issue, two installments of a single story. The first was titled and credited "Saarland. Caution: Tension on the Upswing—Text and photos by our special correspondent Gorta." The second: "What the People of Saarland Say . . . And Who Will They Vote For?—Interviews and photos by our special correspondents Gorta and Friedmann." Many years after its publication, the film director Joris Ivens still remembered how angry Capa was at Lucien Vogel after the first article appeared without his credit: "Capa was very unhappy. He wanted to see his name in print and be paid. Vogel finally worked things out." Vogel did not omit the photographer's credit in the second article. This first appearance of André Friedmann's photographs in *VU* is of historical interest. Following his two appearances in the German press (the Trotsky conference

LA SARRE

CE QUE DISENT
LES SARROIS

...ET POUR QUI
VOTERONT-ILS
?

INTERVIEWS ET PHOTOS
DE NOS ENVOYÉS SPÉCIAUX
GORTA ET FRIEDMANN

in Copenhagen and an exhibition in Berlin), it is considered the third publication of his career and the very first in the French press.

André had been in Paris for a year when he scored this assignment. He left for Saarbrücken, the capital of Saarland, with the journalist simply known as Gorta in September 1934, probably thanks to two people: first and foremost Kertész, who had been working for *VU* since it was founded in 1928 and seems to have recommended Friedmann to Vogel, but also thanks to Goro, the cofounder of the short-lived Anglo-Continental photo agency in Paris. A German journalist and former deputy editor of the *Münchner Illustrierte Presse*, Fritz Gorodiski, known as Goro, had formed a partnership with Maria Eisner

(who had arrived from Berlin in June 1933) to found the agency. As for the journalist who accompanied Friedmann, the young Gorta, another German refugee in Paris, he would later be Anglo-Continental's man in charge of relations with the new American photo agency Black Star, also founded by German émigrés in 1935. In this position, Gorta distributed the first Friedmann photos ever to appear in the United States. When Anglo-Continental folded and was replaced by Alliance Photo, its director, Maria Eisner, would maintain the relationship with Black Star and take charge of the sale of photos by the man soon to be known as Capa. It was André Friedmann's photo story in Saarbrücken that led France to issue him his first photographer's identification card.⊕

VU published Friedmann's two photo stories on Saarland in 1934. The spectacular layout was typical of Lucien Vogel's weekly. Friedmann was credited only for the second story.

First Trip to Spain

In the spring of 1935, André Friedmann traveled to Spain for the first time. His work there would shape the rest of his career as a photographer. At the time, his life in Paris was highly precarious, and he was hesitating to fully commit himself to this profession, which barely paid the bills. His letters to his mother in late 1934 make several mentions of the possibility of working in the film industry, which was then rapidly expanding. He contacted several Paris studios hoping to learn the trade of filmmaking, which was considered more stable. This new photography assignment was therefore something of a double or nothing risk. He wrote as much to his mother from Le Dôme on March 25, 1935: "This is my last chance and I have to make the most of it." Immediately before leaving Paris, he gave himself the tools to succeed by buying the latest Leica, on credit. It was his first model with interchangeable lenses, probably the Leica III, released in Germany in 1935. He told his brother, Cornell: "Dear Junior, You'll really like my new Leica."

Yet trouble hit the moment he crossed the border. The problem: his Hungarian passport. But the French police, accepting that he was a journalist (he had a photographer's card from the weekly *VU*) issued him his very first press card. He wrote about it to his mother from Madrid, full of enthusiasm: "I am now a member of the international press!"

The trip would be a success for two reasons: a series of news stories (a boxing match in San Sebastián, the annual pilgrimage to Seville, bullfights, an aerostat pilot's attempt to set a new altitude record) and the appearance on the scene in Paris of Simon Guttmann, Capa's former boss at the Dephot agency in Berlin, who promised to sell his stories both in France and abroad. Before André's departure, Guttmann's business associate, Henri Daniel, provided him with an advance for future work and his train ticket to Madrid—"first class," André happily reported to his mother.

First, André went to Madrid to cover Spanish pilot Colonel Emilio Herrera's attempt to set a new altitude record by climbing up to eighty-two thousand feet in a hot-air balloon while wearing a diving suit. *VU* published the story along with eight photos credited "Photos André." The cover did not shy away from hyperbole: "A Deep-Sea Diving Suit in the Stratosphere." Yet only the preparations for the flight were depicted. Simon Guttmann, who had André's total confidence, sold the story in Germany to the *Berliner illustrierte Zeitung* (*BIZ*), which put it on the cover. In Paris,

Capa's photo story on the Spanish aerostat pilot appeared on three full pages in the issue of *VU* dated June 5, 1935. The layout as a photo narrative shows the preparations for Colonel Emilio Herrera's flight.

LE COLONEL HERRERA MONTERA-T-IL A 25.000 MÈTRES?

EN SCAPHANDRE

Dans le récipient, on examine encore une fois consciencieusement l'équipement stratosphérique au point de vue résistance dans les différentes températures.

DANS LA STRATOSPHÈRE?

Je suis très honoré d'adresser un salut au public français par l'intermediare de "Vu" avant ma montée dans la stratosphère

Emilio Herrera

Paris Mai 1935

Quelques lignes que le colonel Herrera a spécialement écrites pour les lecteurs de VU, lors de son dernier passage à Paris.

Il n'est guère d'expériences scientifiques qui aient suscité autant de curiosité que les ascensions stratosphériques. Par l'ampleur des aérostats employés, par les vertigineuses altitudes atteintes, par le contraste entre ces grandeurs imposantes et le choc infinitésimal des rayons cosmiques dans les compteurs électroniques, et aussi par la hardiesse des savants qui s'aventurèrent dans ces régions inviolées, les expéditions des Piccard, des Cosyns, des Settle, des Prokovief — héros sortis tout armés du cerveau d'un moderne Jules Verne — étaient destinées à éveiller la curiosité du public et à attirer dans les sentiers rocailleux de la physique moderne les plus profanes des mortels.

C'est peu avant 1910 que la notion de rayonnement cosmique fit son entrée dans la science. Comme un malin génie s'introduit subrepticement dans une pièce close, une mystérieuse radiation pénétra dans les laboratoires ; la pièce que jouait la physique s'accrut d'un personnage nouveau. A vrai dire, on eut d'abord du mal à en découvrir l'identité : tout ce qu'on savait, c'est qu'il était capable de décharger les électroscopes. Toute une meute de chercheurs se lança alors sur ses traces : Milikan, Hess, Kolhörster, Schweildler. Dès 1909, un prédécesseur d'Auguste Piccard, Gockel, monta en ballon à 4.500 mètres, et découvrit que

Dans un tunnel spécialement construit d'après les calculs du colonel Herrera (unique dans son genre en Europe), un ballon d'essai est exposé dans les mêmes conditions atmosphériques que dans la stratosphère. Le véritable ballon sera en soie très légère, il aura 75 mètres de diamètre et ne pèsera que 1.500 kilos.

la vitesse de décharge des électroscopes y était plus forte qu'au sol. L'opinion scientifique fut alors d'avis que ce rayonnement provenait des espaces célestes et qu'il ne dépendait pas du lieu d'observation. Mais, depuis 1932, grâce aux travaux de Piccard, aux voyages de Clay et Berlage et de nos compatriotes Leprince-Ringuet et Auger, à ce cha-

pitre nouveau-né de la science, s'ajoutèrent des pages nouvelles. Il fut démontré que la radiation cosmique transportait de telles quantités d'énergie — des milliards d'électrons-volts (1) — qu'il leur était possible de traverser plusieurs mètres d'eau. Pour les éliminer, les expérimentateurs durent installer leurs appareils au fond des lacs ! Ce sont des phénomènes, de plus en plus tangibles sous le doigt délicat de la physique, que les stratonautes allèrent chercher dans les hauteurs de l'atmosphère. Ils emportaient le compteur à électrons de Geiger-Müller, véritable tourniquet qui permet de recenser un à un les électrons, imperceptibles errants de l'espace. Ainsi reconnurent-ils l'extrême généralité de ce rayonnement, et ils lui attribuèrent une telle importance qu'il pouvait influer, disait Milikan, « non seulement sur les théories actuelles, mais aussi sur toute théorie future concernant l'origine et le destin de l'Univers ».

Ce serait cependant une erreur de croire que, seul, le souci d'élucider ce problème abstrait guidait les premiers stratonautes. La haute atmosphère pose en outre une foule de questions, auxquelles les ballons-sondes n'ont apporté jusqu'ici que des solutions fragmentaires. Les couches à courants horizontaux qui planent à plus de 12.000 mètres sont le séjour idéal de l'avion, d'abord parce qu'elles ignorent les dangereux remous des régions inférieures, puis parce que l'air, extrêmement raréfié n'oppose plus à l'avancement qu'une résistance insignifiante. A 19.000 mètres, altitude atteinte par le ballon *URSS*, la pression n'est plus que de 48 $^m/_m$, alors qu'elle est de 760 $^m/_m$ au sol. D'ingénieux inventeurs, M. Mélot

L'imperméabilité du vêtement en caoutchouc rempli d'air est examinée après un bain de plusieurs heures.

par exemple, s'écartant du chemin tracé par la fusée de M. Esnault-Pelterie, ont conçu les plans d'avions à réaction qui, à 20.000 mètres soutiendraient une vitesse de 1.200 à 1.500 km. à l'heure ! New-York serait à 4 heures de Paris ; on pourrait faire l'aller et retour dans la journée !

On conçoit donc quel intérêt passionné s'attache aux choses de l'atmosphère, si bien connue, croyons-nous puisque nous rampons

PHOTOS ANDRÉ

(1) Energie acquise par un électron sous un potentiel de 1 volt.

52

Le vêtement est rempli d'air afin de constater qu'il ferme hermétiquement.

La poupée stratosphérique est prête pour le départ. C'est ainsi que le colonel Herrera compte bientôt partir dans sa nacelle ouverte pour battre le record stratosphérique espérant dépasser les 25.000 mètres d'altitude.

Le vêtement est composé de deux parties maintenues ensemble par un cercle d'acier. Par cette division, le danger de déchirure est amoindri. Sur la photo, à droite, le Colonel Herrera.

L'équipement stratosphérique complet résistant à toutes les intempéries assure une chaleur égale même par les plus grands changements de température.

dans ses bas-fonds, si mystérieuse en réalité. Aussi le Professeur Piccard vient-il de partir à Varsovie pour préparer l'étude d'un ballon de 60 mètres de diamètre et de 11.200 mètres cubes, pouvant monter à 30.000 mètres. Aussi les Soviets hâtent-ils la construction de l'*Ossoaviachim II*, frère du stratostat qui gravit les cimes de l'atmosphère jusqu'à 22.000 mètres, et celle de la fusée qui pourra, dit-on, s'élever jusqu'à 40 km. Aussi le Professeur Molchanov nous informe-t-il qu'une conférence internationale sur la stratosphère aura lieu en 1936 en U.R.S.S.

D'ailleurs, tout près de nous, une expédition nouvelle s'élabore, sous les auspices du colonel Herrera, directeur de l'Ecole Supérieure Aéronautique espagnole, un des aviateurs les plus connus d'Espagne : c'est lui qui, en 1916, relia pour la première fois par l'air le Maroc à Séville. Nous avons pu le joindre lors de son dernier passage à Paris, et il voulut bien nous exposer les raisons qui l'avaient poussé à utiliser d'autres méthodes que celles qui firent la célébrité du Professeur Piccard et de ses continuateurs.

« Tout d'abord, expliqua l'éminent aviateur, le poids de la cabine fermée utilisée jusqu'ici diminue considérablement les possibilités d'ascension du ballon. Ma nacelle de jonc, ouverte, doit permettre des altitudes beaucoup plus élevées. » Le colonel Herrera s'enfermera d'ailleurs dans une sorte de scaphandre comportant à l'intérieur un vêtement de caoutchouc, et à l'extérieur une enveloppe extrêmement résistante, maintenue par des cercles d'acier. Il faudra en effet au scaphandre une singulière résistance — ainsi du reste qu'à

l'homme — dans cette nacelle ouverte : il aura à supporter une pression de l'ordre de la tonne. Auguste Piccard n'a-t-il pas calculé que la force qui tendait à séparer les deux hémisphères de sa cabine était de trente-deux tonnes ? De plus, la moindre déchirure transformera instantanément le pilote en un bloc de glace, la température étant de quelque 56° au-dessous de zéro.

« Un des avantages de mon système, poursuivit l'inventeur, est de pouvoir employer le cas échéant le parachute. J'ai d'ailleurs dans celui-ci une bouteille d'oxygène qui me permettra de respirer pendant 75 minutes. » Remarquons que l'emploi du parachute n'est nullement incompatible avec celui de la cabine étanche, jusqu'alors exclusivement utilisée. Il suffit dans ce cas de réserver un trou d'homme par passager, et de munir la cabine d'un petit parachute destiné à empêcher la rotation au cours d'une chute éventuelle.

« Pour tenter cette ascension, continua-t-il, je suis obligé d'attendre le mois d'août, période de l'année particulièrement favorable au point de vue des conditions atmosphériques. A cette époque, l'ombre du ballon (lequel a 75 mètres de diamètre) couvre entièrement la nacelle ; c'est là un point capital, car à l'altitude de 25.000 mètres que je compte atteindre, il y a +60° au soleil et —60° à l'ombre. » On se souvient que le professeur Piccard avait obvié à ce grave inconvénient en blanchissant une moitié extérieure de sa cabine et en noircissant l'autre. Comme l'une absorbait toute la chaleur et que l'autre la réfléchissait, il était possible d'obtenir une température acceptable en orientant convenablement la nacelle.

Indépendamment de ses recherches scientifiques, le colonel Herrera parla encore d'un autre objectif : grâce à un appareil photographique pouvant enregistrer les rayons infrarouges, il pourra fixer, à 25.000 mètres, la carte de l'Espagne entière : les rayons infra-rouges, pouvant traverser les nuages, en donneront en effet les détails invisibles à l'œil. Du reste, dernièrement encore, des expériences ont eu lieu entre Calais et Douvres : par temps de brume, la côte française, absolument invisible du port anglais, fut reproduite sur la plaque avec une incroyable précision.

Ainsi le colonel Herrera va-t-il se joindre à la mince mais glorieuse phalange des explorateurs du ciel. C'est près de Madrid, de l'aérodrome des « Quatre Vents », qu'il s'élancera à la conquête de la stratosphère. Puisse-t-il, de ces prodigieuses hauteurs, rapporter maints clichés et, par eux, ajouter un chapitre de plus au beau livre de science où se lisent déjà les noms de Piccard, de Cosyns et de Prokovief.

PIERRE ROUSSEAU.

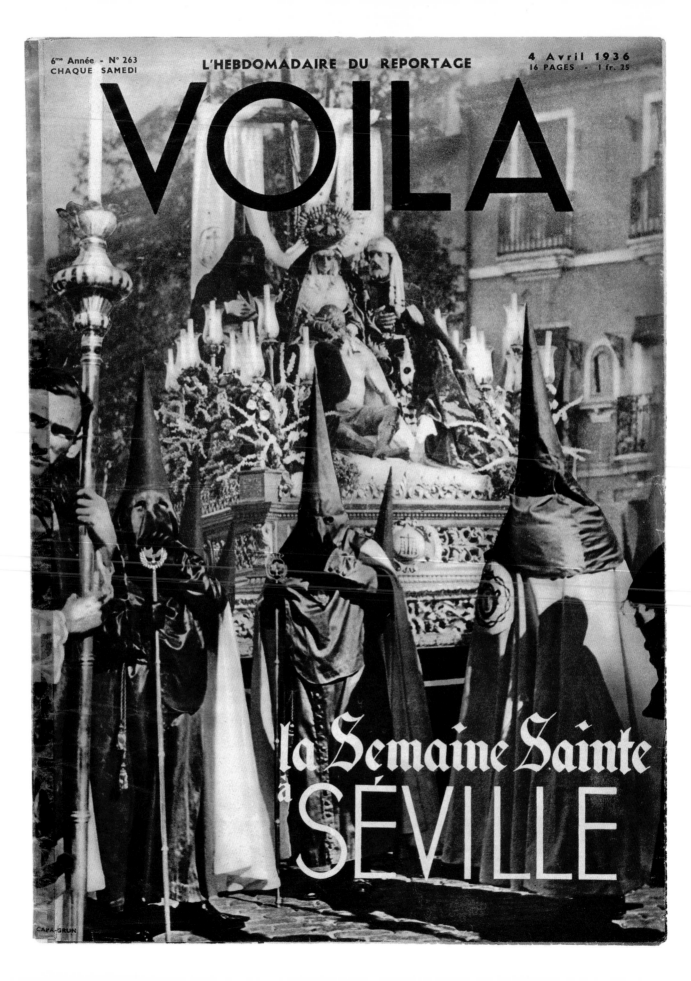

6me Année - N° 263
CHAQUE SAMEDI

L'HEBDOMADAIRE DU REPORTAGE

4 Avril 1936
16 PAGES - 1 fr. 25

VOILA

la Semaine Sainte à SÉVILLE

54

the exile community was shocked by this publication: the Jewish Ullstein family, which owned the newspaper, had been driven out by the Nazis! Under Nazi influence, the paper began publishing flattering pieces about the party. André's involvement with the *BIZ* suggests both that he was desperate for money and that he trusted Guttmann implicitly.

Later, André covered Holy Week in Seville. From the capital of Andalucía, he confided to his love, Gerda Taro: "In Madrid, I had a premonition I would become a zero. When I was in bed at night, I was worried that my stratosphere pilot wouldn't make it to eighty-two thousand

feet, and I had forgotten to photograph his family." He was impressed by the crowd that gathered to watch the Holy Week procession, describing the penitents as being "dressed like members of the Ku Klux Klan," and closing his letter by confessing, "It was irresponsible on my part to come to Seville during the feria." His photos of the Holy Week appeared in *Voilà*, an illustrated weekly and competitor of *VU*, with lyrical text by Spanish journalist Manuel Chaves Nogales.

The sale of his Spanish photo stories earned André Friedmann enough money to allow him to send some home to his family for the first time.⊕

The cover of the issue of *Voilà* about "Holy Week in Seville" was a photomontage of two photos, one by Friedmann, the other by Grün. The paper appeared on April 4, 1936, more than a year after the story was shot. The inside double-page spread features the same mix of the two photographers' work.

LE DÔME

CAFÉ-BAR AMÉRICAIN

108, Boulevard du Montparnasse, 108

Téléphones { DANTON 64-16 / DANTON 72-30 / LITTRÉ 20-39 }

R. C. Seine 255.114

PARIS le 3. février 36.

Kedves drágáim, egész idő alatt értesítést vártam, hogy érkezel, de mint mindig eltolódott az ügy. Jobb is, hogy csak február végén jössz, mert mint mindig december és január gyenge volt, de most újra megindult és mire érkezel minden rendbe lesz. Három-négy hetet kínlódtam a gyomrommal is de az is rendbe jött és újra kezdődik minden. Ma költöztem vissza Gerdához. — Most ő rengeteget segít nekem, mert minden szerkesztővel jóban van és mindenüvé magával visz. Anyagilag persze bajok vannak. Most saját szakállamra kezdtem dolgozni és az egész rengetegbe kerül. A szerkesztőségek csak hetek múlva fizetnek és így várhatunk miatt leszokjuk a lábunkról. A Gerdának nincs talpa a cipője alatt így most nehezen tartjuk a nívót. Mindenesetre dolgozunk, nem koplalunk és majd csak kimászunk a nyomorúságból. Nagy tervek is vannak, de egyenlőre itt kell rendbe jönni. Az öt dollárt Gerdának adtam, de az sajnos a régi adósságra ment. A divatújságot amit apának kellett volna képviselni, másnak adták, mert ő nem válaszolt, nekem írta, hogy Pestnek drágo — és nem elég fényes. Dánielt nem tudod elfelejteni, most csődbe ment. Suttmann írt és szerzett rendelést, ő az egyetlen hű. Most sokat fotografálok és nagyon sokat fejlődtem, a végén csak

Circle of Friends

At the beginning of the twentieth century, the Vavin intersection in the heart of Montparnasse was the meeting place for the painters of the Paris school. The neighborhood's artistic reputation was still alive in the 1930s. With its numerous studios, café terraces, and other so-called "American" bars, Montparnasse was the twenty-four-hour meeting place for artists, intellectuals, and students, both foreign and native. Some were in search of commissions, models, or tips for finding a place to live or work; Le Dôme had a bulletin board for want ads and letters addressed to the café's clientele. Here, people gathered by profession, affinity, or nationality: There was the photographers' table, as well as those for writers, painters, actors, and political activists. Many among them were Jewish émigrés or anti-Fascist leftist activists from Germany or Central Europe, fleeing the Nazi menace or the economic crisis. Today it is hard to imagine the "Tower of Babel" found on these café terraces, where Yiddish and German were as common as French. The little hotels of the Left Bank, which were among the cheapest of the capital, were home to these exiles who lived hand to mouth, scrounging for a way to survive. One example: The artist Man Ray's first studio was simply room thirty-two of the Hôtel des Écoles, rue Delambre, right behind Le Dôme.

André Friedmann lived in the neighborhood, frequenting the small hotels, which he often left under cover of night without paying his bill. The moment he arrived in Paris in the fall of 1933, he turned Le Dôme into his headquarters and office. A small bonus at the time: The café's letterhead was available free of charge, as were ink and pencils. His correspondence with his mother—he wrote her at least once a week—was often written on Le Dôme paper. And so we find him on February 3, 1936, writing as his mother is about to come to Paris for a short stay before her departure for New York. At the time, Gerda Taro lived at the Hôtel de Blois, rue Vavin, across from Le Dôme.

My dear Mother,
I was awaiting news of your arrival, but as usual it was delayed. It is better that you are only coming at the end of the month of February because as usual December and January are very slow. But now business is picking up and by the time you get here, everything will be better.

These three or four last weeks, I've had a lot of stomach pains, but now it's all right.

Today I moved in with Gerda. Now she is the one helping me a lot, for she has good relationships with the newspaper publishers and takes me with her everywhere. Of course financially there

André Friedmann was in the habit of writing to his mother using stationery provided by the Montparnasse cafés where he spent much of his time, including Le Dôme, La Coupole, and A Capoulade, which was on boulevard Saint-Michel and has since closed. The usual subjects of this frequent correspondence were his financial problems and desperate efforts to find work.

RIGHT: This press card made out to David Szymin, the man who would later be known simply as Chim, dates from 1936. It is part of a collection of approximately seven hundred documents, letters, and photographs in the Chim Archive. Chim arrived in Paris in the spring of 1932 to study physics and chemistry at the Sorbonne. He began working as a photographer in 1932 or 1933 thanks to family friend David Rappaport, who was head of the small Rap photo agency. BELOW: The ever-elegant Chim strikes a pose.

are problems. Since I decided to work all by myself, supplies are expensive. The newspaper publishers only pay after a few weeks and for a few francs we really have to wear our shoes out. Gerda's don't have soles anymore and it is becoming very difficult to remain presentable. Anyhow, we're working, we're not dying of hunger, and we'll get out of this mess. There are even some big projects, but for the time being it's here that we have to get by. I gave your five dollars to Gerda, but it just covered what I owed her. Mommy, I'm stopping now, once you're here we'll have plenty of time to chat. If you don't have any money, don't bring me anything. I can still wear my clothes. But if you see something inexpensive and new, you can buy it for your insolent son, and three pairs of size 35 brown stockings for Gerda. I bought a brown pair of pants and I have shirts to wear with it. My shoes are still good and my Japanese friend bought me a raincoat which he brought from London and I also wear a hat. I cut my hair American-style to make you happy, but since you didn't come I couldn't surprise you. At the Fischers*, nothing has changed.

* Family friends who occasionally put him up in Paris.

The German Pierre Gassmann would later say, "What do you want a young man who doesn't speak English or French or have a profession to do? He becomes a photographer!" Gassmann also turned up in Paris with his suitcase and camera in May 1933. One of the first people Gassmann met at the terrace of Le Dôme was his fellow German photographer Gisèle Freund. Then he met the Polish photographer David "Chim" Szymin, who later changed his surname to Seymour, who had been in Paris since the fall of 1931. Chim spoke excellent French, however, to the point of taking physics classes at the Sorbonne.

Chim's father, an important Warsaw publisher, knew all the intellectuals who worked for the Yiddish press in Paris. Chim's father sent him to David Rappaport, who had founded the Photo Rap photo reporting agency on rue des Fossés Saint-Jacques in the mid-twenties. This small agency provided photographs to the Polish press, including *Haynt* [*Today*], and its Paris edition, the *Parizer Haynt*. Chim's first photos were published in August 1933 in *Regards* magazine and were credited "photos Rap-Chim" or "Photo Chim." *Regards* was founded by the French Communist party in 1932 on the model of the German magazines, thanks to the enlightened advice of Willi Münzenberg and his wife, Babette Gross, also refugees in Paris. It was run by "fellow travelers," from André Gide to André Malraux. Illustrated in heliogravure, *Regards* became a weekly in January 1934.

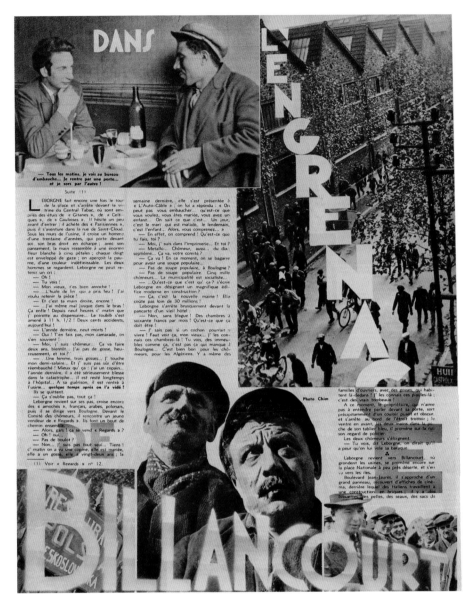

59

ABOVE AND FOLLOWING SPREAD: The French Communist Party's weekly *Regards* published this photo story by David Szymin, with the credit "Photo Chim," over three issues in April 1934. The layout was stunning. Chim's first publication in this paper—a story on coal miners—ran in the August 23, 1933, issue. The photographer continued working for the magazine until his departure for the United States in 1939. Beginning in 1936, he got his friends Capa, Cartier-Bresson, and Taro assignments with *Regards*.

LEFT: The Rap photo agency's official stamp.

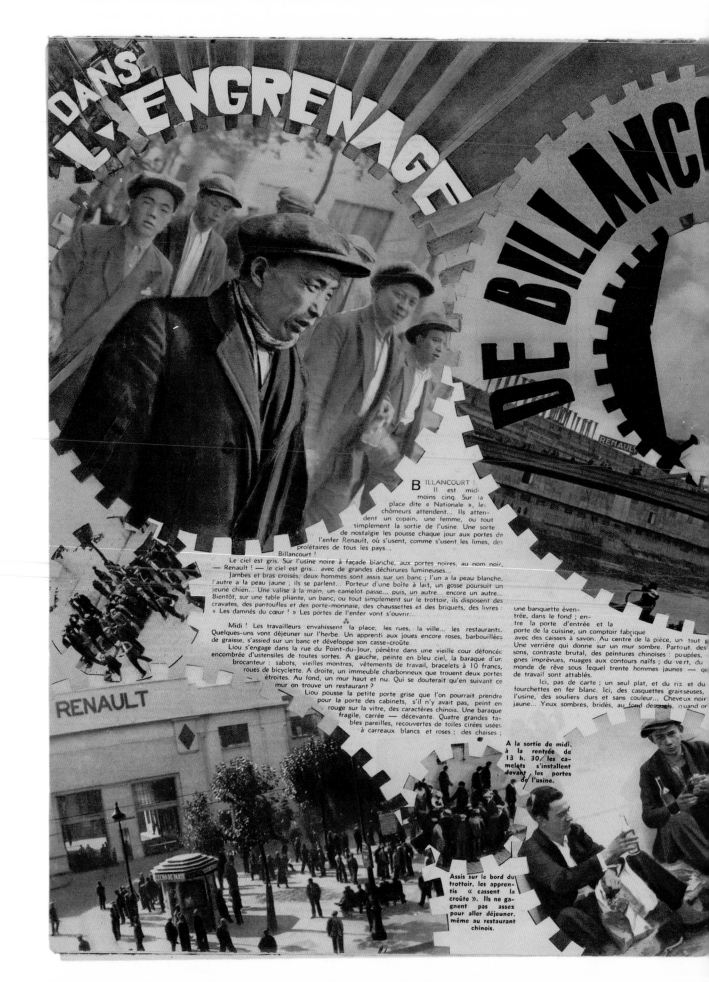

60

RENAULT

BILLANCOURT !
Il est midi
moins cinq. Sur la
place dite « Nationale », les
chômeurs attendent... Ils atten-
dent un copain, une femme, ou tout
simplement la sortie de l'usine. Une sorte
de nostalgie les pousse chaque jour aux portes de
l'enfer Renault, où s'usent, comme s'usent les limes, des
prolétaires de tous les pays...
Billancourt !

Le ciel est gris. Sur l'usine noire à façade blanche, aux portes noires, au nom noir.
— Renault ! — le ciel est gris... avec de grandes déchirures lumineuses...

Jambes et bras croisés, deux hommes sont assis sur un banc ; l'un a la peau blanche,
l'autre a la peau jaune ; ils se parlent... Porteur d'une boîte à lait, un gosse poursuit un
jeune chien... Une valise à la main, un camelot passe... puis, un autre... encore un autre...
Bientôt, sur une table pliante, un banc, ou tout simplement sur le trottoir, ils disposent des
cravates, des pantoufles et des porte-monnaie, des chaussettes et des briquets, des livres :
« Les damnés du cœur ! » Les portes de l'enfer vont s'ouvrir...

Midi ! Les travailleurs envahissent la place, les rues, la ville... les restaurants.
Quelques-uns vont déjeuner sur l'herbe. Un apprenti aux joues encore roses, barbouillées
de graisse, s'assied sur un banc et développe son casse-croûte.
Liou s'engage dans la rue du Point-du-Jour, pénètre dans une vieille cour défoncée
encombrée d'ustensiles de toutes sortes. A gauche, peinte en bleu ciel, la baraque d'un
brocanteur : sabots, vieilles montres, vêtements de travail, bracelets à 10 francs,
roues de bicyclette. A droite, un immeuble charbonneux que trouent deux portes
étroites. Au fond, un mur haut et nu. Qui se douterait qu'en suivant ce
mur on trouve un restaurant ?
Liou pousse la petite porte grise que l'on pourrait prendre
pour la porte des cabinets, s'il n'y avait pas, peint en
rouge sur la vitre, des caractères chinois. Une baraque
fragile, carrée — décevante. Quatre grandes ta-
bles pareilles, recouvertes de toiles cirées usées
à carreaux blancs et roses ; des chaises ;

une banquette éven-
trée, dans le fond ; en-
tre la porte d'entrée et la
porte de la cuisine, un comptoir fabriqué
avec des caisses à savon. Au centre de la pièce, un tout
Une verrière qui donne sur un mur sombre. Partout, des
sons, contraste brutal, des peintures chinoises : poupées,
gnes imprévues, nuages aux contours naïfs ; du vert, du
monde de rêve sous lequel trente hommes jaunes — q
de travail sont attablés.
Ici, pas de carte ; un seul plat, et du riz et du
fourchettes en fer blanc. Ici, des casquettes graisseuses,
l'usine, des souliers durs et sans couleur... Cheveux noir
jaune... Yeux sombres, bridés, au fond desquels, quand on

**A la sortie de midi,
à la rentrée de
13 h. 30, les ca-
melots s'installent
devant les portes
de l'usine.**

**Assis sur le bord du
trottoir, les appren-
tis « cassent la
croûte ». Ils ne ga-
gnent pas assez
pour aller déjeuner
même au restaurant
chinois.**

l'observent, se regardent, lui sourient

Les hommes déjeunent et parlent, parlent... Leur langue a quelque chose d'enfantin Leurs voix montent... C'est comme une chanson monotone, une berceuse étrange qui vous tient toujours éveillé.

Le repas terminé, quelques ouvriers jouent Leborgne s'approche d'eux :

— Ah ! c'est des dominos ?

— Oui... dominos chinois.

Devant chaque joueur, une petite muraille de dominos qui s'allonge, s'écroule, s'allonge encore, change de physionomie à chaque instant : quand la partie est finie, on mélange les petites pièces de bois qui font sur la table un bruit charmant, et l'on recommence.

Un crayon à la main, le patron est assis à la caisse, devant un grand livre à couverture noire ; on ne paie que le samedi... Quelques ouvriers s'en vont... Un plongeur chinois, figure ronde comme la lune, petits yeux malicieux, bras nus, musclés et tatoués, lave les assiettes dans une moitié de tonneau. Souriant dans ses vêtements blancs, coiffé d'une petite calotte blanche, le cuisinier chinois apparaît sur la porte de la cuisine, allume une cigarette et croise ses maigres bras...

Comme un coup de fouet, un coup de sirène ! Les hommes se lèvent L'un d'eux enfile une sorte de pardessus noir, brillant, au col poilu par place, passe sa main large et meurtrie sur sa tête rasée, s'approche de Leborgne, et sort de sa poche un livre qu'il pose sur la table en disant :

— La guerre !

Leborgne ouvre le livre, le feuillette rapidement. Des caractères chinois. Une gravure : une femme chinoise est attachée à un poteau ; un officier japonais, de son sabre, lui coupe les deux seins ! Leborgne referme le livre et dit :

— Je sais, camarade !

Les hommes sortent.

La place « Internationale » est noire d'ouvriers.

Ouvriers de tous les pays ! L'usine va vous prendre ! Dans quelques minutes, vous serez pris dans l'engrenage. — Que tu t'appelles Liou, Tahar ou Pierre, toi qui t'avance déjà vers les pendules, sous l'œil d'un mouchard, tout à l'heure tu ne seras plus qu'un appendice de la machine ! — En attendant, vous vous groupez autour du fakir (qui est une femme), qui est debout sur un tabouret, qui ressemble à un coquelicot fané avec ses oripeaux sales.

— Pensez ce que vous désirez savoir ! On répond dans toutes les langues !

Nègres, Polonais, Chinois, Algériens, vous vous bousculez un peu pour regarder le fakir aux gestes de prêtre ; vous souriez tous du même sourire, vous haussez les épaules et vous

Une venelle puante...
Au fond, le restaurant des ouvriers chinois.

allez vers l'usine.

Vous vous groupez encore autour des camelots qui sont des chômeurs. Voyez ce qu'on vous offre : des souliers en carton, des rasoirs en fer, des bagues en aluminium, des bananes pourries et des bourgeons de sapin.

Vingt mille hommes, femmes, enfants envahissent les forges, les fonderies, les ateliers, les bureaux. Ils marchent vite, très vite ; avant d'être dans l'usine, ils sont déjà pris dans l'engrenage !

Les limes grincent ! Le fer pousse des cris ! Les pistolets donnent la cadence : « Tac, tac, tac, tac, tac... » — Il n'y a que les hommes qu'on n'entend pas. — Et, de temps en temps, comme des coups sourds de canon, de lointains coups de marteau-pilon impriment au sol de Billancourt de perceptibles secousses ! On ferme ! Une barre de fer, peinte en rouge aux extrémités, et surmontée d'un feu rouge, lentement s'abaisse ; ça rappelle un passage à niveau ; on s'attend presque à la claque formidable d'un rapide ! Puis, un rideau tombe sur des poulies, des courroies de transmission et des bras humains secs comme des bielles. L'usine ronfle — pour la guerre !

Les camelots ferment leurs valises et s'en vont. Les chômeurs, mains en poches, restent sur la place, debout, face au bagne, comme des points d'interrogation. — Aucun son de voix humaine ; seul le métal a la parole : « Tac, tac, tac, tac, tac... ». — Les chômeurs : Russes, Italiens, Français. Un Arabe, casquette légèrement sur l'oreille, cache-col blanc, pantoufles aux pieds. Un Polonais, blond, coiffé d'un chapeau qui lui va mal. Un Chinois au regard mélancolique ; il donne la main à une petite fille à la peau nacrée, aux cheveux d'un noir mat.

Là-bas, sur le mur du bagne, un grand écriteau inutile : « Bureau d'embauche », et une flèche...

PIERRE BOCHOT.

(A suivre.)

pêle. Un plafond très bas, en pente d'araignées pendent et, sur les cloix, fleurs monstrueuses, lacs, monta-du jaune, du bleu tendre. Tout un femmes blanches — en vêtements

volonté. Ici, pas de bâtons ; des bleus » imprégnés de l'odeur de s, à reflets bleus... Visages de cuivre de bien, on aperçoit des lueurs métal-... Ici, des mains fraternelles, salies et saignantes !

La porte s'ouvre ; entre Leborgne, un chômeur parisien.

Les prolétaires chinois

Dans la Seine, à l'eau souillée par les égouts des usines, les ménagères lavent leur linge...

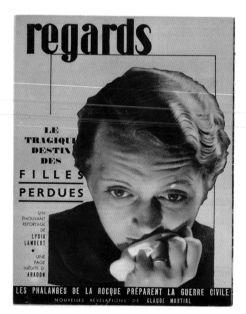

Gerta Pohorylle, known as Gerda
Taro, at a café in Paris (above).
This is probably a staged shot, as
with the photo at right, published
in *Regards* on October 15, 1936,
where Taro poses to illustrate
an article on reform schools for
"lost girls." The photograph is
uncredited.

Together, Gassmann and Chim signed up for the meetings of the Photo Section of the AEAR (Association des écrivains et artistes révolutionnaires [Association of Revolutionary Writers and Artists]). It was close to the French Communist party and run by Louis Aragon, "who knew nothing about photography," according to Gassmann. Here, they would meet another young French photographer, a friend of the surrealists, who had broken with his bourgeois family. He went by the name Henri Cartier, but his full name was Henri Cartier-Bresson. He had just returned from Mexico and New York, where his photos were exhibited. At AEAR, Gassmann also met a young German refugee learning photography, Gerta Pohorylle. As for Chim, he was approached by André Friedmann on a Paris bus because he was carrying a Rolleiflex camera. He introduced Friedmann to Pierre Gassmann and Henri Cartier at Le Dôme, then to Gerta. This would be Capa's first network, that of the anti-Fascists who committed to the struggle against Nazism by bearing witness through images. Also on the scene was André Kertész, who was already a famous photographer, published in *VU*, and who encouraged Friedmann and Brassaï.

Another network must be mentioned, that of the companies and organizations of the Jewish community. These were all places to find help, solidarity, and advice. André Friedmann frequented them during his first journey from Budapest to Berlin in 1931.

LEFT: Capa and Taro at the terrace of Le Dôme in Montparnasse, photographed by their friend Fred Stein. This is one of the only two photos of them together.
BELOW: Chim and Cartier-Bresson posing in Paris on Bastille Day 1938 on the fringes of a demonstration.

63

64

ABOVE: **Gerda Taro, probably photographed by Robert Capa in a hotel room in Paris.**
OPPOSITE, TOP: **Gerda at the typewriter, making faces at photographer Fred Stein.**
OPPOSITE, BOTTOM: **The sleeping Gerda in one of Capa's favorite photos. Four negatives of this scene were found among the negatives in the "Mexican suitcase."**

André and Gerda met in Montparnasse in September 1934. Beginning in October 1935, Gerda worked as an assistant in the Alliance Photo agency headed by Maria Eisner, who had arrived from Berlin in June 1933 and was a friend of Capa's from his German days. Capa's first Paris shots would be distributed by this photo agency, with clients including daily papers and illustrated magazines both in Europe and the United States. Gerda spoke German, French, and English, which she had learned at school in Switzerland, at the Villa Florissant, a boarding school for young women in Lausanne. She wrote and typed the captions for the photographs, which were pasted on the back of the prints and mailed to French and foreign clients.

Capa, Chim, Taro, Cartier, Gassmann. The crew was completed by a final member, Fred Stein. A German and an exile, trained as a lawyer, he became a photographer in Paris and immortalized two lovers at Le Dôme: André and Gerda . . . ⊕

ROBERT

This photo was taken by Capa during his second trip to Spain, in late November or early December 1936. On this trip, he

spent a few days with the French International Brigades volunteers defending Madrid in the buildings of the university campus and, as in this photo, in the Casa de Campo Park. Contrary to appearances, the battle raged in the heart of the city.

Mr CAPPA.

PRÉFECTURE DE POLICE

SERVICE DE LA PRESSE

Les Agents de l'Autorité et de la force publique sont invités à faciliter dans la mesure du possible la mission du porteur du présent et à permettre à sa voiture de couper les files s'il n'y a pas empêchement de force majeure.

Le Préfet de Police

JOURNAL: "*Ce Soir*"

The Invention of a Photographer

The legend begins with the invention of the name "Capa" and the first name "Robert." All his biographers will tell you that his artist's name could have come from his native land: In Hungarian, *kappa* means "hoe, spade" and *càpa*, "shark." One could conclude that the photographer chose the pseudonym to hoe his own row or take a big bite out of life. The second hypothesis, *càpa* meaning "shark," was the one favored by Eva Besnyö, who had known the photographer since their youth in Budapest.

After he and Gerda found the pseudonym Capa and made up the story of the "great American photographer on a stopover in Paris, so busy he remains invisible," in May 1936, André had to choose a first name for himself. He once explained that he took his inspiration from the actor Robert Taylor, whose real name was Spangler Arlington Brugh. The actor had faced the same problem: choosing a name that struck people like a brand and was easy to write, remember, and pronounce. In 1936, the Robert Taylor film on Paris screens was *Camille*, based on Alexandre Dumas's *The Lady of the Camellias*. Capa claimed he had seen this film by the great George Cukor. Another hypothesis, just as improbable as the others, has it that another film—this one by Frank Capra, whose name is not unrelated to "Capa"—might have inspired the couple. *Platinum Blonde*, starring Jean Harlow, told the story of a poor reporter who married the daughter of a billionaire. The pricelessly hammy reporter was played by Robert Williams.

While André became Robert—and Roberto in Spain—his friends Cartier-Bresson and Kertész always called him André.

71

OPPOSITE AND ABOVE: Robert Capa's press card, issued by the daily *Ce soir*. He agreed to head *Ce soir*'s photo department in early 1937. Gerda Taro and Henri Cartier-Bresson also worked there. This is an aluminum press pass issued by the Préfecture de police (police commission), on which a photo of Mr. CAPPA. (*sic*) is printed.

The Reporter in Action

72

Though the cover of the July 8, 1936, issue of *VU* was dedicated to Catalonia, five pages were devoted to the new president of the council Léon Blum's first steps on the job at the League of Nations in Geneva. He was followed by the photographer Lucien Aigner, but it was Capa who caught the incident. Lucien Vogel was pleased with these lively photos.

Action, a scoop, any story that could be told in pictures—these were hallmarks of Capa's work. He made his mark as a photojournalist with the very first publication of images credited "Photos Robert Capa," in the pages of *VU* magazine on July 8, 1936. This photo story was told in five pictures spread over a whole page. A dramatic sixth photo, printed with a black border, is not part of the series and does not seem to have been taken by Capa. Journalist Madeleine Jacob, author of the accompanying article entitled "Vae Victis" ("Woe to the Defeated"), does not refer to the photos for a simple reason: She was inside the Palace of Nations, the headquarters of the League of Nations in Geneva, Switzerland, and therefore could not bear witness to what was taking place outside.

Tuesday, June 30, 1936, went down in history for the speech delivered by Haile Selassie I, exiled king of kings of Ethiopia. Both Léon Blum, the head of the French government, and Anthony Eden, foreign secretary and future prime minister of the United Kingdom, were in the audience. In October 1935, Benito Mussolini's Fascist Italy had launched an invasion of Ethiopia. Standing before the League of Nations, the Negus ("king" in the Tigrigna language) issued a scathing warning to the Western powers: "If the League of Nations does not offer a military response to Italian aggression, it is digging its own grave!" But despite defense agreements and the anti-Fascist speeches of France's Popular Front, the trend of the time was toward nonintervention, every man for himself.

Robert Capa was in the room during Selassie's speech. The first photograph he took shows the audience's reaction to the commotion that erupted in the second-floor press section. A group of Italian journalists, in attempting to justify the occupation of Addis Ababa, had insulted the Ethiopian emperor. League of Nations police set to work removing the troublemakers, but in the confusion they arrested a blameless Spanish journalist who was criticizing his Italian colleagues. Capa noticed immediately and followed the police as they hustled the innocent man out. And Capa captured the scene: the Spanish journalist, protesting his innocence, being dragged off by the military police, his head muzzled by a zealous officer. Never mind that Capa's fourth shot was blurry. At that time, camera bodies were not equipped with wind-up cranks, much less motors. One had to be quick to turn the "mushroom," the big round button that advanced the film for the next picture. Things happened suddenly. Capa had to capture the moment, the movement, stake his ground for the action, focus at full speed, and frame with precision. And the young photographer was up to the challenge. He got as close to the subject as he could. At twenty-three years old and five foot seven, he did not back off. The event caused an uproar in the civilized world of diplomacy, and "the Geneva incidents" would long symbolize the intent of the extremists to silence those who refused to fall in line.

Lucien Vogel, head of *VU* magazine, was also in Geneva, probably to cover the first official visit by Léon Blum, who had been chosen as France's new head of state, president of the council, the previous

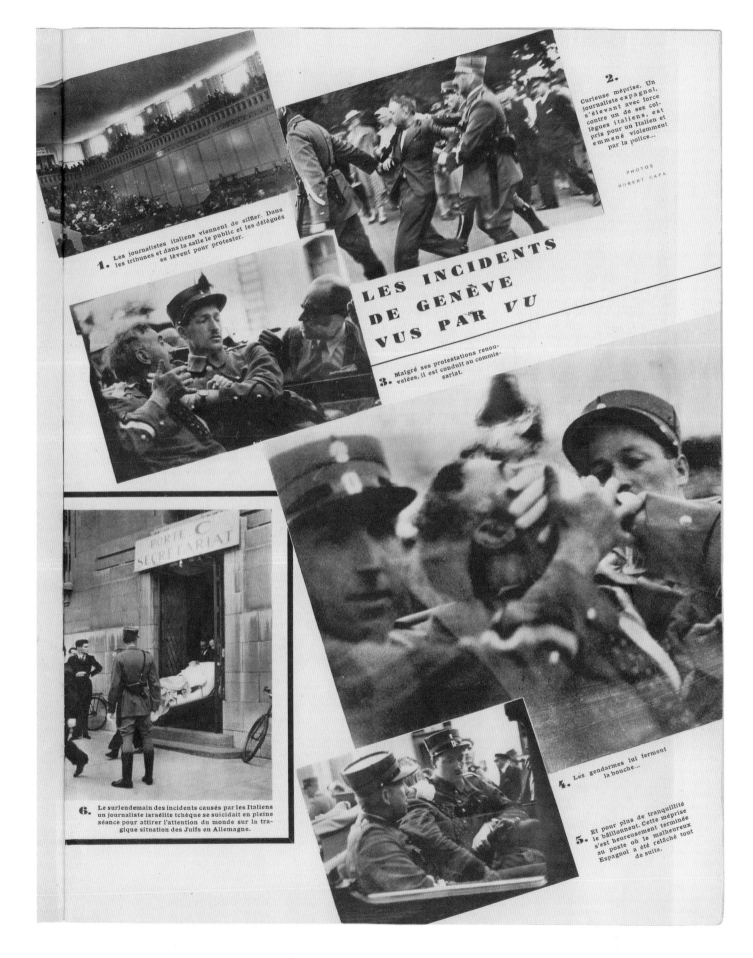

2. Curieuse méprise. Un journaliste espagnol, s'élevant avec force contre un de ses collègues italiens, est pris pour un Italien et emmené violemment par la police...

PHOTOS
ROBERT CAPA

1. Les journalistes italiens viennent de siffler. Dans la salle le public et les délégués les tribunes et dans la salle le public et les délégués se lèvent pour protester.

LES INCIDENTS
DE GENÈVE
VUS PAR VU

3. Malgré ses protestations renouvelées, il est conduit au commissariat.

PORTE C
SECRÉTARIAT

4. Les gendarmes lui ferment la bouche...

6. Le surlendemain des incidents causés par les Italiens un journaliste israélite tchèque se suicidait en pleine séance pour attirer l'attention du monde sur la tragique situation des Juifs en Allemagne.

5. Et pour plus de tranquillité le bâillonnent. Cette méprise s'est heureusement terminée au poste où le malheureux Espagnol a été relâché tout de suite.

week. *VU* had also sent a photographer, the Hungarian Lucien Aigner, already famous for his portraits of Benito Mussolini, to follow Blum. In Geneva that day, Vogel recognized Capa, still known as André Friedmann, running after the arrested Spanish journalist. At the time, André was working for Maria Eisner's Alliance Photo agency, where his girlfriend, Gerda, was charged with the sale of photos to newspapers. André had begun pretending to be a famous American photographer named Capa. The following week, when Gerda offered *VU* the "great Capa's" Geneva photos for 300 francs (by way of comparison, an issue of the newspaper then cost 2 francs; a Leica II with a 50 mm lens cost 1,745 francs), Lucien Vogel reached straight for his phone: "This Capa business is very interesting, but tell that ridiculous greenhorn Friedmann, the guy who photographs all over the place in his filthy leather jacket, to show up at my office at nine sharp tomorrow morning." Whether apocryphal or not, this story, told by Richard Whelan in his biography of Capa, reveals André and Gerda's sometimes transparent stratagem to increase their revenue.

Where did the name Capa come from in the first place? Many theories have been advanced to explain the pseudonym's origins. One thing is certain: In Paris, another photographer shared his surname. Georges Friedmann worked for *L'intransigeant*, which made it advantageous for André to find another name. The idea to pass himself off as an American photographer by the name of Robert Capa appears to have originated with Gerda. This subterfuge allowed her to sell André's photos to newspapers for three times the going rate: one hundred and fifty francs apiece instead of fifty! The name had to be simple, short, easy to spell and remember, and, even

outside France, ethnically neutral. It may have been inspired by Frank Capra, the American film director then at the height of his fame for *It Happened One Night*, which in 1934 had won all five major Oscars. The name Robert is also thought to have been inspired by the movies, borrowed from the actor Robert Taylor, who played Greta Garbo's lover in the 1936 film *Camille*. Gerda Taro, Greta Garbo? Maybe. In any case, it is worth mentioning that Gerta Pohorylle changed names around the same time as her lover. On April 7, 1936, in the middle of a letter to his mother from Paris, André had written: "I am working under a new name. I am being called Robert Capa. One could nearly say that it is a rebirth, but this time it didn't cause anyone any pain."⊕

74

le marignan

TÉLÉPHONE :
Balzac 43-81
ET LA SUITE
INTER

Société Anonyme
Capital 1.000.000 fr.
R.C. Seine 267.044 B

27, CHAMPS-ÉLYSÉES **RESTAURANT**

75

Kedves jó anyám,

PARIS, le 8. avril. 1936

mint látod előkelő a papír, de ez mint mindég nem
jelent semmit, csak várni kell itt valakire, hát ki-
használom a szép papírt és az időt. Leveleednek örültem és
épp tegnap kaptam Öcsitől amin halálra nevettem
magam. A, kicsi rengeteget fejlődött és pompás ember
lett belöle. Én úgy látszik hogy munkára adtam fejemet
és rengeteget dolgozom. Remélem, hogy e hónap végéig ki-
fizetem adósságaim és föleg remélem, hogy fel tudom
emeltetni elsejétől a fizetésemet, mert lehetetlen ki-
jönni belöle. Én kapok 1100. fr-t és az 500 fr- költségem
van rá. Szeretném úgy átváltoztatni, hogy havi 500 fr-t kapok
anyogra és heti 250 fr-t, mint előleget a fizetésre. Való-
színüleg az fog is menni. Új név alatt dolgozom Robert
Capának hívnak és így majd elkell mondani újra
születtem (ezuttal nem fájt senkinek). Szállónkat e hó
végén elhagyjuk és rendes hotelbe költözünk mig
egy kis lakásra jut. Egyenlöre minden mindegy
és csak az a fontos, hogy a munka haladjon, mert
már unom az örökös tervezgetést. Most heti három
riportot csinálok, hát képzelheted mennyit kell dolgoz-
nom. De mindezt hamarossan együtt átfecsegjük.

Photographer for the Popular Front

Before becoming war reporters on the Spanish front, Capa and David "Chim" Seymour were on the same beat as Henri Cartier-Bresson, Willy Ronis, François Kollar, André Kertész, and others among their colleagues reporting for the French press about "lendemains qui chantent," the "better tomorrows" promised by the Popular Front. At the time, the news was at their doorsteps, in the streets of Paris and its suburbs. The Popular Front lasted only twelve months, but these photographers, whether political or economic refugees, of French or foreign origin, immortalized their actions. The rue Froidevaux gang and the Alliance Photo team covered the Popular Front movement with dedication.

Bastille Day, 1936, the only national holiday celebrated by this leftist government, was, in a way, its apotheosis. The

special issue of *VU* published July 15, 1936, referred to "three days of celebration." The cover was a beautiful photograph of a child wearing a cap sitting on his father's shoulders, waving a red, white, and blue flag with the column on the place de la Bastille in the background. It is credited "Photo Capa." The photograph of Léon Blum standing at the official tribune on the place de la Nation during the afternoon people's parade was also taken by Robert Capa; Blum is seen with one hand raised—not his fist, which was the Popular Front's rallying sign—and the other brandishing the lamp given him by the Carmaux miners when they went on strike in 1892. The scene captured by Capa remains the symbol of the day. Showing the head of state as one with the workers—"the bastards in caps," as they were called by the extremist right-wing press—was unprecedented in France.

The French press of the 1930s was enormously influential, enjoying the power of untrammeled free speech. Newspapers were diverse, thought-provoking, and, in tune with the times, free-swinging. No one was neutral. You were either "for" or "against."

The economic crisis, which struck France in 1931, emptied savings accounts and drove tens of thousands of workers into unemployment. The political crisis reached its climax in February 1934, dividing France in two. The cover on the November 30, 1935, issue of *VU* magazine put the issue starkly: "If the French fought each other. National Front versus Popular Front. Who would win?" The specter of civil war haunted journalists and politicians. But the final showdown would take place in the voting booth, leaving minority extremists to hurl their deprecations at each other.

On the morning of May 3, 1936, during the second round of the legislative elections, Capa was at the city hall of Saint-Denis to photograph the voters. That evening, the Socialists, Communists, and Radicals, allied

ABOVE: This *VU* cover shot of the Popular Front march on Bastille Day 1936 was the first taken by the brand-new photojournalist known as Robert Capa. During this period, *Regards* and *VU* published many photos by Capa, Cartier-Bresson, and Chim, but without mentioning their names. **OPPOSITE:** Capa's photograph of Léon Blum on Bastille Day in 1936.

in an electoral coalition named Rassemblement populaire (Popular Rally), won the elections, and Léon Blum, secretary general of the leading leftist party with 146 elected officials, was named president of the council.

Before Blum could even be inaugurated on June 2, a massive social protest, reflecting the pro-left environment in France at the time, broke out, including strikes and factory occupations, beginning in the aviation factories in Le Havre, then spreading throughout the country. These incredible events—France swinging to the left for the first time in its history—would be covered by dozens of photojournalists. The elite team of Capa, Chim, and Cartier-Bresson—all of them under thirty—clearly rose to the top, carving out a fine reputation in editorial offices. Yet Capa and Chim's photos of striking factories or street protests appeared uncredited in *Regards* magazine. Even when Capa succeeded in getting into the Renault factory to take pictures, during a sit-in strike, his name was nowhere to be seen.

Cartier-Bresson had broken ties with his bourgeois family and was going by the simplified name of Cartier. His family owned the textile mill that produced Thiriez (later DMC) sewing thread, and along with many other factories throughout France, they were crippled by strikes from May to June 1936. Capa's biographer, Richard Whelan, recounts the episode on Sunday, June 14, following the signing of the Matignon social program. The Communist Party held a rally at the Buffalo stadium in Montrouge at which a delegation from the textile mills was holding up a banner that read CARTIER-BRESSON. Capa was there. Perhaps as a nod to his friend Henri, he framed only the first part of the name, intentionally leaving out "Bresson." No one has seen that photo; however, in the ICP archives, there is a photo showing a "Bresson" sign in the middle of a demonstration.⊕

78

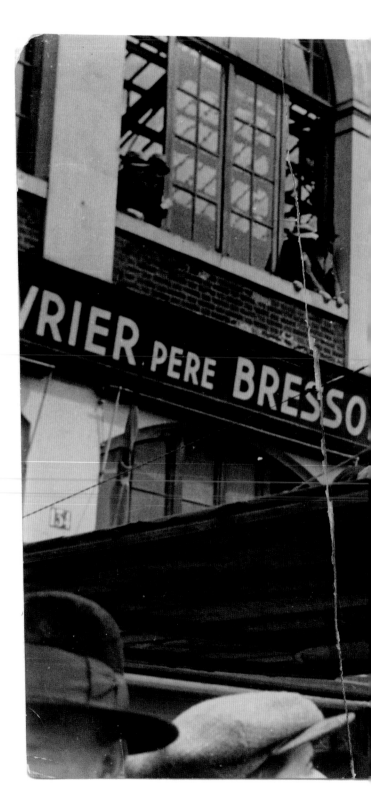

Captured by Capa, the Popular Front march passes under a sign bearing the name "Bresson." The surname, perhaps, reminded Capa of the factories belonging to the family of his friend Cartier-Bresson.

Capa in Marseille

In 1935, André's letters to his mother mention that he had to go to Marseille for a commission. In September, he referred to his photo story in this city, "which really appealed [to him]," but did not specify its subject. The Marseille photos taken on La Canebière vanished until the negatives were found in the attic at 37, rue Froidevaux. One of these images shows the Mobiles des Reformes Monument, erected in 1894 to commemorate the thousand inhabitants of the Bouches-du-Rhône who died during the Franco-Prussian War. The monument stands near the Saint-Vincent-de-Paul Church, and a large group of protesters can be seen raising their fists in support of the Popular Front. This might be a demonstration in favor of the 1935 Bastille Day "vow for the unity of the left," or perhaps a meeting against the occupation of Ethiopia by Fascist Italy. In any case, the photos are typical Capa: vertical shot, people in motion, and a tight frame. His signature style. Unfortunately, we were unable to find any sign of these photos in the press.⊕

FILM

Capa Among the Radical-Socialists

On Thursday, October 22, 1936, Capa was not in Spain, but in Biarritz, France. He was covering the opening of the Thirty-fifth Congress of the Radical-Socialist Party, which was part of the Popular Front government. Among those in the casino's great hall with the delegates were Édouard Herriot, president of the chamber of deputies, Édouard Daladier, vice president of the council, who had been Léon Blum's minister of defense, and Camille Chautemps, minister of state. The stakes were high: Would the Radical Party maintain its support for Léon Blum and remain part of the Rassemblement populaire along with the SFIO and the PCF (French Communist Party)? Many PCF senators had already declared their opposition to the Popular Front's economic policies. Debates were heated. In the great hall, those in favor of remaining raised their fists and lashed out against those opposed, who held out their arms like the Fascists. Once again, Capa photographed faces up close, capturing the violence of the arguments. These two photographs were found in the attic at rue Froidevaux. In Biarritz, Capa was accompanied by Albert Bayet, a professor at the Sorbonne and a member of the Radical Party. *Regards* published Bayet's article under the title "Un coups manqué" ("A Missed Opportunity") on October 29, with five photographs by Capa. *VU* published some of his photos with Jean Luchaire's article on the same subject. The profoundly divided Radical-Socialist Party finally chose to maintain its support for Blum thanks to Daladier's efforts to persuade its members. Yet as *VU* magazine pointed out, this was only a brief reprieve.⊕

Paris Takes to the Streets

These three photographs taken in Paris before or during the time of the Popular Front have never been published. They were also found in the attic at 37, rue Froidevaux. In the first horizontal photograph, we recognize the Lycée Louis-le-Grand on rue Saint-Jacques, near the Sorbonne in Paris. The date and purpose of this demonstration are hard to know. Capa was then randomly photographing people participating in or just watching happenings in the street. Based on the elegant outfits worn by the demonstrators, it is likely that they are opponents of the Popular Front. There is not a woman in sight among them. But Capa did capture a Paris street urchin hanging from a lamp-post. At several points in his career, he would focus on children's faces, as did his friend Chim. In 1991, Richard Whelan published a book about Capa and children called *Children of War, Children of Peace*, considering it a major theme in his work. ⊕

Barcelona at War

"I can remember the first time they left
for Spain as though it was yesterday," said
Willy Ronis. "André and Gerda were at
my place. They were deeply in love, and
she was so happy to go there with him.
They were as broke as ever, and I did what
I could and made them a meal. They had
breakfast at my house, just before leaving
for Barcelona." It was August 1936.

André Kertész had a different version:
He thought Capa and Taro had been in
Spain since July to cover the People's
Olympiad. Organized by Republican Spain,
this event was to draw six thousand anti-
Fascist athletes from twenty-two nations,
all of whom refused to participate in the
Berlin Olympic Games staged by Hitler.
The competitions were to take place from
July 22 to 26 at Montjuïc Stadium. The
Catalan Jaume Miravitlles was secretary

of the executive committee. The German
photographers Hans Namuth and Georg
Reisner were already in Barcelona. But the
Olympiad never took place.

During the night of July 18, the first
shots of the Spanish civil war rang out in
Barcelona as the people took up arms in
answer to the rebel generals' *pronuncia-
miento* against the elected government.
Miravitlles was forced to cancel the Olym-
piad, and some of the athletes joined the
battle on the militia's side.

In Paris, Lucien Vogel, then head of *VU*,
arranged for a team of journalists to prepare
a special issue covering the latest events.
He chartered a plane at Le Bourget and
set off for Barcelona as soon as he could;
newsreel journalists from *Éclair-journal* and
France-actualités left with him. The plane
crash-landed in the city of Alcañiz, in the
province of Teruel. Vogel, his head and legs
injured, donated the damaged plane to the

VU EN ESPAGNE

la défense de la République

PRIX : 5 FRANCS
NUMÉRO SPÉCIAL
SAMEDI 29 AOUT 1936
DIRECTEUR : LUCIEN VOGEL
PHOTO REISNER

Spanish Republic, and his team of journalists eventually made its way to Barcelona.

Capa was not aboard the plane. He was to join the others by train, but it appears that the advance he had received to pay for his ticket was spent settling old debts or lost on a bet. In any case, Capa was not traveling alone. While Vogel did not consider Taro a photographer—she was an assistant at Alliance Photo—and only Capa was accredited by *VU*, the young woman had chosen to take her chances and accompany him. She had been given a press card by the Dutch agency A.B.C. Press Service in February 1936 and now turned to A.B.C. for accreditation in Spain. Irme Schaber, Gerda Taro's biographer, believes the couple arrived on August 5 and left in early September. But according to Roméo Martinez, a contemporary of Capa's and an expert on the history of photography, it was only on August 14 that Capa and Taro were able to scrape the money together for the trip and take the train from Carcassonne to Barcelona. Lucien Vogel's special issue, called "Defending the Republic," was on newsstands in Paris on August 29. It was crammed with dozens of pictures by "Cappa [*sic*], Madeleine Jacob, Maurice, Namuth, Reisner, and Vogel," and also by Gerda Taro, whose name did not appear.

Despite the special issue's significant success, *VU*'s Swiss stockholders fired Vogel, who was considered to be too personally involved in the Spanish conflict. Capa maintained his ties to the paper for a time, while Vogel put his journalistic skills at the service of the Republican cause. He would be the man behind two more special editions: In January 1937, he edited an issue of *L'illustré du petit journal* entitled "Six Months of Civil War in Spain," and in the summer of 1937 he edited "Spain Invaded: A Year of Nonintervention." Both publications featured numerous photographs by Capa, and by Taro, Chim, Namuth, and Reisner.⊕

Three Capa negatives found in the rue Froidevaux apartment, showing an unidentified Spanish village.

Militiawomen in Training

One of the foreign press's favorite subjects during this Spanish summer was the appearance of armed militiawomen. As the people grabbed every rifle they could find, women did not hang back. It was like nothing that had ever been seen before. Capa and Taro traveled in the propaganda commission's car to the suburbs of Barcelona to see a training session during which militiawomen practiced firing pistols and rifles. The photos of the exercise were published—uncredited—in *VU*'s special issue under the title "When Women Get Involved: Portraits of Militiawomen." One of the photos became famous, a shot of a young woman wearing high heels, her knee to the ground, firing a pistol. The militiawoman is photographed in profile, her face hidden. The photo is in the square format of the Rolleiflex photos attributed to Taro. An unpublished negative from this series was found at 37, rue Froidevaux, revealing the subject's face. It is indeed the same woman, now standing at attention, her rifle against her shoulder and her face severe.⊕

A series of photographs of the training session near Barcelona for militiawomen in blue overalls was published on August 29, 1936, in a special issue of *VU*.

A negative from the series was found at rue Froidevaux. The press was particularly keen on photos of armed women, a novelty at the time.

92

Capa captured these
militiamen waiting near
a car during a military
training session close
to Barcelona.

93

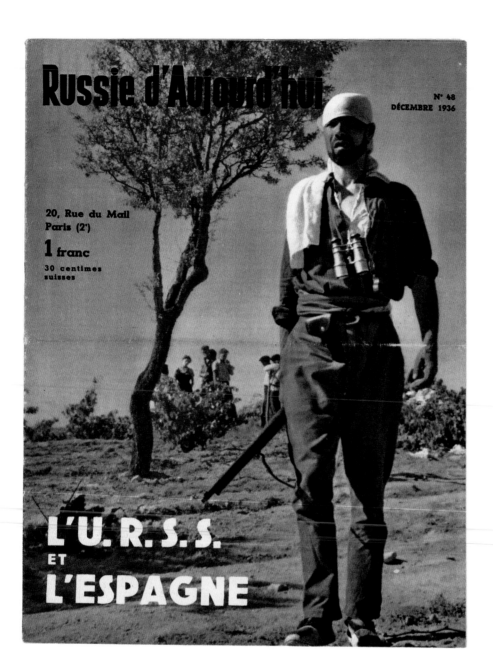

Russie d'Aujourd'hui

N° 48
DÉCEMBRE 1936

20, Rue du Mail
Paris (2°)

1 franc
30 centimes
suisses

L'U.R.S.S.
ET
L'ESPAGNE

Looking for Combat in Aragon

Jaume Miravitlles, initially the secretary general of the Central Committee of Anti-Fascist Militias, was later named commissioner of propaganda for the Generalitat of Catalonia, the regional government. He supervised the arrival of foreign journalists and helped them travel on local roads by providing them with requisitioned vehicles, gasoline, and even drivers. Since Capa and Taro were his friends, he introduced them as correspondents for the Generalitat. Yet during this first trip on the roads of Spain, the two photojournalists despaired at their inability to find any actual combat to photograph. In 1936 they were still mainly faced with a war of position and had to make do with photographing the citizenry in arms.

Lucien Vogel's team returned to Paris with the rolls of film Capa and Taro had shot in Barcelona in order to print and quickly publish them. Remaining in Spain, Capa and Taro made for Aragon, where the Republican militias were fighting to seize the city of Saragossa from Franco's troops. Mostly they photographed militiamen of the various political factions, civilian volunteers wearing a miscellany of uniforms. In two of the photographs shown on the opposite page, their subjects posed in shooting position behind a low wall, but we know they weren't actually shooting because the photographer was facing them. Capa and Taro then set to work creating a gallery of portraits. Photographs such as the one of this fighter wearing a white scarf to protect himself from the sun, published on the cover of *Russie d'aujourd'hui* (*Russia Today*), would be reprinted in countless

ABOVE: **In Paris, the paper** *Russie d'aujourd'hui* (*Russia Today*) **published Capa's photo of a Spanish militiaman on the Aragon front.**

OPPOSITE, TOP: **An image of the same soldier, behind a low stone wall, ready for combat. This soldier obviously impressed Capa and Taro, as both of them photographed him several times.**
OPPOSITE, BOTTOM: **A similar photo, printed in the English journal** *Spain at War.*

To a Free People

By JOHN GAWSWORTH

To a free people
Behind barricades and
 boulders,
I address these lines
From a brain that smoulders
Resentfully
At the totalitarian affront
Now forcing them to bear
 the brunt
Of the massed attack on
 democracy
While we. . . .

But here I suggest
The kernel of a jest :
Red berry of winter !
Red hell of shell splinter !
(Bread from the skies
Was dropped with reason—
To plump the pullets of the
 season
And sharpen death agonies !)

Photo, Taro

Here is my hand, brother,
 Though it hold but a pen
 It would grip your grease
 of cartridge,
 The oil from the bolts
 of men
 Worthy of the name
 As the women of Spain :
 The heroine of Saragossa
 Has lived again.
 The Cid has arisen
 From out a Franco prison
 And tilted at Death's
 windmill
 Without a thought of
 gain.

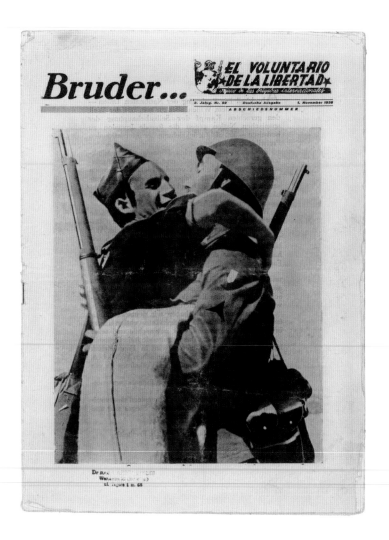

Bruder... **EL VOLUNTARIO DE LA LIBERTAD**

pamphlets expressing support for the Spanish Loyalists. The month was August 1936, the setting near Huesca, and intense heat gripped the province of Aragon. Both Capa and Taro photographed this man, who looked like a pirate, over and over again.

Riding in the Generalitat of Catalonia's press vehicle with Capa and Taro was the Austrian journalist and academic Franz Borkenau. In *The Spanish Cockpit*, his important account of the Spanish civil war, Borkenau described his trip with the two photographers and their passage through the village of Leciñena, near Saragossa, then occupied by a column from the POUM (Partido obrero de unificación Marxista [Workers' Party of Marxist Unification])— the anti-Stalin militia that spearheaded the Spanish civil war and demanded a radical agrarian reform. Its commander, Manuel Grossi, a miner from Asturias and leader of the 1934 uprising, was impatient to go into combat. Unfortunately, the Republican army generals were holding the column in Leciñena. Capa photographed the "Poumists" across from their headquarters as they drank wine in great gulps straight from *porrones*, the traditional Spanish wine carafes. Frustrated at this desperately static front, Capa and Taro moved on, heading south for Andalusia.⊕

Mysteries of an Icon

The caption for this beautiful, poignant, and dramatic photo, shown on the right, from World War I states: "Dragoon on reconnaissance, photographed as a bullet hits his shoulder. Name of the wounded man: Pierre Quér... This is the first rigorously authenticated document of this type that we have held in our hands." In the history of photography, it is extremely rare for a photographer to capture a soldier in action being hit by an enemy bullet. The symbolic weight of Capa's famous photo singlehandedly sums up the drama of the Spanish civil war. This icon of twentieth-century photojournalism (see left) is known as "The Falling Soldier" or "Death of Loyalist Militiaman" or "The Moment of Death."

Despite multiple discoveries of Capa negatives and photos in recent years, the negative of this photograph about which so much ink has been expended is yet to be located. Sadly, it was not among those found in the "Mexican suitcase." Its absence has left us to examine period prints and publications and question the photo's framing and thus the identity of the person who took it. However, we now know that the identification of the falling soldier as Federico Borrell García is not correct. The date the photo is said to have been taken—September 5, 1936—has also been contested. And it has recently been proven that the picture was taken in Espejo rather than Cerro Muriano, both of which are villages near Córdoba. Every certainty has been shattered, reinforcing the mystery surrounding this icon and feeding speculation about the war scene's authenticity.

OPPOSITE: **The Museum of Modern Art in New York's print of "Death of Loyalist Militiaman," one of only two period prints. It was made "from the original negative by Capa."**
ABOVE: **A French dragoon struck by a German bullet during World War I. Photo published in the weekly *Le miroir* on May 9, 1915.**

COMMENT
ILS
ONT FUI

Telle une scène calquée sur la Bible, la vision de ces trois fugitives au visage douloureux évoque les exodes tragiques de l'Ancien Testament. .PHOTO CAPA

C'est la migration du peuple d'une province tout entière, au pas lent des mulets lourdement chargés, parmi les cris des enfants, sous le dur soleil.
PHOTO CAPA

Le jarret vif, la poitrine au vent, fusil au poing, ils dévalaient la pente couverte d'un chaume raide.. Soudain l'essor est brisé, une balle a sifflé — une balle fratricide — et leur sang est bu par la terre natale...
PHOTOS CAPA

Peut-être vivaient-ils heureux, peut-être coulaient-ils des jours paisibles dans un calme village... La guerre civile est venue et avec elle le désespoir, l'écroulement d'un foyer dans la misère. CAPA

VU magazine first published the photo of the militiaman on September 23, 1936. This print is doubly intriguing: It is accompanied by another print of a felled (and photographed) militiaman at exactly the same place; its framing is that of a 24 × 36 shot cropped at the top.

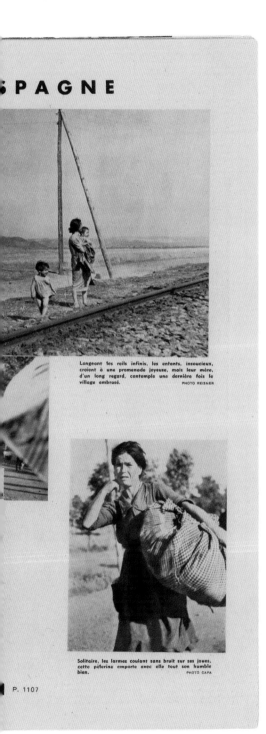

Longeant les rails infinis, les enfants, insouciens, croient à une promenade joyeuse, mais leur mère, d'un long regard, contemple une dernière fois le village embrasé.
PHOTO REISNER

Solitaire, les larmes coulant sans bruit sur ses joues, cette pèlerine emporte avec elle tout son humble bien.
PHOTO CAPA

P. 1107

Let's begin by examining the question of framing, which seems to be a simple detail but is far more complicated and intriguing than it appears. There are two period prints of the photo. The first, held at the Salamanca Archives, was found in 1979 in a suitcase of prints that belonged to Spanish prime minister Juan Negrín. It is in a classic 24 × 36 format without any inscription on the back and does not provide any additional information. The second, held at the Museum of Modern Art in New York, is more interesting. The photo is glued to a cream-colored piece of cardboard, which must have been tacked at all four corners. The print is in poor condition but has clearly been extensively restored. When observed through a magnifying glass, traces of folding are visible on three sides, and the gelatin is crackled and entirely gone in several places. The hue is deep, high contrast, and velvety. The militiaman is also very sharp, unlike the grass in the background, which is relatively blurry. The framing slightly crops the butt of the rifle on the left and the militiaman's espadrilles—we can see the sole of the right foot. The sky at the top of the photo is far darker than what is below, particularly in the two corners. An inscription in black pencil on the cardboard reads, "By Robert Capa (a print from original neg)." Other annotations have been imperfectly erased but cannot be deciphered. The inventory number is 126 1959; 1959 means that the

item entered the collection that year and tells us it had had a long prior life. The backing board also bears the inscription, in English, "Robert Capa. Spanish soldier drop with a bullet through his head. July 12, 1937. Gift of Edward Steichen." It is believed that the photographers Wayne F. Miller and William Eugene Smith, who worked with Capa at *Life* magazine, gave this print to Edward Steichen, most likely after having taken it out of Time-Life's archives. In 1947, Steichen became curator of MoMA's photo department, where he came to attention two years later with the exhibition The Exact Instant, which displayed three hundred press photographs in their publication context. The print then entered the collection of the famous New York museum.

It is in an unusual format, taller than a Leica 24 × 36 without being square like a Rolleiflex 6 × 6. Horizontally, the framing is identical to the print in the Salamanca Archives (with the rifle butt cropped), but far more sky is included. Some have, therefore, come to the conclusion that this could be a vertically cropped photo taken on a 6 × 6 by Gerda Taro. But this explanation is not convincing: Based on the many period prints reproduced in this volume (like the MoMA print), we can ascertain that this was neither a 24 × 36 nor a 6 × 6 format, but a larger or taller one. At the time, cropping was common, based on the sizes of paper available, the photographer's intentions, and the newspaper's layout.

101

These pictures of shattered Spain and Spaniards are identified by actual cuttings from various newspapers relating to the events they illustrate

Two photomontages using photos by Capa and Taro, published in the British daily *News Chronicle*'s special issue on Spain in 1938. Surprisingly, in this paper, the militiaman's rifle butt is complete, which suggests that the photograph may have been retouched.

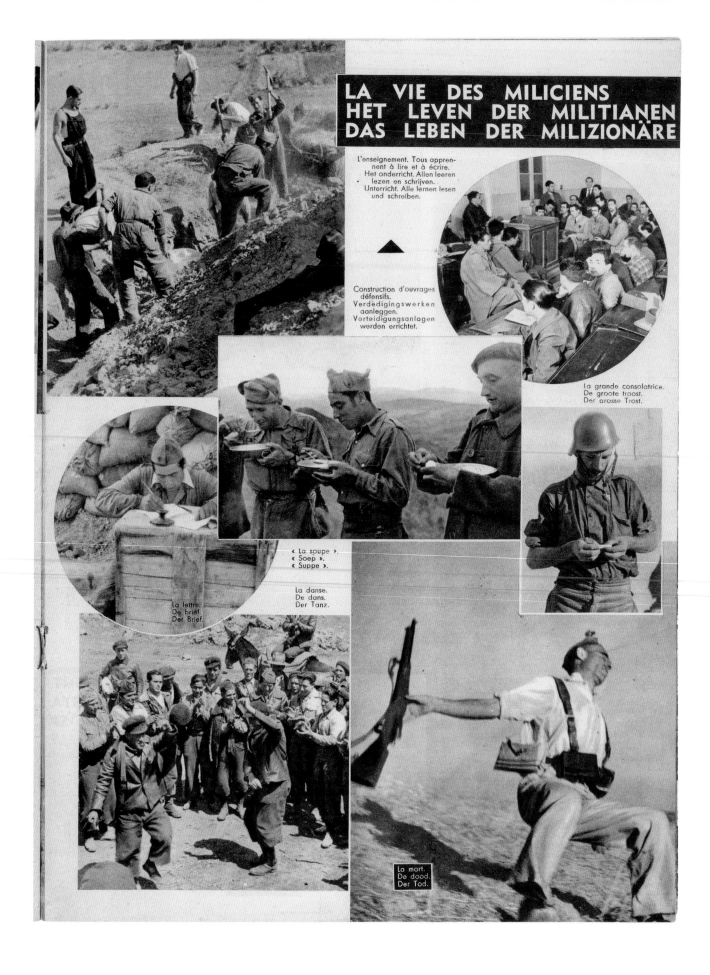

LA VIE DES MILICIENS
HET LEVEN DER MILITIANEN
DAS LEBEN DER MILIZIONÄRE

L'enseignement. Tous apprennent à lire et à écrire.
Het onderricht. Allen leeren lezen en schrijven.
Unterricht. Alle lernen lesen und schreiben.

Construction d'ouvrages défensifs.
Verdedigingswerken aanleggen.
Verteidigungsanlagen werden errichtet.

La grande consolatrice.
De groote troost.
Der grosse Trost.

« La soupe ».
« Soep ».
« Suppe ».

La danse.
De dans.
Der Tanz.

La lettre.
De brief.
Der Brief.

La mort.
De dood.
Der Tod.

The exhibition This Is War! Robert
Capa at Work, held at the ICP in New York
in 2007, established that Robert Capa and
Gerda Taro were indeed present the day
the photograph was created by displaying
forty photographs taken on the same date
as "The Falling Soldier." The exhibition
included rectangular photos taken with a
Leica and attributed to Capa and square
photos taken by Gerda on her Rolleiflex.
At certain points they photograph side by
side in the trenches—one can see their
shadows. Then they separate. Capa shoots
the militiamen brandishing their guns.
We recognize the two men alleged to have
died later that day. Gerda Taro follows them
as they climb the hill and photographs
the first, sitting and shooting into the air.
Clearly, at this particular moment, there is
no enemy facing them: The two militiamen
are posing for the two reporters until the
tragic moment. Richard Whelan's thesis in
the exhibition catalog is that bullets then
surprised the two soldiers and cut them
down one after the other. He bases his
hypothesis on the last three photos in the
series, which show unidentifiable mili-
tiamen lying on the grass. They are dead,
according to Whelan, who argues that more
than two soldiers were killed that day. The
researcher explains that "reality is never all
black or all white. This is no more a photo-
graph of someone pretending to be hit by a
bullet than it is an image taken in the heart
of battle."

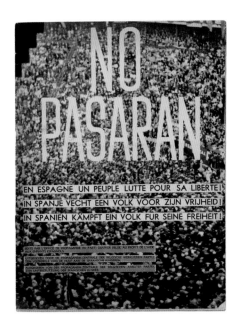

The photo was first published in *VU*
on September 23, 1936. This is where
questions begin to arise (see page 100). In
fact, *two* photos appear in the paper, one
above the other, depicting two militiamen
shot down in the same place. The pictures
are obviously not of the same man: The
subjects wear different clothing and are
clearly recognizable in other shots from
the same series. Yet they are falling in the
same place—the hill's stubble and the sky
are identical—each struck down by a bullet.
Strange. The caption states, "Legs tense,
chests out, rifles in hand, they charge down
the steep hill covered in stubble. Suddenly,
their flight is broken, a bullet has whistled
through the air—a fratricidal bullet—and
their blood is lapped up by the native
land." In general, commentators do not
pick up on the ambiguous word *fratricidal*,
which could mean either that a bullet has
been fired by a friendly militiaman or by
an enemy in this war between two Spains.
But how likely is it that a second soldier
would also be hit by "a fratricidal bullet" in
the same place a moment later? Not very
likely at all.

Various appearances of "The
Falling Soldier" in the press
(left, in *No pasaran*, below in *Life*
magazine). The photo published
by *Regards* magazine in 1937
has a framing similar to the
MoMA print: It is taller than the
classic 24 × 36.

In fact, this mysterious photo was not published often during the war itself, and never in Spain. While the use of photos of civilian victims of bombings was constant in Republican propaganda, that of a dead militiaman was probably intentionally avoided; in wartime, official censors assiduously avoid showing pictures of their own dead soldiers. But even in Europe and the United States, appearances of "The Falling Soldier" were rare. *Regards* published the famous photo a month after it appeared in *VU*, with a higher frame, identical to the MoMA print. And like *VU*, the June 28, 1937, edition of *Paris-soir* ran both photos of the militiamen to illustrate an article by its special correspondent Antoine de Saint-Exupéry entitled "The War on the Carabanchel Front. Sergeant, Why Do You Accept Dying?" The first photo's caption was "Hit!!!"; the second's, "Fallen!!!" The only propaganda pamphlet to publish the photo was a publication of the Belgian Workers' Party, largely consisting of photos by Capa, Chim, and Taro. In the United States, it was published in *Time* magazine on October 8, 1936, while *Life* waited nearly a full year, until July 12, 1937—the date on the MoMA print. The caption is explicit: "Robert Capa's camera catches a Spanish soldier the instant he is dropped by a bullet through the head in front of Córdoba." This caption is similar to the one on the MoMA print. A month later, *Life* republished the photo in an issue covering Gerda Taro's death, but in a classic 24 × 36 format.

107

This is the "official" photo distributed by Magnum. Take the time to compare it, point by point, to the MoMA print on pages 98–99.

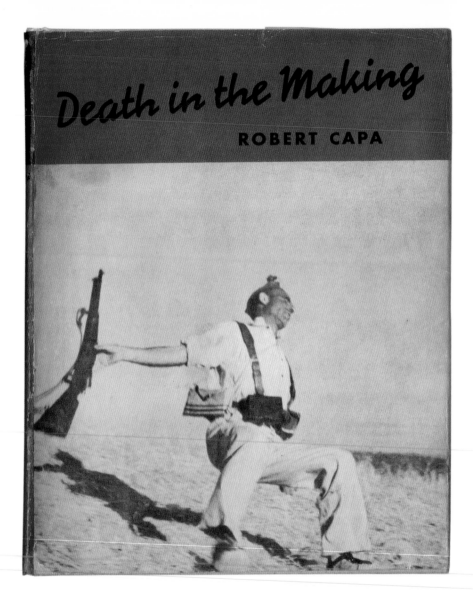

published in New York in 1938 as a tribute to Gerda Taro.

While discussion of this strange framing and its author may be interesting, it is ultimately not the most significant issue regarding "The Falling Soldier." The circumstances under which the photo was taken have led to the more heated debate. In 1975, *The Sunday Times* published a long article by Phillip Knightley drawn from his book *The First Casualty*, a detailed analysis of the work of war correspondents from Crimea to Vietnam. The article led to an uproar. Knightley built his case on the page in *VU* featuring two militiamen and the *Life* caption. For the defense, he called on accounts by Cornell Capa, Henri Cartier-Bresson, Ted Allan, Martha Gellhorn, and John Hersey. But he set the greatest store by a witness for the prosecution, O'Dowd Gallagher, a South African war correspondent who covered the Spanish civil war for the London *Daily Express*. Gallagher claimed that during the war Capa had told him that Republican officers had staged a photo shoot for him by having the militiamen maneuver to make up for the absence of any real combat. Satisfied with the results, Capa is alleged to have told Gallagher, "If you want to have a good shot from the heart of the action, it is essential not to have an overly demanding setup. When your hand shakes just a little, you get a first-rate war photo." Gallagher's account was ultimately discredited by a different, directly contradictory version that he later provided.

The only direct witness to the scene was Georges Soria, the journalist for *L'humanité* who was accompanying Capa. Soria does not remember the name of the place where the photo was taken or the exact date (he refers to late August), but says that enemy machine guns were crackling that day and that "Bob was taking pictures as if nothing was wrong." Capa's

The cover of the book *Death in the Making*, published as a tribute to Gerda Taro in New York in 1938, displays yet another version of "The Falling Soldier." Here, the framing is unusual in its width, with nearly the entire rifle butt appearing, while it is cut off in the other prints.

We have found two other published instances of the photo, which only add to the confusion. The center-left British daily *News Chronicle*, for which Arthur Koestler wrote, published a special issue on Spain in 1938 whose double-page center spread featured two spectacular photomontages: Taro's picture of a peasant armed with a pitchfork was at the center of one of the montages, while "The Falling Soldier" was surrounded by a montage of ruins left by Francoist bombings. Here, the rifle butt is seen in its entirety—which may of course be due to a touch-up. Yet the same detail of the rifle butt strikes the eye on the cover of *Death in the Making*, the book Capa

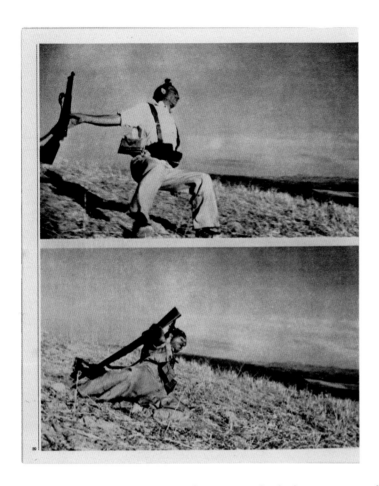

statement of fact that it at first sight
appears.

*The following statement is included
at the request of Robert Capa's
brother Cornell Capa.*

*"For 39 years Robert Capa's
'moment of death' has been subjected
to the closest scrutiny of knowledge-
able editors, reprinted time and time
again, and viewed by millions through-
out the world.*

*"For 39 years Bob's reputation as
a brave and honest photo-journalist
has remained the highest in the Press
community, the community of his
peers. It would appear that Phillip
Knightley rests his denigrating specula-
tions on the purported conversations
between my brother and a* Daily
Express *correspondent, O. D. Gallag-
her, who was covering the Spanish
Civil War. Is it conceivable that
throughout the 39 years, including the
period of Bob's own lifetime, Gallagher
remained a silent witness to an alleged
fraud? Why did he not reveal what
only he knew when Bob was alive to
respond to his allegations?*

*"It saddens me to think that
Phillip Knightley would launch an
attack on such a flimsy record on the
credibility of the photograph and the
integrity of the photographer."*

One other symbol in Spain was
Ernest Hemingway, by far the most

In his article "Truth, the First
Casualty of War," published
in *The Sunday Times Magazine*
on September 29, 1975,
Phillip Knightley claimed that
propaganda was central to
journalists' work during the
Spanish civil war, using Capa's
"The Falling Soldier" as an
example. Cornell Capa published
a rebuttal in the same paper (see
page 260).

own comments on his photo appeared in
an article in the *New York World-Telegram*
dated September 1, 1937. The journalist
relaying Capa's comments explained that
the militiaman had been struck by a burst
of machine-gun fire and that Capa caught
the scene. The only direct quote in the
article runs, "No tricks were necessary to
take pictures in Spain. You don't have to
pose your camera. The pictures are there,
and you just take them. The truth is the best
picture, the best propaganda."

Cornell Capa sharply rebutted the
attacks on his brother's honesty in *The
Sunday Times*: "Why didn't Gallagher reveal
what he knew when Bob was alive and he
could respond?" The controversy grew.
What do you think of the most famous
photo of the Spanish civil war, the one of
the militiaman falling, hit by a bullet as he
charged up a hill? Is it a staged photo? The
nagging question kept coming back. Capa,

who died in 1954, was no longer able to
defend himself. Capa's biographer, Richard
Whelan, who has since passed on, headed
up Capa's defenders with Cornell Capa, also
now dead.

In 1996, a new element cropped up.
Mario Brotóns Jordá, a Spanish histo-
rian, claimed that the militiaman was
called Federico Borrell García, and he
was fighting in an anarchist column in
Cerro Muriano, near Córdoba, when Capa
photographed him being struck by enemy
fire. This information was repeated in the
international press without any discus-
sion. Yet in 2007, the makers of a Spanish
documentary uncovered an article in a 1937
anarchist paper, *Ruta confederal*, describing
the circumstances of the death of this
Federico Borrell García; they do not match
the scene of the falling soldier. Addition-
ally, a comparison of a photo of Borrell
García with that of Capa's militiaman was

not convincing—the soldier is clearly older. In short, "The Falling Soldier" no longer has an identity.

The alleged site of the photograph, Cerro Muriano, remained to be confirmed. Combat had indeed taken place in this village near Córdoba in early September. Yet in 2007 the Spanish academic José Manuel Susperregui was intrigued by a detail in one of the new photos uncovered by ICP. Five militiamen are seen, rifles at the ready, with white buildings far in the background. Cerro Muriano has no buildings to match those . . . Susperregui began trying to track down the place in the photograph. But how do you find a landscape identified only by a ridgetop and a few white houses? Patience eventually

paid off. Inhabitants of Espejo, another village on the outskirts of Córdoba but a long way from Cerro Muriano, recognized the ridgetop and the three olive presses visible on the hill. Three other researchers, Ernest Alós, Carles Querol, and Fernando Penco Valenzuela, later pinpointed the exact place where the photo was taken. But there remained one problem: There was no fighting on September 5, 1936, at that place.

The page facing "The Falling Soldier" in the September 1936 issue of *VU* (see pages 100–101) features a series of photos that were identified as having been taken at Cerro Muriano. They show villagers fleeing the battle—a classic war scene. Some are by Capa, while others are credited to Hans

111

Spanish researcher José Manuel Susperregui's investigations argued that the photo above, captured during the same photo shoot as "The Falling Soldier," was taken in Espejo rather than Cerro Muriano (both are villages near Córdoba). Compare the ridge and the buildings in the bottom of the valley (left photo) with a recent photograph of the Espejo landscape (right).

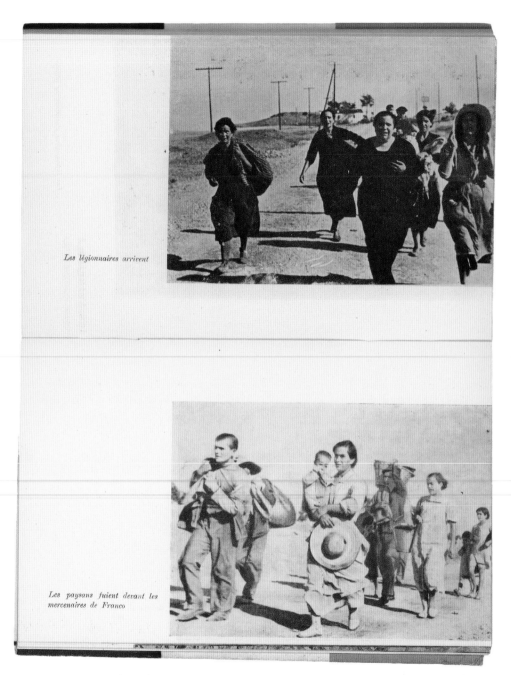

Les légionnaires arrivent

Les paysans fuient devant les mercenaires de Franco

Two photos Robert Capa took of civilians fleeing the Francoist assault in Cerro Muriano were included in Arthur Koestler's book *L'Espagne ensanglantée* (*Bloody Spain*), published in Paris in 1937.

Todo lo que es vida, trabajo y humanidad huye al paso del fascismo. He aquí en su emocionante patetismo mujeres y niños a través del campo por no caer en manos de esas hordas que deshonran la civilización. Si hubiese suficiente ternura en los corazones, ante este cuadro el mundo se levantaría indignado contra el fascismo

Nuestros bravos tiradores

113

The December 1, 1936, issue of the anarchist paper *Tiempos nuevos* published a Hans Namuth photo of civilians in Cerro Muriano along with a Robert Capa photograph taken in Espejo.

Namuth and Georg Reisner, both German photographers. These photos were available in Spain and were freely published in the Spanish press as well as in the rest of Europe, and even in Arthur Koestler's propaganda book, *L'Espagne ensanglantée* (*Bloody Spain*). Like *VU*, the anarchist newspaper *Tiempos nuevos* published photos taken in Espejo at the same time as the "The Falling Soldier," accompanied by those of the fleeing people of Cerro Muriano. An account by Jaume Miravitlles, head of propaganda for Catalonia, lends credence to the theory that these photos were indeed printed in Spain. In 1976, he wrote about "The Falling Soldier": "Some have talked of a 'montage.' This isn't true. [Capa] developed it in the Generalitat of Catalonia's propaganda commission's labs and came to show it to me. I was utterly fascinated and astonished by a totally new image until then unknown in the whole history of photography."

The final piece of evidence is a gripping photograph taken by Hans Namuth in Cerro Muriano. Namuth always maintained he never saw Capa there. They had photographed the same fleeing villagers at different points without running into each other. Yet his camera captured an image of two figures wearing overalls and carrying bags over their shoulders, moving in the opposite direction of the villagers fleeing combat. These two figures look a lot like Capa and Taro, resolutely heading toward the battle.⊕

Several teams of photographers and journalists were in Cerro Muriano, including Capa and Taro on one side and the Germans Georg Reisner and Hans Namuth on the other. In this photo by Namuth, two figures are seen walking against the current of the fleeing crowd. They could be Capa and Taro.

114

A Lesson in Photojournalism in Madrid

¡No pasarán! They shall not pass! Chim's photo of a banner bearing this slogan in Madrid would be seen around the world. In the freezing winter of 1936, the watchword coined by Dolores Ibárruri, "La Pasion-aria," stirred the defenders of the Spanish Republic. International Brigades volunteers streamed to Spain and went directly into the front lines to block the Fascists. You had to be with them, and Capa was! On November 16, 1936, the editorial department of *Regards* received a short-term Spanish visa for Capa. His trip was planned to last three weeks, from November 18 to December 5. In a letter serving as a laissez-passer, or document in lieu of a passport, the paper's administrator stated, "Mister Capa-Friedmann is our only photojournalist especially assigned to Madrid and the various fronts. We ask all competent authorities and organizations of the Spanish Republic to welcome him and aid him materially and morally by taking into account that the documents he will send to our paper in France will serve the interests of the Spanish Republic."

When Lucien Vogel lost control of *VU* with the publication of the special issue on Spain, Capa and Taro began sending their photos to *Regards* instead. Joining Chim, who had long worked for this Communist weekly, they formed a trio that would produce the most extraordinary coverage of the Spanish civil war. From the uprising of the military in July 1936 to the end of that year, *Regards* devoted 30 percent of its editorial layout to the Spanish conflict. Chim would initially take the lion's share,

ABOVE: This emblematic photo of Madrid at war appeared in the November 11, 1937, issue of *Regards*. It was probably taken by Chim.
RIGHT: Brochure for the Hotel Florida, where many journalists lived during the war. The hotel has since been destroyed.
OPPOSITE: A page of the *Pesti napló képes melléklete* (the illustrated supplement of Budapest daily *Pesti napló*) dated January 24, 1937, featured photos by Capa (at the university campus) and Chim (a photo story on the warship *Jaime I*). Title: "Images from the Siege of Madrid," subtitle: "Foot Soldiers and Sailors Stand Guard in the University Quarter."

KÉPEK AZ OSTROMLOTT MADRIDBÓL

GYALOGOS ÉS TENGERÉSZ ŐRÖK AZ EGYETEMI VÁROSRÉSZBEN

with his photos credited on the front page. But Capa soon caught up and shot past him, and Taro was eventually credited for the photos she took.

After their first trip to Spain at the end of the summer, Capa and Taro had returned to France. Capa covered the Radical Party congress, then returned to Spain alone, Taro remaining in Paris. The photographer arrived in Madrid on November 18, a little late: The four columns of Franco's army had attacked the city ten days earlier and now seemed unstoppable. War had taken hold of the heart of the city. There was fighting in Casa de Campo Park, a little more than half a mile from the center. People rode the tram to the front lines. Franco's cannons and planes ripped buildings apart. Journalists shuttled between the Telefónica Building and the Florida and Palace hotels trying to cobble their coverage together. The street of Gran Via had become the antechamber—the waiting room—on the edge of the battle.

Capa photographed the populace as people fled the bombings, particularly those who sought shelter in the subway, and spent a great deal of time with the International Brigades volunteers. In his memoirs, Alexei Eisner, aide-de-camp to General Lukács of the Twelfth International Brigade, recounts his first encounter with Capa: "A four-seat

119

Period press photo by Capa of destruction in the western suburbs of Madrid. This photo was used on the cover of this small propaganda pamphlet published in 1938 in Barcelona.

BARBARIE ET CIVILISATION

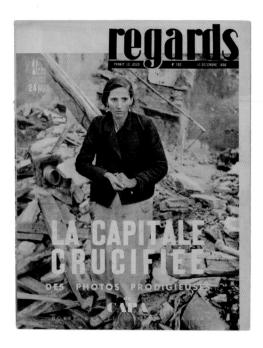

regards

PARAIT LE JEUDI · N° 152 · 10 DÉCEMBRE 1936

1 fr 25

24 PAGES

LA CAPITALE CRUCIFIÉE

DES PHOTOS PRODIGIEUSES

DE CAPA

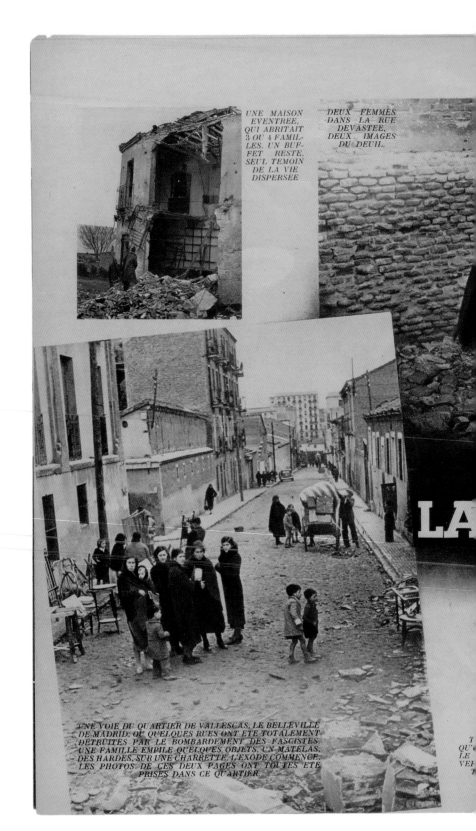

UNE MAISON ÉVENTRÉE, QUI ABRITAIT 3 OU 4 FAMILLES. UN BUFFET RESTE, SEUL TÉMOIN DE LA VIE DISPERSÉE

DEUX FEMMES DANS LA RUE DÉVASTÉE, DEUX IMAGES DU DEUIL.

UNE VOIE DU QUARTIER DE VALLESCAS, LE BELLEVILLE DE MADRID, OÙ QUELQUES RUES ONT ÉTÉ TOTALEMENT DÉTRUITES PAR LE BOMBARDEMENT DES FASCISTES. UNE FAMILLE EMPILE QUELQUES OBJETS, UN MATELAS, DES HARDES, SUR UNE CHARRETTE. L'EXODE COMMENCE. LES PHOTOS DE CES DEUX PAGES ONT TOUTES ÉTÉ PRISES DANS CE QUARTIER.

120

Citroën pulled up in a halo of blue smoke, its windshield shattered, mudguards twisted, radiator dented. A dark-haired young man in civilian clothes got out of the car. Two cameras of unusual size in yellow leather cases hung from his neck. He told us he wanted to take pictures of the international volunteers; he said he was representing *Regards*, showed his laissez-passer, and asked for a guide so he could visit the different battalions." Angry, General Lukács said, "Maybe he'd like me to take him there on horseback too? Get him out of here! If he persists, he's going to get himself pistol-whipped!" But at last the general relented, on the condition that his own picture not be taken, and that the photographer not be allowed to expose himself by daylight on the front lines. Which infuriated Capa: "I'm a war correspondent! I'm not here to make postcards!" In the end, he abided by the rules—and made history.

Over seventeen days, Capa shot the photo stories that staked out his place in the annals of photojournalism. By devoting an exceptional amount of room to Capa's photos in its four December issues,

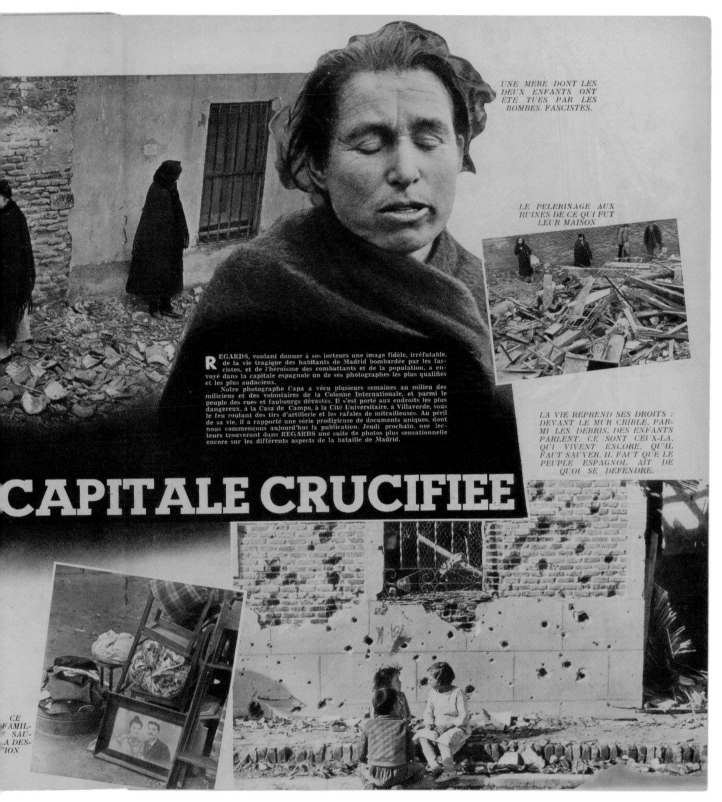

UNE MERE DONT LES
DEUX ENFANTS ONT
ETE TUES PAR LES
BOMBES FASCISTES.

LE PELERINAGE AUX
RUINES DE CE QUI FUT
LEUR MAISON

R EGARDS, voulant donner à ses lecteurs une image fidèle, irréfutable, de la vie tragique des habitants de Madrid bombardée par les fascistes, et de l'héroisme des combattants et de la population, a envoyé dans la capitale espagnole un de ses photographes les plus qualifiés et les plus audacieux.

Notre photographe Capa a vécu plusieurs semaines au milieu des miliciens et des volontaires de la Colonne Internationale, et parmi le peuple des rues et faubourgs dévastés. Il s'est porté aux endroits les plus dangereux, à la Casa de Campo, à la Cité Universitaire, à Villaverde, sous le feu roulant des tirs d'artillerie et les rafales de mitrailleuses. Au péril de sa vie, il a rapporté une série prodigieuse de documents uniques, dont nous commençons aujourd'hui la publication. Jeudi prochain, nos lecteurs trouveront dans REGARDS une suite de photos plus sensationnelle encore sur les différents aspects de la bataille de Madrid.

LA VIE REPREND SES DROITS :
DEVANT LE MUR CRIBLE, PARMI LES DEBRIS, DES ENFANTS
PARLENT. CE SONT CEUX-LA,
QUI VIVENT ENCORE, QU'IL
FAUT SAUVER. IL FAUT QUE LE
PEUPLE ESPAGNOL AIT DE
QUOI SE DEFENDRE.

CAPITALE CRUCIFIEE

CE
FAMIL-
SAU-
A DES-
'ION

121

The cover and a double-page spread of issue number 152 of *Regards* (December 10, 1936). Capa's name appears in bold letters beneath the title; the paper used the photos and its captions to recount the events.

Regards offered extraordinary exposure to a photographer who had been an unknown six months earlier. The Capa festival began on December 10. The magazine's cover photo was of a terrified woman in the ruins, beneath the headline "The Crucified Capital, Stupendous Photographs by Capa, Our Special Correspondent in Madrid." Inside, a series of dramatic snapshots showed women and children in their bombed-out neighborhoods. The magazine praised its correspondent's audacity. Back in Paris, Capa participated in choosing the layout and the captions. The next week, December 17, *Regards*' headline ran: "Our Special Correspondents in the Line of Fire with the Volunteers for Freedom. Twelve Pages of Extraordinary Photos by Capa, Articles by Tzara, Aragon, Koltzov." Inside, the paper continued to extol its photographer's qualities: "Our photographer Capa has shared the life of peril and heroism of anti-Fascist volunteers, who have come from all over the world to fight for freedom with their Spanish brothers and are grouped into International Brigades on the battlefield." That week, *Regards* published forty-one photos by Capa, including on its front and back covers. All told, there were fourteen pages of a gripping photo story from the heart of Madrid at war. They show

Capa's photo story on the Battle of Madrid was also published on three pages in *The Illustrated London News* on December 19, 1936. The English paper, which did not credit photos, put the emphasis on refugees in the subway and especially the International Brigades volunteers entrenched in the buildings of the university campus.

1142—THE ILLUSTRATED LONDON NEWS—Dec. 19, 1936

THE DESPERATE FIGHTING AMID THE SCHOLASTIC BUILDINGS OF THE UNIVERSITY CITY OF MADRID.

ONE OF THE NEW BUILDINGS IN THE UNIVERSITY CITY, MADRID, SHOWING THE EFFECTS OF RIFLE-AND SHELL-FIRE

A GOVERNMENT MACHINE-G ROOM IN ONE OF THE A

A MACHINE-GUN CREW AMMUNITION BOXES STACKE

REFUGEES, WITH THEIR BELONGINGS, OUTSIDE A BUILDING WRECKED BY BOMBARDMENT.

QUARTERS IN A SCIENCE L AND PERSONAL EFFECTS ARR

The only concrete result of the general offensive ordered by General Franco on November 15 was that the insurgents crossed the Manzanares and penetrated into the University City, which borders Madrid on the north-west. This group of ambitiously conceived academic buildings, originally designed as King Alfonso's jubilee monument and since continued as a Republican monument to Liberal culture, became the scene of the most bitter fighting.

The insurgents, it appeared, aimed at ge skirts of Madrid, where more open cou their tanks and cavalry to advantage. established themselves in the Hospital had taken up positions round the Unive edge. The international column was in

WITH THE GOVERNMENT FORCES, WHO ALMOST ENCIRCLED FRANCO'S TROOPS IN THIS SALIENT.

IN A PARTIALLY WRECKED
IC FOUNDATIONS.

TION; WITH NUMEROUS
HE FOREGROUND.

ATORY; WITH RATIONS
D AMONG THE APPARATUS.

A LEWIS GUN AND CREW.

MILITIA OF ONE OF THE GOVERNMENT GARRISONS
AT THEIR MEAL BESIDE THEIR MACHINE-GUN.

A MACHINE-GUNNER WITH ANOTHER TYPE OF WEAPON AND
SCREENED BY BOOKS AND A MATTRESS.

MILITIAMEN BILLETED IN A SCIENCE LABORATORY.

123

footing in the northern out-
ould enable them to employ
end of the month they had
But the Government forces
'ity right down to the river's
e in the West Park (on the

south of the University City) and defending the road to El Escorial. The
position of the insurgents, who were subject to fire from all directions, was
far from comfortable. The groups of troops holding the various big buildings
had frequently no means of communication with each other during the day,
as they were under fire from many directions. Their line of communication
from the rear was also narrow. All their supplies had to be brought across .

a small stretch of the Manzanares between the Puerta Hierro and the Bridge
of the French. Their ability to maintain themselves there was attributed
by some to the Government's lack of storm troops capable of turning them
out. Others credited the Government command and their advisers with the
astute plan of leaving their enemies in this precarious and deadly salient
which prestige forced them to maintain.

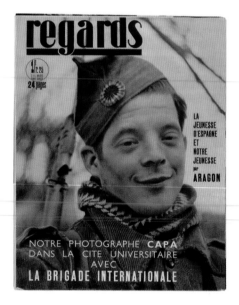

On December 17, *Regards* published an extraordinary issue containing fourteen pages of photos by Capa. This was major recognition for the photographer: To have such a large number of photos published in a single issue was unique. The same image, showing foreign brigadiers in Madrid, was published in Paris in 1938.

the soldiers of the Franco-Belgian Battalion firing their rifles, machine guns, and cannons from the gutted medical school and the philosophy department building. For the first time, the French public could see pictures of these men about whom the worldwide press was beginning to talk. The smile of Fernando, a fifteen-year-old Spaniard from Saint-Denis, was an eye-catching part of the photo story. This Parisian street kid wearing a cap decorated with a red, white, and blue cockade on the Madrid front was one of the many memorable faces Capa captured to embody the courage of the anti-Fascist fighters.

This extraordinary December 17 issue of *Regards* was followed three days later by the appearance of a full page of photos by Capa in *Paris-soir*. This major French newspaper—which distributed more than one million copies daily—devoted its back page to photographs presented in dramatic terms: "In Madrid, while the squadrons bomb the city and the population takes refuge in the subway." But *Paris-soir* did not credit the photo. The previous day,

December 19, Capa's photo story had been published in London across three pages in *The Illustrated London News*, with a total of eleven photos captioned, as in *Regards*. The English paper made no special mention of the photographer and omitted his credit. The same thing occurred, around the same time, in the Catalan newspaper *Moments*, which published a two-page spread under the title "War Again . . . The Madrid Saga." Even in Budapest, the picture supplement of the daily *Pesti napló* published Capa's Madrid photos. They would soon make their way all around the world. Capa had reached the top!

In her book *Photography and Society*, the German photographer Gisèle Freund wrote, "Photojournalism only begins once the image itself becomes the story that tells the events through a series of photographs, accompanied by a text strictly limited to captions." This definition perfectly suits the work accomplished in Madrid by Capa, the photographer "who knew how tell a story in pictures," as Cartier-Bresson put it. ⊕

In its January 1, 1937, issue, the
newspaper *Russie d'aujourd'hui*
(*Russia Today*), published in Paris,
offered its readers this curious
colorization of a Capa photo
(above) showing refugees in the
Madrid subway, as well as this
spectacular photomontage (right)
using photos by Capa and Chim.

Tout du long des 3 à 400 kilomètres qui séparent Madrid de Valence, nous avons croisé tantôt des autos légères — celles des services militaires ou celles des groupements du Front populaire — filant à vive allure ; tantôt des files de lourds camions amenant des vivres et munitions vers la capitale. Nous avons dépassé maintes fois les caravanes de paysans portant vers la Cité ardente les produits de cette terre que Franco rêve de leur reprendre.

La nuit est tombée depuis longtemps, une nuit glaciale qui nous incite à nous blottir les uns contre les autres. Nous traversons des villages où ne brille aucune lumière, où ne circule aucun être humain. Mais des hommes veillent. Vingt fois, l'obscurité est trouée par la lampe de poche ou la lanterne d'un poste de miliciens, surgi à tel carrefour ou à telle entrée de village. Des gars de vingt ans, fusil à l'épaule, blottis dans une couverture ou sous un ample manteau, s'avant du poing fermé porté à la hauteur du front, examinant nos permis de circulation et nous quittant après un chantant « Salud, camarada ! ».

Nous avons eu toutes les malchances en cours de route : pannes au moteur, pneus éclatés. Bref, nous arrivons à Madrid avec huit heures de retard sur les prévisions. Il est trois heures du matin. L'obscurité est totale. Pas une lumière aux fenêtres des grands immeubles bordant ces belles avenues. Pas une seule personne dans la rue (la circulation est interdite après dix heures du soir).

Nous finissons par trouver un hôtel. Escalier de marbre. Épais tapis partout. Chambres spacieuses « tout confort », avec salle de bains. Trois pesetas, même pas cent sous, pour une chambre dans un palace princier. Pour l'instant, nous ne cherchons pas à comprendre, car nous sommes abrutis de fatigue.

A neuf heures, nous avons été réveillés par une rumeur qui montait de la rue. Nous nous précipitons aux fenêtres ; nous constatons alors que la moitié des carreaux manquent et qu'à l'étage supérieur, la façade est traversée de trous d'obus.

Tout à côté de notre hôtel, l'Hôtel Alfonso », nous apercevons un splendide building : le Central Téléphonique de Madrid, tant visé par l'aviation et l'artillerie rebelles. Nous comprenons alors le bon marché des chambres!

De notre balcon, nous voyons la foule circuler et des balayeuses mécaniques arroser la chaussée. Est-ce là tableau d'une ville située en première ligne du front ?

Vite, descendons nous mêler à ces hommes et à ces femmes vers qui monte l'admiration des millions d'antifascistes de partout.

La Gran Via, la Puerta del Sol. Des gens vont et viennent. Des marchands d'insignes, de képis de miliciens, de lacets, de ceintures, etc... De vieilles marchandes de journaux, tout comme sur nos grands boulevards. Des tramways passent, bondés. Devant un magasin, une longue file d'hommes : ils font la queue pour obtenir un paquet de tabac. Plus loin, une longue file de femmes, de jeunes filles, d'enfants : on attend la distribution du lait, du pain, du sucre Les visages portent les marques de privations. Nulle lamentation. Une sérénité, un courage tranquille.

Un escadron de cavalerie passe : vision rapide de la jeune armée populaire en marche.

Un attroupement. On déblaie les mines d'une maison atteinte par le bombardement de la nuit dernière. Quelques nouveaux noms à ajouter à la liste des femmes et des enfants madrilènes massacrés pendant leur sommeil.

Les grands cinémas sont ouverts. Ici, on passe « Les Temps Modernes », là-bas « Tchapaiev ». Seul changement : au lieu du soir, on joue l'après-midi.

Au Ministère de l'Instruction publique, M. Aguilar, délégué du gouvernement, nous conte ceci :

— « La Junte de défense de Madrid a ordonné l'évacuation de la population civile. Quelques centaines de milliers d'habitants l'ont exécutée. Les autres — c'est-à-dire pas loin d'un million d'âmes — ne veulent pas quitter leur ville. Tenez, un cas précis. J'ai reçu la visite il y a quelque temps d'une dame professeur au lycée et qui vit avec sa fille dans une maison située à un kilomètre du front. Habitant le rez-de-chaussée d'une maison dont tous ses étages étaient cuasi-démolis, elle venait me demander d'intervenir près de la Junte pour obtenir un logement un plus confortable. Est-ce là endroit de la ville moins visé. Je lui ai répondu que j'étais décidé à intervenir mais que la Junte me répondrait certainement : « Bien. Cette dame, professeur de lycée, n'a rien à faire à Madrid puisque les lycées sont fermés. Nous allons la faire partir sur Valence ! » Sur quoi, mon interlocutrice m'a prié de ne faire aucune démarche !... »

Le secrétaire des « Amis de l'U.R.S.S. » de Madrid est employé au Central Téléphonique, ce splendide bâtiment de quinze étages qui domine toute la ville.

— « Notre Central est particulièrement visé par les rebelles. Car d'ici, nous continuons à communiquer avec Valence, Barcelone, le monde ; d'ici, chaque jour, nous lançons nos émissions radiophoniques. Aussi s'acharnent-ils contre la « Telefono ». Nous avons reçu une centaine d'obus, mais par une chance extraordinaire, ils n'ont causé que peu de victimes : cinq blessés en tout. Par contre, les immeubles avoisinants que n'ont reçu abondance ce qui nous était destiné et il y a eu de nombreux morts. Le personnel du Central est absolument admirable. Il vient chaque jour à son poste et continue son travail même pendant les bombardements. Pas une seule jeune fille employée n'a demandé à quitter son emploi... »

Non plus loin, une fabrique travaille pour les besoins de la guerre. Elle tourne jour et nuit. Elle a déjà été atteinte plus d'une fois par le bombardement de l'ennemi. Des ouvriers sont tués ou blessés. Le lendemain, le syndicat des métallos comble les vides et la production continue. Mieux, L'U.G.T. a organisé dans cette usine le mouvement Stakhanov, on l'appelle comme cela là-bas comme à Moscou. Les équipes se lancent des défis. Et chaque jour on travaille une heure et demie de plus sans être payé, volontairement. Ce mouvement se développe maintenant dans toutes les fabriques. Des résultats, en voici : dans tel atelier d'optique, il fallait trois mois pour fabriquer 25 instruments perfectionnés : il faut maintenant 14 jours. Dans un atelier de mécanique de précision, la réparation d'un poste de téléphone de campagne demandait un jour de travail ; actuellement, 60 postes sont revus et réparés en 15 jours, etc.

L'admirable jeunesse madrilène — socialistes et communistes unis dans une seule organisation — aide, de toutes ses forces non mobilisées, l'U.G.T. dans ce travail de choc.

Aujourd'hui, nous avons visité le front de Carabanchel.

C'est à moins d'un kilomètre de l'endroit précis où le tramway a son point terminus et où la circulation de la population civile s'arrête. Munis de l'autorisation du commandement militaire, vous passez une série de barricades. Vous franchissez le Manzanarès, pointe extrême de l'avance rebelle le 6 novembre dernier et vous vous trouvez dans le faubourg de Carabanchel. Un jeune communiste politique — il a 23 ans, ouvrier typographe, membre de la Jeunesse Socialiste Unifiée de Madrid — nous guide à travers des maisons entièrement ou partiellement démolies Aux murs de ces maisons, vous voyez encore — et c'est poignant — des portraits de famille : le père, la mère, les enfants, ont posé gravement devant l'objectif. Dans une armoire, la vaisselle est encore rangée, presque intacte. Dans tel foyer à demi détruit, des jouets traînent dans un coin. Ces modestes demeures de banlieue avaient quelques mètres carrés de jardins ; dans l'un, un magnifique rosier tout en fleurs — la vie à quelques mètres de la mort.

Les secondes lignes Les boyaux. Quelques mètres sous terre et nous voici aux avant-postes. A sept mètres des fascistes. Des balles sifflent ; instinctivement, nous baissons la tête.

On nous présente un « dynamiteros », un de ceux qui laissent approcher les tanks ennemis et leur lancent des grenades au bon endroit. L'histoire des dynamiteros vaut d'être contée. Ceux de nos lecteurs qui ont vu le film « Les Marins de Cronstadt » se rappelleront certainement comment un garde rouge réduit un tank à l'inaction. Or, « Les Marins de Cronstadt » a eu l'un des honneurs de tous les écrans espagnols. L'acte du garde soviétique a éveillé des milliers d'imitateurs dans la jeunesse républicaine. C'est un de ceux-là — il n'a pas vingt ans — qui veut nous montrer comment on s'en sert-on-faire. Il nous montre une des grenades de sa fabrication. Il la pose sur une simple corde. Un autre soldat allume la mèche et notre « dynamiteros », l'adresse extraordinaire, se sert de sa corde comme d'une fronde et envoie la grenade à soixante mètres de là, dans une maison tenue par l'adversaire. Par le créneau, nous constatons que l'objectif a été atteint. Admirable jeunesse obligée de se battre avec des moyens aussi primitifs.

Quand nous revenons aux secondes lignes, le café nous est servi. On nous présente le commandant de la brigade : un paysan d'une quarantaine d'années, en costume civil de velours côtelé. Nous échangeons nos impressions : c'est le jeune commissaire qui nous répond. Car le commandant ne dit rien, mais il écoute avidement. Visiblement, il doit être plus à l'aise au combat qu'à discuter perspectives politiques. Lui et le jeune commissaire nous font penser inévitablement à Tchapaiev et Fourmanov.

Le commissaire nous fait visiter une petite maisonnette miraculeusement épargnée. On y a installé le siège de la section des « Amis de l'U.R.S.S. » de la brigade. On y apprend à lire et à écrire aux soldats illettrés. On y parle de stratégie militaire.

Quand nous sortons, un obus ennemi explose à dix mètres de nous.

— « Tiens, ils se réveillent ? », interroge le commissaire.

Et sans plus, nous continuons le chemin. Nous croisons des terrassiers, pelle sur l'épaule — ce sont des volontaires pour les travaux du front. Nous rencontrons aussi un camion remorquant — arme nouvelle — un haut-parleur puissant la nuit tombée celui-ci porte la parole républicaine jusqu'à cinq kilomètres à l'intérieur des lignes fascistes.

Nous revoici enfin dans Madrid, ne parvenant pas à concevoir que la vie continue ainsi, à moins d'un kilomètre du front. Dans un square, des enfants jouent ; ils se poursuivent en criant. Sur le boulevard, des couples passent, enlacés.

Dans cette partie de Madrid, partout, des ouvrages de défense. Si Franco avait pénétré dans la ville le 7 novembre, il aurait dû se léger maison par maison.

Dans un cinéma de quartier, meeting des « Amis de l'U.R.S.S. » à onze heures du matin, pour ratifier la délégation de Madrid qui se rend en U.R.S.S. pour 1er Mai. Une musique militaire prête son concours. « Internationale », Hymne de Riego, Hymne de Valence, « Marseillaise ». Le public chante. Il fait une ovation à ses délégués. I, acclame chaudement les représentants de la section française des « Amis de l'U.R.S.S. » Des coups sourds : le bombardement a repris. Mais le meeting continue.

Le peuple espagnol n'oublie pas et n'oubliera jamais l'attitude de solidarité agissante prise par l'U.R.S.S. A tel point, que le général Miaja a été un des premiers à donner son adhésion à la section madrilène des « Amis de l'Union Soviétique », A tel point le glorieux animateur de la défense de Madrid tint à recevoir la délégation mondiale des A.U.S. pour nous faire part de son admiration pour l'U.R.S.S. et, en outre, de sa certitude de la victoire finale des armées républicaines.

Le lecteur attend certainement une conclusion à ces notes qui rendent bien imparfaitement l'atmosphère de la ville ardente dont on ne peut plus prononcer le nom qu'avec émotion et admiration.

J'ai acquis la certitude que Madrid est imprenable. Chaque jour elle passe voir se discipliner, armée populaire, se développer l'industrie de guerre, s'épurer l'arrière du front (des complices de Franco qui espionnaient, provoquaient (comme à Barcelone), essayaient de désunir les forces antifascistes. Que peuvent les généraux rebelles contre un peuple tout entier, dressé pour l'indépendance de son pays ?

J Fremier

MADRID 1937

RIGHT: The facade of the Spanish pavilion at the 1937 international exhibition in Paris. For the occasion, the Republic called on the artists Picasso, Miró, and Calder, as well as the photographers Capa, Taro, and Chim.

ABOVE: Long attributed to Robert Capa, this photo was published on the cover of the October 29, 1936, issue of *Regards*, uncredited. It was actually taken by Chim. The militiaman is guarding the Las Descalzas Reales monastery in Madrid.
OPPOSITE: Chim's photograph was used in a montage at the international exhibition in Paris titled Saving the Monuments.

Photomontages at the 1937 International Exhibition

Thirty-one million visitors in seven months! The Exposition Internationale des Arts et Techniques dans la Vie Moderne (International Exposition Dedicated to Art and Technology in Modern Life) held in Paris in 1937, is primarily remembered for the foreshadowing face-off between the Soviet and Nazi pavilions on the right bank of the Pont d'Iéna, and for Pablo Picasso's painting *Guernica*, which was first exhibited to the public here. The final international exhibition hosted by France, it took place between May 4 and November 25, while the Spanish civil war raged across the border. Fifty-two exhibiting nations set up shop from the Colline de Chaillot to the Champ de Mars. The exhibition

was not opened to the public until May 25 because of strikes that slowed preparations. Warring Republican Spain erected its modest two-story pavilion on the Left Bank, in the shadow of the Eiffel Tower.

At the entrance, a large photo showed a line of soldiers with the heading, "We fight for Spain's unity, we fight for the integrity of the Spanish territory." On the other side of the facade, under a photograph of two Spanish militiamen wearing espadrilles and eating their meager rations, were the words, "There are over half a million Spaniards with bayonets in the trenches who won't let themselves be tread upon. President Azaña."

The pavilion exalted the suffering of the people and lauded the accomplishments of the Spanish Republic: agrarian reform, coeducation in public schools, war industry, and assistance to refugees. The pavilion opened late, several weeks after the official inauguration, because of the extreme difficulties Spain, a country at war, faced in completing construction. Another problem was Picasso, who did not deliver *Guernica* until June. The tragic news of the bombing of the Basque town was not revealed in France until April 30. The giant canvas (25.5 × 11.4 feet) was installed on the ground floor, on the patio.

The Catalan architect Josep Lluís Sert designed the building in collaboration with Madrid architect Luis Lacasa Navarro. Max Aub, associate general curator for the Spanish pavilion, who had been born in France in 1902 but raised and educated in Valencia and naturalized by the Spanish Republic, was the man directly responsible for the participation of artists ranging from Miró, Picasso, and Calder to filmmaker Luis Buñuel. Buñuel was in charge of cultural activities for the pavilion and also screened his film *España 36* there, featuring film stills by Robert Capa.

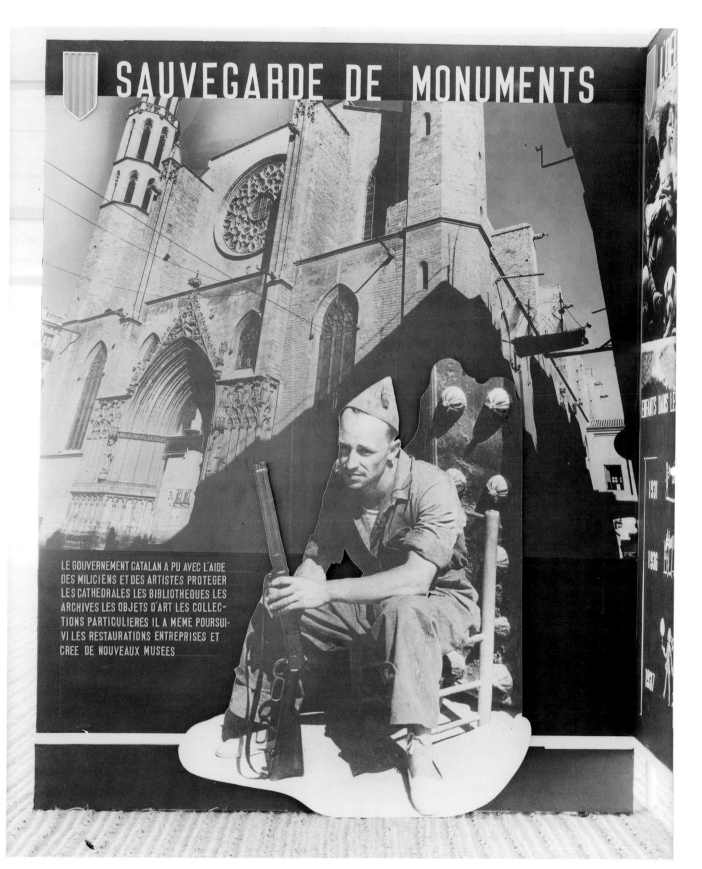

L'INDUSTRIE DE GU[ERRE]

EN P[...]
NOUVE[...]
GANISE[...]
AUX B[...]

LES HOMMES AU FRONT LES FEMMES A L'USINE

LA PUISSANTE INDUSTRIE CATALANE S'EST
TRANSFORMÉE EN INDUSTRIE DE GUERRE

130

The soldier with a bugle photographed by Gerda Taro symbolizes the creation of a real army to serve the Spanish Republic. The photo was taken in Valencia in March 1937.

TANK FABRIQUÉ A BARCELONE

Throughout, themes emphasized at the exhibition (schools, hospitals, agriculture, industry, military, regions, et cetera) were highlighted by large photomontages on wood panels. Among Robert Capa's friends who participated in printing these large-format exhibits, Pierre Gassmann would recall developing giant prints "with a mop on the tile floor" in a lab belonging to his Hungarian friend Taci Czigany on rue Delambre. While the consequences of the war were ever present in the montages, none of the photographs bluntly depicted the war itself: Frontline combat was not on display, and Capa's "The Falling Soldier" was therefore not included. That photograph would come to embody the Spanish conflict only much later, then becoming its preeminent symbol.

The montages did include uncredited photographs taken by Capa, Taro, and Chim behind the front lines, among them one of a soldier guarding the Las Descalzas Reales monastery in Madrid entitled Saving the Monuments. A print of this shot long attributed to Robert Capa was found in Negrín's suitcase restored to Spain by Sweden in 1979. The photo was actually taken by Chim; its negative surfaced among those in the "Mexican suitcase." In the panel dedicated to "War Industry," the photograph of the soldier sounding a bugle is by Gerda Taro; its negative was also found in the "Mexican suitcase." It was taken for a photo story shot in Valencia in March 1937, during a presentation of the People's Army of the Republic, also known as the People's New Army, which was created to integrate Spanish volunteers—the militiamen—into the regular army. Despite the presence of Picasso's painting, which was generally poorly understood and deemed not figurative enough by the Spanish authorities, the press (with the exception of the Communist newspapers) did not take much interest in the Spanish pavilion.⊕

131

Ce soir, Capa's First Newspaper Job

ABOVE: With Aragon, Jean-Richard Bloch headed *Ce soir*, the newspaper where Capa worked. This photograph shows him in his office, whose furniture was designed by Charlotte Perriand.

OPPOSITE: The daily *Ce soir* promotes its collaborator Robert Capa. Though Capa was famous for his extraordinary photos showing the fierceness of the Battle of Teruel, this January 1938 issue featured only his written account.

"**Then room to room** combat began. A merciless grenade battle. Every wall seemed to have been mined; explosions rang out from every direction. Rising up above the sharp sound of revolver fire in the rare seconds of silence that followed a grenade explosion, one could hear cries of *Arriba España!* and the moans of the unfortunates taken hostage by the dissidents when they barricaded themselves into the palace."

As the excerpt above suggests, the article shown on the opposite page and published in *Ce soir* on Saturday, January 8, 1938, was an exceptional account of the Battle of Teruel and the surrender of the Franco forces. It was credited to Robert Capa and appeared without photographs. The war correspondent described the situation in the capital of Aragon, to which he had traveled with Herbert Matthews, a correspondent for *The New York Times*. The combat that took place there from December 14, 1937, to February 22, 1938, house to house and in the freezing cold, was so bloody that some historians describe it as the "Spanish Stalingrad." Capa's sympathies were manifest: "The city was ours," he wrote. He had chosen his side, that of the legally elected government. He expressed his compassion for the civilian victims, trapped in the basements to escape Nationalist bombings, but also for the fighters engaged in hand-to-hand combat in the ruins. The article's title referred to Robert Capa as a "collaborator" of the new publication.

NOTRE COLLABORATEUR ROBERT CAPA REVENANT DE TERUEL, NOUS DÉCRIT
la lutte implacable dans les souterrains de la ville

« Teruel est reprise, le général Rojo est fait prisonnier. »

Nous étions à peine de retour à Barcelone et nous nous installions à l'hôtel Majestic avec quelques journalistes lorsque cette stupéfiante nouvelle, diffusée par la radio rebelle, vint nous arracher à notre repos. Nous avions quitté Teruel le 2 janvier ; elle était alors aux mains des gouvernementaux, sauf le palais du Gobierno Civil, où une résistance désespérée se poursuivait. Mais tout le reste de la ville était à nous, ainsi que les environs sur près de 10 kilomètres de profondeur.

Il n'était plus question de rester à Barcelone. Nous reprîmes la route sur cette vieille Ford avec laquelle nous avions fait deux fois par jour, pendant une semaine, la navette entre Teruel et Valence.

Au col de Raguda (1.700 mètres d'altitude), d'innombrables voitures étaient arrêtées. La neige recouvrait la route sur une hauteur de 60 centimètres. Il y avait là de gros camions, des tanks, des canons. De l'autre côté, les nôtres résistaient aux attaques furieuses d'un adversaire parfaitement ravitaillé.

Mais nous eûmes bientôt la preuve de la parfaite organisation de l'armée espagnole. Un véritable plan de travail fut mis en œuvre pour débloquer la route : soldats, chauffeurs, paysans des villages voisins dégagèrent le chemin et poussèrent les voitures. Mètre par mètre, le long convoi avança. Cela dura vingt heures. Mais à minuit toute la route se trouvait dégagée et les voitures roulaient rapidement vers la ville.

« Ce fut un des principaux épisodes de la bataille », nous disaient le lendemain les officiers en mettant pied à terre sur la grande place de Teruel.

Quelle ne fut pas notre surprise, en arrivant à Teruel. La ville, que nous avions quittée pleine de soldats, semblait vide. Personne dans les rues.

Au loin, très haut dans le ciel, extraordinairement clair malgré le froid intense, volaient quarante avions dans la direction de la Muella.

Quelques minutes après notre arrivée, nous nous dirigeons vers le palais du Gobernio Civil, autour duquel s'empressent les hommes de la quarantième brigade, exclusivement composée d'habitants du pays.

— Vous tombez bien, nous dit le colonel. Vous allez assister à la prise du dernier îlot de résistance que les factieux ont conservé dans la ville.

Cinq minutes ne s'étaient pas écoulées, qu'au milieu d'un fracas épouvantable, un des murs s'ouvrit. Une mine avait été placée sous un angle et la déflagration causa une brèche énorme dans la muraille où les soldats se précipitèrent au milieu des décombres.

Ce fut alors la lutte de chambre en chambre. Une lutte sans merci, à la grenade. Tous les murs semblaient avoir été minés : des explosions retentissaient de partout. Dominant les bruits secs des revolvers, entre les rares secondes de silence qui suivaient l'éclatement des grenades, on entendait au cœur du bâtiment s'élever les cris d'*Arriba Espana!* et les plaintes des malheureux que les factieux avaient entraînés avec eux pour leur servir d'otage, au moment où ils s'enfermèrent dans le palais.

On avançait avec une prudence extrême : on ne savait où se trouvaient les femmes et les enfants. Les cris se mêlaient aux explosions. Au bout d'un instant, le premier prisonnier parut : c'était un garde civil, un homme au visage défait, qu'un jeune garçon de Teruel tenait en respect avec le revolver qu'il venait de lui prendre.

Un par un, les cinquante prisonniers suivirent.

Lorsque toute résistance fut réduite, on rechercha la population civile. Ce fut un spectacle affreux, plus tragique encore que tous ceux que nous avions vus jusque-là.

Plus de cinquante personnes, des femmes et des enfants pour la plupart, aveuglées par la lumière, nous montraient leurs visages cadavériques, souillés de sang et de crasse. Depuis plus de quinze jours, ils étaient enfermés dans les sous-sols, vivant dans une terreur continuelle, nourris des restes des repas de la garnison et de quelques sardines qu'on leur jetait quotidiennement. Bien peu eurent la force de se lever : il fallut les aider à sortir. Raconter cette scène pitoyable est impossible.

En même temps que s'était accomplie la prise du palais, la bataille faisait rage, à neuf kilomètres de là, sur le front, aux deux points névralgiques de l'attaque ennemie.

Dans la montagne couverte de neige se distinguait au loin les flocons gris des explosions.

Nous rencontrons des officiers à qui nous donnons lecture des communiqués rebelles. Ils s'exclament : « Cette bataille s'est déroulée à Séville, peut-être, mais sûrement pas à Teruel. »

Et ils nous donnent des précisions sur les opérations en cours :

Le 1er janvier, les factieux envoyèrent 60 avions bombarder la Muela. Si nous avons reculé alors, *c'est uniquement pour ne pas sacrifier inutilement une division*. Nous retirions nos positions pendant la journée ; la nuit, nous reprenions plus de la moitié du terrain perdu.

Et comme, avant de quitter la ville, nous voyons un groupe d'officiers, nous demandons comment se nomme celui qui parle à leur centre, on nous répond :

— Celui-là, mais c'est le général Rojo. Il ne s'est jamais si bien porté que depuis qu'il est en « captivité ».

Robert CAPA.

A Teruel, les gouvernementaux ont brisé une offensive acharnée... puis ils ont attaqué victorieusement dans le secteur de la Muela...

133

Ce soir had set up its offices near the Paris Opéra, at 31, rue du Quatre-Septembre. The newspaper's editorial staff was headed by two writers, Louis Aragon, a member of the French Communist Party, and Jean-Richard Bloch, "a fellow traveler." The leftist daily's objective was clear: to compete with the Prouvost group's powerful *Paris-soir*, whose editorial department was run by Pierre Lazareff and Raymond Manevy, and its photo desk by Paul Renaudon. *Ce soir*'s first issue appeared on March 1, 1937. Starting at one hundred thousand copies an issue, it would reach two hundred and sixty thousand copies two years later by establishing itself as the major daily of the Popular Front. The paper was founded with the help of the Spanish Republic, which had sought to organize support for its cause in Paris since late 1936. Another participant was Willi Münzenberg, the "red Hearst," then in exile in Paris. Münzenberg was the master of propaganda for the Communist Internationale and a friend of Lucien Vogel's, the founder of *VU*.

Élie Richard was stolen away from *Paris-soir* to serve as technical expert, while Gaston Bensan, then working with the French Communist Party's publishing house, was appointed administrator. The twenty-three-year-old Robert Capa was named the newspaper's official photographer and was probably also the head of its photo desk. His friends participated in the adventure too. Gerda Taro's photos taken in Spain were regularly published in the newspaper in choice spots, as with this image of a Republican soldier dreaming of peace and playing with a dove, reproduced on the cover in July 1937. Chim and Cartier-Bresson's photos were also published.

Ce soir provided both Henri Cartier-Bresson and Robert Capa with their first

salaried positions. They were paid monthly and left free to cover whatever they wanted. Cartier-Bresson went to London to shoot the coronation of King Edward VIII, accompanied by Paul Nizan, who headed *Ce soir*'s foreign politics section. Capa, Chim, and Taro returned to Spain to take up their reporting there. "*Ce soir* was something of a model for us when it came time to imagine how the Magnum agency would work," Cartier-Bresson later explained. All of the photographers retained a tremendous amount of freedom. Thus Capa chose to leave for Spain again rather than stay to cover subjects in Paris.

It was during this period, in 1937, that he founded the Atelier Robert Capa at 37, rue Froidevaux, entrusting the darkroom to his friend Csiki Weisz. He does not appear to have had an exclusive deal with *Ce soir*; he developed his own distribution network, selling his photographs to other publications in London, New York, and Amsterdam. His fame and contacts abroad now allowed him to bypass the photo agencies, which would have claimed a high percentage of each sale. Capa clearly aspired to go into business for himself, which would enable him to distribute his friends' photos too. He occasionally did this for Willy Ronis, who also continued his association with the Rapho agency.

Over three years, thanks to the quality of their work in Spain, Capa, Cartier-Bresson, Taro, and Chim made history with *Ce soir*, helping to make the newspaper a true competitor of *Paris-soir*, whose print run was over one million copies per issue! Louis Aragon spoke of the experience this way:

"To know where we stood in that war, you had to read *Ce soir*, that's the truth. And that's how we won over hundreds of thousands of *Paris-soir* readers in that period. We were well informed. With Georges

POUR LES ENFANTS DE PARIS

6e édition

Ce soir
GRAND QUOTIDIEN D'INFORMATION INDÉPENDANT

6e édition

NUMERO 149

PREMIÈRE ANNÉE

Ops. 99.34 - 15.60 (8 lig. groupées) — 40 cent. — Jeudi 29 Juillet 1937 — 40 cent. — 31, rue du 4-Septembre, Paris - 2e.

EN VIVARAIS
pays de légende

Un viticulteur se soigne

Les rebelles sont arrêtés
devant VILLANUEVA DE LA CANADA

Lire dans la troisième page

LES CHINOIS ONT REPRIS
FENG-TAI et LANG-FANG

Les Japonais bombardent Pékin

Tokio, 28 juillet. — On mande de Tien-Tsin que les troupes japonaises ont attaqué et occupé hier soir Hsing-Kang, au sud de Pékin, après un sévère combat au cours duquel les Chinois auraient abandonné 500 morts ou blessés. Les pertes japonaises seraient également considérables.

Changhaï, 28 juillet. — Suivant des nouvelles de source japonaise, les troupes nippones ont attaqué ce matin à 3 h. 30 les casernes de Hsi-Yuan, près de Pékin et ont également occupé la ville de Nanyuan, au sud de Pékin, après lui avoir fait subir un bombardement aérien.

Les troupes chinoises à Feng-Tai et à Lang-Fang

Londres, 28 juillet. — Le ministère chinois des affaires étrangères annonce à Nankin que les troupes chinoises ont repris ce matin aux Japonais les villes de Feng-Tai et de Lang-Fan.

D'autre part, les Chinois progresseraient également avec rapidité dans la direction de Toung-Chou et auraient enlevé trois chars d'assaut à leurs adversaires.

A Changhaï, où l'agence Central News a annoncé que les forces chinoises, après trois heures de combat, avaient occupé l'aérodrome de Chao-Kia-Chou, situé au sud des Japonais, l'enthousiasme règne. Les troupes chinoises se seraient emparées de sept avions à Chao-Kia-Chou.

Lire nos autres informations dans la troisième page

MAGDA FONTANGE
avait voulu "punir" M. de CHAMBRUN

Un soir, à la gare du Nord, celle qui avait connu le Duce tira sur l'ambassadeur.

Elle expliquera son geste demain en correctionnelle

Lire dans la cinquième page

NOTRE PREMIERE FETE DE L'ENFANCE
au Théâtre SARAH-BERNHARDT

C'est aujourd'hui, à nos bureaux, de 14 à 15 heures, que 1.400 enfants de Paris et de la région parisienne ont retiré les cartes d'entrée pour notre fête de demain. Rappelons que le Théâtre du Peuple représentera, pour nos jeunes invités « TROIS CONTES D'ANDERSEN ».

A l'entr'acte, un goûter sera offert par « Ce soir ». 400 places ont été réservées aux enfants de l'Assistance publique.

Cette première fête est réservée aux enfants des chômeurs. Mais nous en organiserons une autre...

Lire l'article dans la sixième page

L'une des photos que notre collaboratrice Gerda Taro nous envoya de Madrid

« Plus que jamais Euzkadi garde la certitude du succès final »

nous dit le président Aguirre

Lire dans la septième page l'interview prise par Louis PARROT

14 MORTS
Le courrier aérien Rotterdam-Bruxelles-Paris tombe en flammes

Lire dans la troisième page

des viticulteurs et des coloniaux font leur cure à Vals

...Mais les "congés payés" n'ont été invités que pour septembre

par Stéphane MANIER

Vals, juillet 1937. — Ça, c'est de la grande musique. Ainsi s'exprimait devant la noblesse campagnarde des monts de l'Ardèche un Parisien assis près de moi dans l'autocar qui nous menait du Puy à Vals.

Selon la largeur des vallées le lumière changeait et nous présentait au détours des routes en lacets, de vert, villages éclairés de bleu, de vert ou de mauve.

Les Cévennes ne ressemblent ni aux Alpes grandiloquentes et tragiques, ni à cette fresque magique que dessinent les Pyrénées. Les Cévennes ont Vivarais, c'est de la campagne dans les monts, de la campagne substantielle, bien assise et qui ne craint pas de monter près du ciel des plateaux tandis d'arbres et de près. Partout, où que ce soit, dans tous les petits bourgs, on vous glisse à l'oreille :

— Notre source donne une eau qui fait des miracles.

L'Auvergne plantureuse, forte, recèle des trésors de santé qui ont leur légende et créent un climat de mystère. Ces trésors, guérisseurs et rebouteux, depuis des siècles, se transmettent de père en fils le secret des eaux, les utilisent, avec gestes et incantations. Il y a des eaux pétillantes, fées, aux autres chargées de substances énergétiques, les unes glacées, les autres bouillantes. Il y a des eaux mouvantes, noires où jaunes qui procurent aux malades paysans des guérisons gratuites.

Lire la suite dans la 5e page

LES ARTISANS de la batellerie ONT ROMPU eux-mêmes LES BARRAGES CE MATIN

La mort de Gerda TARO
A TROUVÉ DANS TOUTE LA PRESSE ET DANS LA POPULATION PARISIENNE
un douloureux écho (LIRE PAGE 3)

Lorsque notre malheureuse amie suivait les opérations sur le front de Madrid

Mme SERAFIAN
meurtrière du dentiste qui compromit sa fille
répond de son geste devant les jurés de la Seine

Lire dans la troisième page

A la Ville-du-Bois un avion militaire S'ECRASE AU SOL

Le pilote et le passager sont tués

(De notre correspondant particulier.) Versailles, 28 juillet (par téléphone). — Un avion militaire de la base aérienne de Villacoublay évoluait ce matin vers 8 h. 40 au-dessus de la région de Palaiseau.

En passant au-dessus du territoire de la Ville-du-Bois, l'appareil, on ne sait pour quelle cause, se mit à piquer vers le sol, où il alla s'écraser.

Quelques instants après, des habitants qui avaient vu l'appareil en difficulté se portaient au secours des aviateurs.

Le pilote, qui est un officier de réserve, M. Petelet, avait le thorax enfoncé et ne donnait plus signe de vie.

Quant au passager, il fut retiré des débris de l'avion grièvement blessé et transporté à l'hôpital de Longjumeau. Il s'agit du caporal-chef Georges Mallet, qui a succombé à ses blessures.

L'appareil est un Sanitaire n° 250, immatriculé sous le numéro M.165.

Le corps du pilote décédé a été transporté à la mairie de la Ville-du-Bois. Une enquête est ouverte pour établir les causes de cet accident.

Pêcheurs, retenez la date du 15 août pour le Concours de pêche organisé à Juvisy, par la « Haute-Seine », sous le patronage de « Ce soir ».

Au pont de Saint-Cloud
UNE JEUNE FEMME TUE SON AMI
puis saute dans l'autobus

Rachel Bansse
(Lire dans la 3e page)

Dès l'aube, aux écluses de Marly et à Bougival, les péniches sont venues se ranger le long des berges...

AUX ABATTOIRS LA GRÈVE SE POURSUIT DANS LE CALME
Une entrevue a eu lieu en fin de matinée à la présidence du Conseil

Lire nos informations dans la cinquième page

Un officier de l'air recueille les instruments de bord de l'appareil dans le but de déterminer les circonstances de l'accident

A droite : Une construction pittoresque à Villanueva de la Canada.

Ci-dessous : Deux miliciens sur le seuil d'une porte, au-dessus de laquelle est écrit le nom du village reconquis.

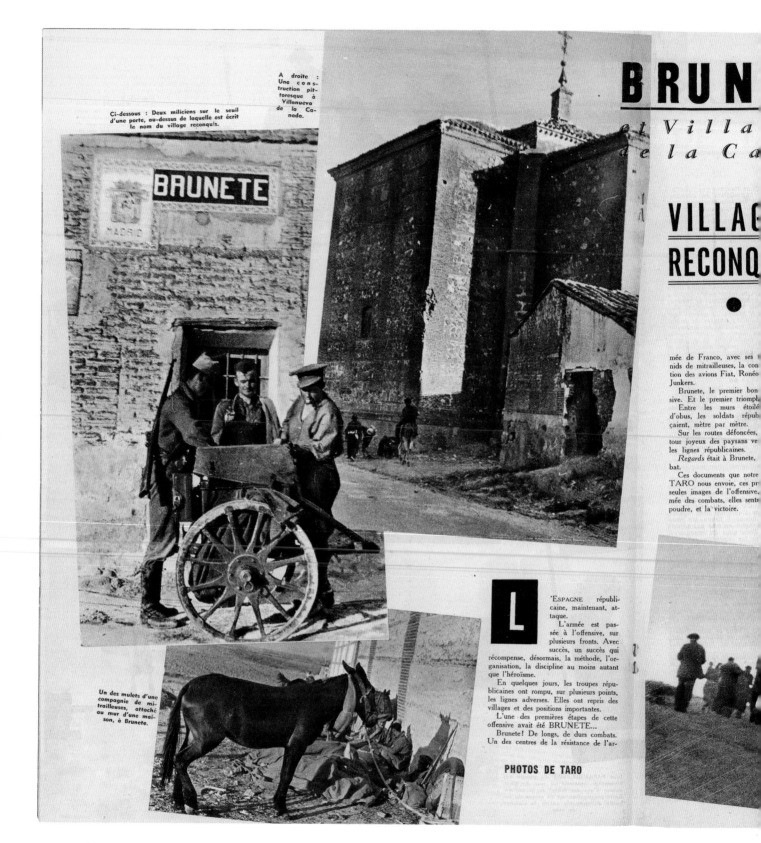

Un des mulets d'une compagnie de mitrailleuses, attaché au mur d'une maison, à Brunete.

BRUN

et Villa
de la Ca

VILLAG
RECONQ

●

mée de Franco, avec ses
nids de mitrailleuses, la con
tion des avions Fiat, Ronéo
Junkers.

Brunete, le premier bon
sive. Et le premier triompl

Entre les murs étoilé
d'obus, les soldats répub
çaient, mètre par mètre.

Sur les routes défoncées,
tour joyeux des paysans ve
les lignes républicaines.

Regards était à Brunete,
bat.

Ces documents que notre
TARO nous envoie, ces pr
seules images de l'offensive,
mée des combats, elles sent
poudre, et la victoire.

'ESPAGNE républi-
caine, maintenant, atta-
que.

L'armée est pas-
sée à l'offensive, sur
plusieurs fronts. Avec
succès, un succès qui
récompense, désormais, la méthode, l'or-
ganisation, la discipline au moins autant
que l'héroïsme.

En quelques jours, les troupes répu-
blicaines ont rompu, sur plusieurs points,
les lignes adverses. Elles ont repris des
villages et des positions importantes.

L'une des premières étapes de cette
offensive avait été BRUNETE...

Brunete ! De longs, de durs combats.
Un des centres de la résistance de l'ar-

PHOTOS DE TARO

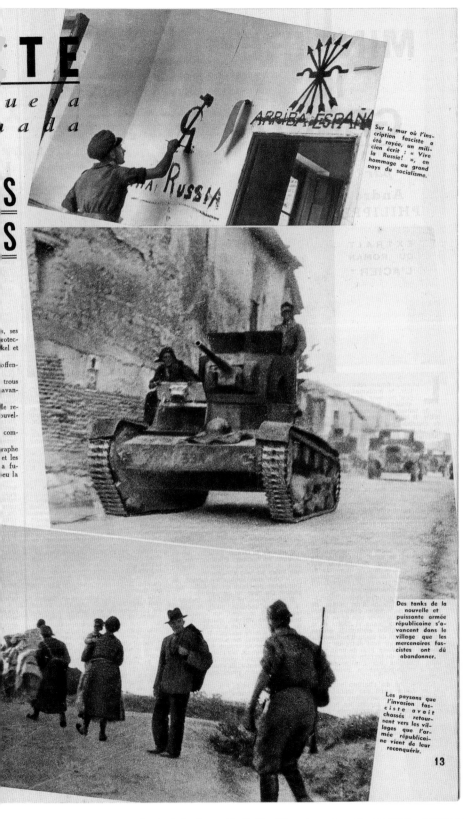

Sur le mur où l'inscription fasciste a été rayée, un milicien écrit : « Vive la Russie! », en hommage au grand pays du socialisme.

Des tanks de la nouvelle et puissante armée républicaine s'avancent dans le village que les mercenaires fascistes ont dû abandonner.

Les paysans que l'invasion fasciste avait chassés retournent vers les villages que l'armée républicaine vient de leur reconquérir.

13

Taro's photo story on the Battle of Brunete—where she was killed—appeared in the July 22, 1937, issue of *Regards*. On August 10, 1937, *Ce soir* published a page of her photos under the title "What Gerda Taro Saw the Day Before She Died."

Soria as a correspondent and a team of photographers like that, the competition might as well give up! These were friends of Cartier's [Cartier-Bresson] who had had his first Paris exhibition at the Maison de la culture [House of Culture] at my request. I used to say—and I was right—that he was the greatest photographer of the period. Thanks to him we were able to send an extraordinary team to Madrid. Extraordinary from every point of view—the political, the acute sense of what would capture the imagination . . . As for the photo itself . . . the art of photography, it was the avant-garde of the time . . . And they were daredevils too! Courage . . . Robert Capa, Gerda Taro, Chim."

Then came the tragedy that rocked the newspaper and its readers: the accidental death of Gerda Taro on the Brunete front in late July 1937. Taro was attempting to flee a combat zone under attack by Nationalist planes and artillery, riding the running board of a speeding car. A Republican tank hit the car, then ran over her. Severely injured, she was taken to the American field hospital in Escorial where she died the next morning, Monday, July 26, 1937, at six AM. She would have been twenty-seven years old on August 1. Robert Capa learned the news from a newspaper he was reading in his dentist's waiting room in Paris; Aragon later confirmed that it was true. Capa had last seen his love on Bastille Day, when she returned from Spain to deliver her photographs. Her coverage of the Battle of Brunete had been highly productive. Always on the front lines, Gerda was then confirming her reputation as being among the best of all the war correspondents. She had been one of the few photographers to document the short-lived capture of the city of Brunete by the Republicans (in a photo story published in *Regards* and *Ce soir*). This event fed hopes of a major military reversal

138

in favor of the Loyalists; however, Franco's army finally won the battle with the support of German planes of the Condor Legion. The Battle of Brunete was a particularly bloody one, with more than twenty-five thousand Republican casualties in a single month, including four thousand three hundred members of the International Brigades and not counting medical corps volunteers. It was here that ambulance driver Julian Bell, nephew of Virginia Woolf, died after only one month in Spain.

The Communist journalist Georges Soria, the *L'humanité* and *Ce soir* correspondent in Spain, was also in Brunete then. Soria accompanied Gerda's body to the French border. He wrote, "From Madrid, Gerda's hearse was sent to Valencia, where a second farewell ceremony took place. In the suffocating summer humidity and the intoxicating perfume of countless lilies, the people of Valencia streamed by the bier of the beautiful foreigner, displayed beneath a giant portrait framed in black, her eyes laughing. Then, following by car 150 feet behind the hearse, which was brimming with wreaths and bouquets, I traveled up to Port-Bou at the Spanish border, certain I would find Bob [Capa] there. But Bob, devastated, was not there. It was philosopher and novelist Paul Nizan, a close associate of Aragon's on the daily *Ce soir*, who was waiting for me. Nizan took over from me to accompany the hearse to Paris, which took its turn giving Gerda an imposing funeral."

Paul Nizan would keep a photograph of Gerda taken by Capa pinned to the wall of his office at the newspaper. It shows Gerda against a Spanish milepost bearing the initials PC (Communist Party) and was published on the cover of *Ce soir* to announce its contributor's death. The same cover also featured the black-framed smiling portrait from her farewell in

Valencia. On August 1, 1937, a long funeral cortege passed before the newspaper's offices on rue du Quatre-Septembre; an enormous crowd, preceded by dozens of young girls carrying white flowers, surrounded the hearse. The emotion was palpable. The Communist Party was burying the "Joan of Arc of the anti-Fascist struggle" with pomp, although it appears Gerda had never become a party member. The Parisian crowd was also paying tribute to the victims of the Spanish civil war. At Père-Lachaise Cemetery in Paris, the two heads of *Ce soir*, Aragon and Bloch, gave the eulogy for the "Skylark of Brunete."

Overcome with sorrow, Robert Capa followed the coffin weeping silently. In 1954, Louis Aragon described the scene in *Les lettres Françaises*: "I will remember my whole life long that terrible morning when it fell to me to tell Robert Capa that it was true, that tragedy had struck down his love. And the people of Paris gave the little Taro an extraordinary funeral, when all the flowers in the world seemed to come together. Standing by my side, Capa cried and hid his eyes against my shoulder whenever the cortege came to a halt." Cartier-Bresson was also at Père-Lachaise. He had never seen his friend in such a state and would tell people that "afterward [Capa] was never the same."

In the United States, *Life* magazine paid tribute to Gerda Taro on August 17 by publishing her photographs on a double-page spread entitled "The Spanish Civil War Kills Its First Female Photographer." A brief article explained "that she is probably the first female photographer ever to have been killed in action. And that her photographs are among the best to have come out of Spain over the last year . . . Gerda Taro was an open propagandist for the Loyalists and only took photographs from behind government lines." *Life* added, "Her Paris

89 Woman Photographer Crushed by Loyalist Tank

Probably the first woman photographer ever killed in action, pretty Gerda Taro covering the Spanish Civil War for the Paris "Ce Soir," was crushed by a Loyalist tank during the great battle of Brunete on July 26, 1937. The Loyalists had taken Brunete, lost it, taken it again, and then lost it. Gerda Taro had left Brunete once in the retreat, and then decided to join the Loyalist rear guard in the city. For almost an hour she had crouched with a remaining battalion under Rebel bombardment. Finally she hopped on the running board of a press car. Suddenly, as part of a Loyalist counter attack, a tank, cruising blind, careened into view. With an unexpected swerve the creeping, shell-spitting monster bumped the daring young woman from her perch and crushed her beneath the revolving lugs! She died the following morning in the Escorial Hospital her husband-photographer, Robert Capa, at her side.

To know the HORRORS OF WAR is to want PEACE

This is one of a series of 240 True Stories of Modern Warfare. Save to get them all. Copyright 1938, GUM, INC., Phila., Pa.

THE CAMERA OVERSEAS: THE SPANISH WAR KILLS ITS FI

The pretty little woman at left is Gerda Taro, 25, Polish woman photographer whose best pictures are shown on these two pages. On July 26, she was killed in line of duty photographing the Spanish Civil War. She is probably the first woman photographer ever killed in action. And her pictures were some of the best out of Spain in the last year.

Already a score of reporters and cameramen have lost their lives reporting the Spanish Civil War. It is not for lack of courage that the war has been inadequately reported and photographed. Modern war uses propaganda as a weapon and both sides in Spain have ruthlessly censored news and pictures. Gerda Taro was frankly a propagandist for the Loyalists, taking pictures only behind the Government's lines. Her Paris newspaper for the past five months has been the Communist *Ce Soir*. Last year, she married a fellow photographer named Robert Capa. Capa's picture of a shot Loyalist (*shown above*) was used as a frontispiece in the July 12 LIFE.

Gerda Taro's last job was to photograph the great battle of Brunete, in which, between July 18 and 25 the Loyalists defended the salient they had cracked in the Rebel lines west of Madrid. The Loyalists took it, lost it, took it and lost it again. Gerda Taro left Brunete once on the final retreat, then decided to rejoin the Loyalist rear guard in Brunete. For an hour she crouched with a last battalion under the Rebel bombardment. Then she hopped on the running board of the car of Federated Press Reporter Ted Allen. Her death occurred in one of those unheroic ways that war also provides. A Loyalist tank headed for the front line careened into view, swerved into Allen's car and crushed Gerda Taro. She died next morning in the Escorial hospital.

At Cordoba, Photographer Gerda Taro pushed up gunner operating his gun inside a shaded dugou

Last Taro picture showed Loyalist defenders at the Brunete railway station.

PHOTOGRAPHER TARO IN MILITIAMAN'S OVERALLS NAPS BESIDE A SPANISH ROAD

On the Madrid front Gerda Taro and husband Robert Capa took this series of Asturian *dynamiteros* slinging dynamite. **The fuse is lit** by a comrade in an advance post of the Loyalist trenches in North Spain. Both were miners before the war. **The dynamitero** gives his homemade grenade a whirl in his homemade sling and lets it go toward the Rebel lines.

At Segovia near Madrid, Taro, who was not afrai photographed a dead Frenchman on Governme

140

In an article published August 16, 1937, *Life* magazine stated: "Her photographs are among the best to have come out of Spain over the last year."

t lines to snap this machine
d attack here in June failed.

French Communists, fighting for the Spanish Government in their trenches outside Madrid, willingly posed for their fellow Communist, Gerda Taro, with a fine pair of field glasses.

TARO WAS BEST AT SUCH PICTURES AS THIS OF A MADRID NURSERY IN THE MIDST OF WAR

Gerda Taro's grave at Père-Lachaise is adorned with a sculpture by Alberto Giacometti.

141

newspaper over the last five months was the Communist *Ce soir*." And so a legend was born. Beautiful, young, courageous, and committed: grounds enough to include Taro in a 1938 series of 240 advertising cards printed by a Philadelphia chewing gum company and dedicated to the heroes of the "true stories of modern war," with a color drawing depicting the tragic accident in Brunete.

In the spring of 1938, the French Communist Party asked sculptor Alberto Giacometti to design Gerda Taro's tomb in the heart of the ninety-seventh division of Père-Lachaise. He created a mineral tomb in limestone with a cup and a bird, a falcon, representing the Egyptian god Horus, a symbol of immortality. The following epitaph was engraved on the tomb at the newspaper's request: "Gerda Taro—photographer for *Ce soir*—died July 25, 1937, on the front at Brunete, Spain, while doing her job." This inscription would be chiseled away in August 1942 at the command of the Nazi occupants.⊕

PICTURE POST

Vol. I. No. 10. December 3, 1938

The Greatest War-Photographer in the World: Robert Capa

In the following pages you see a series of pictures of the Spanish War. Regular readers of "Picture Post" know that we do not lightly praise the work we publish. We present these pictures as simply the finest pictures of front-line action ever taken. They are the work of Robert Capa. Capa is a Hungarian by birth; but, being small and dark, he is often taken for a Spaniard. He likes working in Spain better than anywhere in the world. He is a passionate democrat, and he lives to take photographs. Over a year ago, Capa's wife, on her way back to join her husband in Paris, was killed in Spain. She was standing on the running-board of a car when it collided with a tank. Capa went to China and took pictures of the Chinese war, some of which we have already published. To-day, Capa is back in Spain, taking pictures fo. "Picture Post."

PICTURE POST 13

ABOVE: In December 1938, *Picture Post* hailed Robert Capa as the greatest war photographer in the world but ran a Gerda Taro photo of him filming. In the same issue, the paper published the photographer's most spectacular story, about the Battle of Rio Segre. OPPOSITE: Stills from the film *España 1936* (*Spain 1936*) produced by Luis Buñuel and directed by Jean-Paul Le Chanois with footage shot in Spain, including stills by Capa.

The Man with the Movie Camera

The greatest war photographer in the world. This portrait published in *Picture Post* in December 1938 shows Capa carrying a film camera rather than a still camera—a rather unusual way to present a photographer. This issue of the British magazine edited by the Hungarian Stephan Lorant published Capa's photo story on the Battle of Rio Segre, which was probably his most beautiful coverage of the Spanish civil war. These photos, a striking series of shots taken in the heart of the firefight, were published by the major magazines with spectacular layouts reminiscent of movie shots. Capa had an uncanny ability to capture movement and action with his still camera, possibly because he also worked with a film camera.

Capa arrived at the general staff of the Twelfth International Brigade in Madrid in December 1936 accompanied by Russian filmmaker Roman Karmen. Together, they captured images—Karmen with his film camera, Capa with his still cameras. Some of the shots taken at the Madrid university campus were used in *España 36*, a film made by Luis Buñuel in Paris. At the time, the Surrealist filmmaker was working at the Spanish embassy, where he was in charge of espionage and collecting propaganda images to be used in documentaries and the press. In *España 36*, he used images taken by Capa and Karmen at the Madrid university campus.

ESPAGNE
1936
Un grand reportage cinématographique

ABOVE: Henri Cartier-Bresson
photographed during the Spanish civil war
in October 1937. He always regretted not
having another photo taken. He is between
Jacques Lemare and Herbert Kline,
with whom he is directing a film about
American volunteers.

BELOW: A postcard of an image from
another film Cartier-Bresson shot in Spain.

OPPOSITE: The documentary concludes
with the words, "In a few weeks,
150 veterans of this brave and heroic
army will return to the United States."
These captions are set on top of images
shot by Capa.

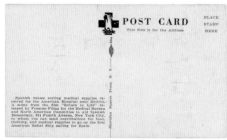

IN SPAIN — THE LINCOLN BRI-
GADE WITH THE SPANISH
PEOPLE STILL FIGHT ON
AGAINST FASCISM . . .

IN A FEW WEEKS 150 VETER-
ANS OF THIS BRAVE AND HE-
ROIC ARMY WILL RETURN TO
AMERICA FOR REHABILITA-
TION . . .

IN AMERICA — WE MUST CON-
TINUE OUR TRADITION OF
FIGHTING FOR DEMOCRACY

España 36 was one of many documen-
taries produced as propaganda during the
civil war. Initially, these were compila-
tion films made from newsreels. Later,
directors went out into the field, as was
the case for Ernest Hemingway and Joris
Ivens's collaboration *The Spanish Earth*.
In New York, Paul Strand and Leo Hurwitz
edited the film *Heart of Spain*. Dissatisfied
with the results, Strand asked the director
Herbert Kline to go to Paris in order to ask
Cartier to make a second film on sanitary
assistance to Spanish Republicans. In
late summer 1937, a crew consisting of
Herbert Kline, Henri Cartier-Bresson, and
Jacques Lemare (from the Ciné-Liberté
cooperative, which had close ties to the
communists) arrived in Spain. Cartier-
Bresson and Lemare had met in the
Association des écrivains et Artistes révo-
lutionnaires (Association of Revolutionary
Writers and Artists). All three went to the
hospitals in Benicàssim, near Valencia, and
recorded the images used in the film *Return
to Life*. In October 1937, just after the Battle
of the Ebro, they interrupted the shoot
and left for two days to visit the American
volunteers of the Abraham Lincoln Brigade
on the Aragon front and shot *With the
Abraham Lincoln Brigade in Spain*. In this
film recently rediscovered by Spanish
researcher Juan Salas, images of farmers—
shot on the Córdoba front by Capa—and
those of the body of a soldier in the Basque
country were added to the negative in Paris
in order to clarify the context. While Capa
and his friend Cartier never crossed paths
in Spain, their work is combined in this
film. *Return to Life* and *With the Abraham
Lincoln Brigade in Spain* were produced
by the American Medical Bureau to Aid
Spanish Democracy, an organization that
therefore also employed Capa.

Images shot by Robert Capa during the Segovia assault by Republican forces during the Spanish civil war. These are taken from one of *The March of Time* newsreels.

Capa began using a film camera himself in mid-1937. In May, he ended his contract with *Ce soir* in Paris and began looking for new clients. He turned to the American press group Time-Life, headed by Henry Luce. His first photos in *Life*, portraying the Madrid resistance, had been published in January 1937. The magazine was then only two months old but was expected to be a major success. The group also had other ambitions. In 1935, it had partnered with Warner Brothers to produce newsreels. Over 1,500 theaters in the United States now projected *The March of Time* before the feature presentation. The twenty-minute program would run for sixteen years, always accompanied by the voice of announcer Westbrook Van Voorhis, nicknamed "The Voice of Doom." One or several national or international subjects were covered each month. These genuine documentaries operated somewhere between spectacle and information, combining news footage, archival images, and sequences reenacted in the studio.

Capa now had a 35 mm Bell & Howell camera, an Eyemo, given to him by Richard de Rochemont, then European coordinator for *The March of Time*. Richard's brother, Louis de Rochemont, was based in Hollywood, where he edited the films. On May 31, Capa was back in Spain with Gerda Taro, following a Republican offensive near Segovia. Both switched back and forth between still and film cameras. The light handheld camera they used did not record sound, shot black-and-white, and had a 100-foot film magazine, which allowed them to shoot three minutes at a stretch. The tripod was heavy and cumbersome. Neither Capa nor Taro knew the techniques of shooting motion picture film. So they improvised. At the Navacerrada ridge, they filmed tanks maneuvering, then Republican officers consulting the battle plans. Back in Madrid, they went to the area near Carabanchel to film a group of *dinamiteros*, and then traveled to the mining region south of the capital. The Tchapaïev Battalion of the International Brigades was stationed near Peñarroya. Its political commissioner was none other than the German writer Alfred Kantorowicz, who Capa and Taro had met in Paris. Together, they staged the taking of the village of La Granjuela, which the battalion had captured the previous April 5. The troops happily lent themselves to the reenactment. Henry Luce used to tell his directors to "use what is false to make what is real." During this stay, Gerda Taro became the battalion's mascot. In late June, Capa returned to Paris and gave Richard de Rochemont their footage. Only a little of it was used in the final cut of *Rehearsal for War*, the monthly installment of *The March of Time* projected on American screens in the fall of 1937. The title perfectly expresses the analysis of the Spanish war that predicted it was a "rehearsal" for a future global conflict. ⊕

The Framing
of a Photo

148

In its October 22, 1936, issue, the newspaper *Regards* criticized its competitor *VU* for publishing a cropped photo by Capa, thus distorting its meaning. Indeed, trimming the image to remove the closed fists of these Alsatian women saluting the Popular Front makes the significance of the photo totally different.

Whether or not the original framing of a photograph must be respected when published has been a recurrent subject of debate throughout the history of photography. As early as the 1930s, Henri Cartier-Bresson had the following instructions written on the back of his pictures: "Photograph must not be altered by trimming." This respect for the integrity of the image would be at the heart of the Magnum photographers' cooperative founded by Capa and his friends. Before World War II, cropping of photos was common, generally for layout reasons, but also to allow for manipulation—which makes the matter more than a question of aesthetics. In this regard, the conflict between *Regards* and *VU* is a textbook example.

Facing a page displaying six beautiful photos of Spain by Chim, the October 22, 1936, issue of the weekly *Regards* published a photo by Robert Capa showing Alsatian women in traditional costume raising their fists, accompanied by the cover of *VU* with the same photo trimmed to cut out the raised fists. The Communist paper was denouncing *VU*'s change of political orientation, as well as the firing of Lucien Vogel following the publication of a special issue dedicated to Spain that was little appreciated by stockbrokers. *Regards*' comment runs as follows, with no mention that the photo is by Capa: "This Alsatian woman in costume representing 'the true face of Alsace' was photographed at the Strasbourg Communist meeting among her comrades, her fist closed, and on this page you see the original photo... which *VU* [used on its] cover... simply by removing the fists raised to salute the Popular Front."⊕

"LE VRAI VISAGE DE L'ALSACE"

VOUS avez sous les yeux, à droite, la couverture du numéro du 14 octobre de l'hebdomadaire « VU » (nouvelle direction). L'Alsacienne qui y figure est destinée à représenter « le vrai visage de l'Alsace ». A l'intérieur du numéro, un article, à propos des meetings communistes des 10 et 11 octobre en Alsace-Lorraine, prétend nous montrer ce visage. Nous en détachons ces quelques phrases :

« La formidable tournée de propagande initialement projetée par le Parti communiste ne pouvait que provoquer un trouble certain. » « Une crainte surtout se manifestait : entendre un élu communiste répondre au discours 'de 'Nuremberg. » « La lutte semble donc se circonscrire nettement entre les partisans de l'ordre, d'un côté, et, de l'autre, le Parti communiste ». « Si les 120 réunions projetées avaient eu lieu, l'ALSACE SE SERAIT SENSIBLEMENT ELOIGNEE DE LA FRANCE. Telle est l'opinion générale. ». « VU » veut donc prouver que l'Alsace est contre le Front Populaire, et que « les partisans de l'ordre » sont à droite. Il a, dans ce cas, assez maladroitement choisi la photo destinée à illustrer cette thèse. Car cette Alsacienne en costume qui représente le « vrai visage de l'Alsace », elle a été photographiée au meeting communiste de Strasbourg, au milieu de ses compagnes le poing fermé, et vous voyez sur cette page la photo originale dont « VU » a tiré sa couverture... en enlevant simplement les poings fermés pour le salut du Front Populaire. Il arrive quelquefois, comme vous voyez, que l'on altère la vérité par... omission. Mais ne dit-on pas que M. Pierre Laval s'intéresse particulièrement à « VU et LU » (nouvelle direction)? Et chacun connaît sa manière.

Combat Books, in New York…

While Capa, Taro, and Chim's work was published in the professional or activist press, it also appeared—often uncredited—in several ambitious but underexposed books. Characterized by high-quality design, these books were made or supported by the Spanish Republic's propaganda services or by its supporters. The volumes featured over the following pages were published in New York, London, Moscow, and Barcelona. They share the objective of revealing a people's struggle through images. The subjects never varied: women and children plagued by random bombings, the protection of works of art, the raising of a people's army, farmers at work, and soldiers facing the enemy. Here, photography was used as a propaganda tool to gain support, particularly abroad.

The most gripping of these books was Robert Capa's *Death in the Making*, an homage to Gerda Taro. It appeared in 1938 with the following text on the opening page: "*Death in the Making* by Robert Capa. Photographs by Robert Capa and Gerda Taro. Captions by Robert Capa. Translated by Jay Allen, preface by Jay Allen, arrangement by André Kertész." The book was ninety-five pages long and contained one hundred and fifty photos—about half by Capa, the rest by Taro and Chim—and was laid out in a highly modern style. The back cover read, "Allen knows Capa. Allen

knew Gerda Taro before she was killed. He knows how the two of them followed the republican battalions into perilous action, how they risked their lives daily to make for the outside world a pictorial record of the most heroic struggle of modern times." It continued: "Robert Capa and Gerda Taro take us into peasant homes and fields, to bread-lines, munitions factories, railroad stations, cafes and theaters as well as to the front-line trenches." This superb volume issued by Covici-Friede Publishers has never been republished and is impossible to find.

American journalist Jay Allen had become an expert on Spain as a correspondent for the *Chicago Tribune* since the early thirties. He had reported on the 1934 revolution and since lived in Málaga. He was famous for interviewing General Franco in July 1936 and writing about the massacre perpetrated by insurgent troops in Badajoz

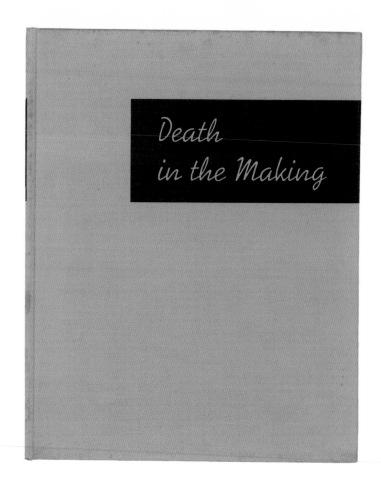

OPPOSITE, TOP: *Death in the Making*'s flyleaf states that the photos in the book are by Robert Capa and Gerda Taro but does not mention Chim, though he was responsible for several of the photo stories it contained.
OPPOSITE, BOTTOM: The book's dedication read, "For Gerda Taro, who spent one year at the Spanish front—and who stayed on. Madrid, December, 1937. R.C."

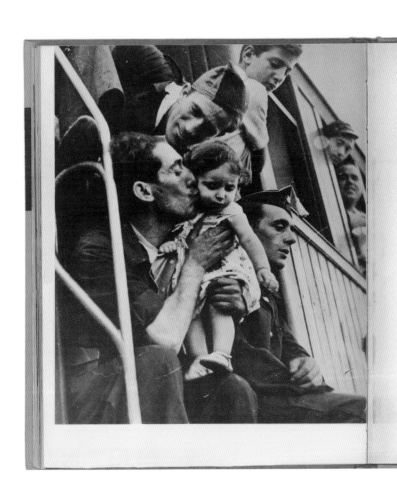

Death in the Making

BY ROBERT CAPA

PHOTOGRAPHS BY ROBERT CAPA AND GERDA TARO

CAPTIONS BY ROBERT CAPA, TRANSLATED BY JAY ALLEN
PREFACE BY JAY ALLEN. ARRANGEMENT BY ANDRÉ KERTESZ

COVICI · FRIEDE

PUBLISHERS · NEW YORK

FOR GERDA TARO,

WHO SPENT ONE YEAR AT THE SPANISH FRONT,

AND WHO STAYED ON.

Madrid, December, 1937. R.C.

Typical of the women of loyalist Spain is Dolores Ibarurri. La Pasionaria, the Passion Flower, they called her when she used to talk to the miners in the old days with a consuming eloquence. The granddaughters of dukes, the wives of merchants, the women in the fields, accept her as such. It was she who made *the* phrase of the war, "Better to die on one's feet than to live on one's knees."

The capital's slaughter-house lay between the lines. On one side the defenders, on the other the Moors in rebel service. Hand grenades sail over the areas where once sheep bleated before the killing. The miniature catapults that send the missiles across to the enemy are overworked.

The wounded arrive from the lines up ahead, the bloodflow staunched with first-aid dressings.

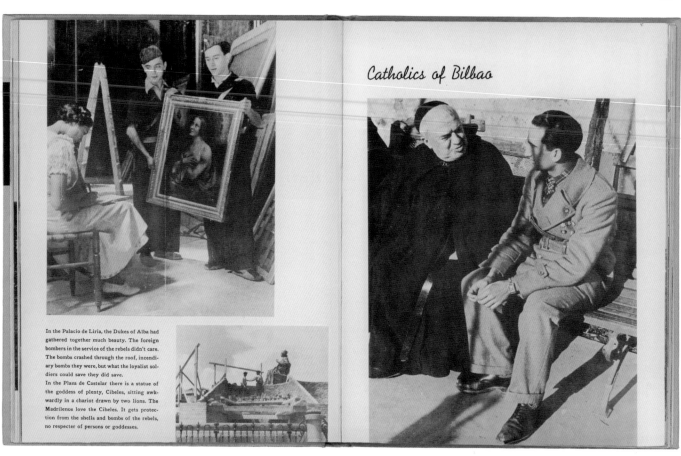

Catholics of Bilbao

In the Palacio de Liria, the Dukes of Alba had gathered together much beauty. The foreign bombers in the service of the rebels didn't care. The bombs crashed through the roof, incendiary bombs they were, but what the loyalist soldiers could save they did save.

In the Plaza de Castelar there is a statue of the goddess of plenty, Cibeles, sitting awkwardly in a chariot drawn by two lions. The Madrilenos love the Cibeles. It gets protection from the shells and bombs of the rebels, no respecter of persons or goddesses.

Capa Reports Spain

DEATH IN THE MAKING, by Robert Capa; preface by Jay Allen; Covici-Friede; $2.50.

A BOY AND girl met in Paris. Both were photographers. Both had left Germany because night had set in. And the swastika was a shadow over the moon. Both loved life and because they loved life, what should they do when the same shadow threatened the cities and countryside of Spain? Both packed their cameras and left for Spain.

For one year, Robert Capa and Gerda Taro focused their lenses on the people who were facing Franco's guns. The boy and girl remembered Hitler and the cameras clicked under their fingers and the little boxes held the story of a people fighting for life, liberty, bread and dreams.

The girl was killed one day, crushed by a twelve-ton tank. Her body was taken back to Paris and laid beside Henri Barbusse. The boy, remembering the girl Gerda Taro, continued clicking his camera where both had left off when she died on the battlefield.

This is a book of photographs by this boy and girl. Faces to be remembered, songs in black and white. Did I hear of a friend of mine, a writer, a descendant of the Spanish people, who went to Spain and came back doubtful? Did he see these faces? Did he hear the cry of that Spanish woman: "Better to die on one's feet than to live on one's knees"? I am told that this friend of mine is old. I can very well believe that. I know it now after seeing this book. Once upon a time my friend was young and when he was young he believed in life. Old age can be beautiful too but my friend is old at forty. He does not believe in Spain and life.

This book deserved a more careful printing job. But even that has not marred the imaginative craftsmanship in these pages. It is a long time since the days of our own Civil War when the American photographer, Matthew Brady, recorded the life of Lincoln and the rank and file soldier in the Union army. From Brady to Capa and Taro. The struggle for life and freedom continues.

The preface to this book by Jay

Robert Capa, best-known still photographer in Spain. Many of Capa's pictures are on pages 11 to 27

Allen is as living a thing as the pictures. Jay Allen is right when he says that this book, *Death in the Making* might have been "called *Life in the Making* with as much truth."

—JOSEPH PASS

in August. An unwavering supporter of the Spanish Republic, this excellent journalist would become an ardent propagandist. In his long preface to *Death in the Making*, Allen wrote, "And then came copies of *VU* and *Regards* and in their pages I saw the faces I knew, the true face of Spain and nearly always it was in photographs, very simple moving photographs, like those in this book that were signed by a Robert Capa and sometimes a Gerda Taro. Names that meant nothing to me." Allen met Capa in 1937 in Bilbao and Taro in Madrid, shortly before she left for the Battle of Brunete and lost her life. He ended his preface with these words, "He might have called it *Life in the Making* with as much truth." Capa's first exhibition in the United States would take that very name. In its February 28, 1938, issue, *Time* announced the opening "last week" of an exhibition of two hundred

photos by Robert Capa at Manhattan's New School for Social Research. The magazine also reported on the accidental death of Capa's "wife," Gerda Taro. *Death in the Making* was sold at the exhibition, as can be seen in the photo showing Julia Friedmann, Capa's mother, proudly displaying her son's book in the university hallway where his photos were hanging.⊕

ABOVE, LEFT: A review of *Death in the Making* appeared in an April 1938 issue of *The Fight for Peace and Democracy* intended to raise funds for the Spanish Republic. The same issue featured fifteen pages of photos by Capa and Taro.
ABOVE, RIGHT: Julia Friedmann, Capa's mother, at her son's New York photo exhibition in July 1938.

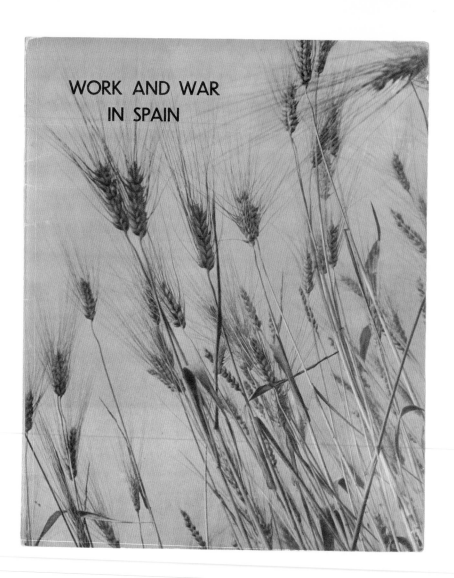

WORK AND WAR
IN SPAIN

ABOVE AND OPPOSITE: The covers
of the two books published in
London by the Spanish Republic's
embassy. Both volumes contain
many uncredited photos by Capa,
Chim, and Taro.
RIGHT: Another UK publication
by the Spanish Republic's
propaganda services, the
newspaper *Voice of Spain*, with
a cover by Taro.

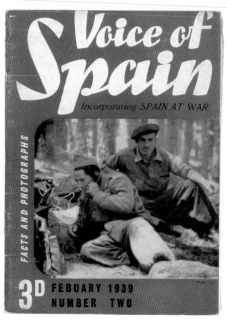

Voice of
Spain

Incorporating SPAIN AT WAR

FACTS AND PHOTOGRAPHS

3D FEBUARY 1939
NUMBER TWO

...London

A Spanish militiaman photographed
head-on—wearing an improvised uniform,
a helmet on his head, a frank look in his
eyes—was the face of Spain in arms in
the photograph on the cover of the book
La lucha del pueblo Español por su libertad
(*The Spanish People's Fight for Liberty*).
The photo was long attributed to Walter
Reuter, a German photographer and
friend of Capa's, who loaned him his lab
in Barcelona to develop his photos during
the Spanish civil war. Capa returned the
favor in Paris in 1939, on rue Froidevaux.
As a result of the discovery of a book of
contact sheets in 2005, we know that this
magnificent photo was actually taken by
Capa. It is part of a series of portraits taken
on the Aragon front at the very beginning
of the offensive launched in the region, in a
zone where Capa and Taro were despairing
ever to find combat. This approach to
photographing faces head-on is a Capa
trademark. The portrait can also be found
among the photomontages in the Chilean
poet Pablo Neruda's book *España en el
corazón* (*Spain in My Heart*), published in
Santiago de Chile in 1937.

 La lucha del pueblo español por su libertad
was published in three languages—Spanish,
English, and French—in London in 1937.
Prefaced by the journalist Antonio Ramos
Oliveira, the volume contained 128 pages

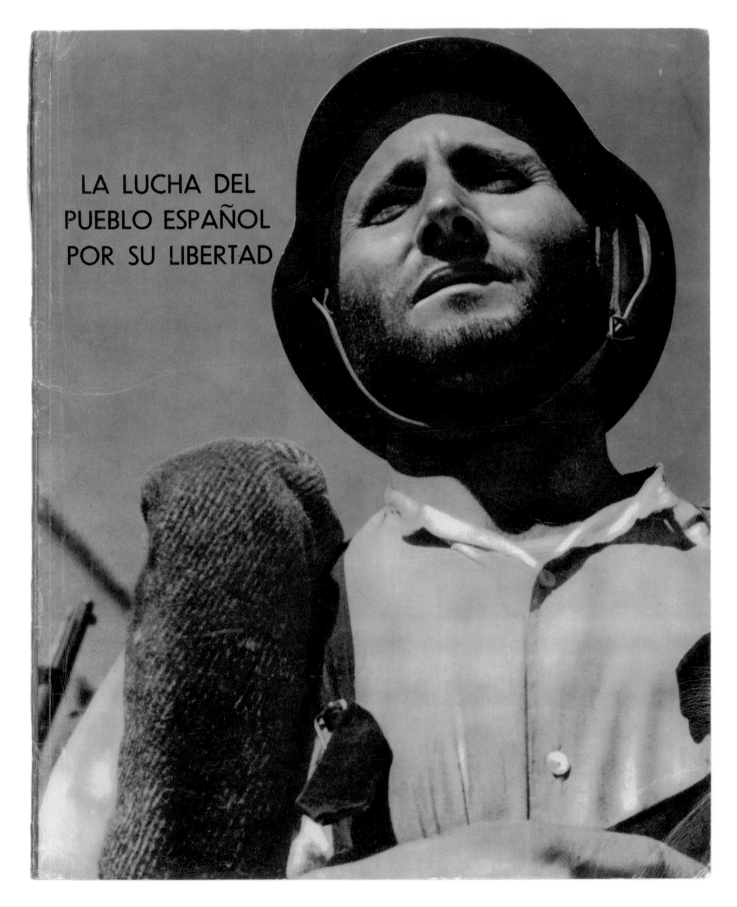

LA LUCHA DEL
PUEBLO ESPAÑOL
POR SU LIBERTAD

157

158

ABOVE: The original Robert Capa
photo used in the photo book
*La lucha del pueblo español por su
libertad.*
OPPOSITE: Two inside spreads;
the photos at top are by Capa, at
bottom by Chim.

exclusively composed of captioned photo-
graphs. At least half of them were by Taro,
Chim, and Capa, who could claim the most.
The book was published by the embassy
of the Spanish Republic's press services,
headed by Pablo de Azcárate. Azcárate
oversaw intense propaganda efforts in
London, organizing exhibitions and
conferences and publishing newspapers
and pamphlets. He repeated the experience
in 1938 with a second volume entitled *Work
and War in Spain*, also illustrated by Capa,
Chim, and Taro. The photos in both these
volumes were not credited. The books'
flyleaves simply stated that they were
provided by agencies, including Alliance
Photo, which distributed the trio's work.
The photos' authors were long unknown.

In 1979, an elegant little Vuitton trunk
was found in Sweden and turned over to
the Spanish authorities by the Swedish
ambassador in Madrid. Along with some
documents, the suitcase contained
ninety-seven photos of the Spanish civil
war taken by Robert Capa, Gerda Taro,
Chim, and Fred Stein. The exact purpose
of the contents of this suitcase belonging
to Juan Negrín, president of the council of
the Spanish Republic, remains an object
of speculation. The pictures give such a
thorough view of the conflict's different
aspects that they might have been gathered
for publication or an exhibition: the battles
of Madrid, Brunete, and the Ebro; the
misfortunes of the civilian population; and
portraits of Republican leaders. They form

UNA AMETRALLADORA QUE CORTA EL
PASO A LOS REBELDES EN MADRID

A MACHINE-GUN HOLDING UP THE REBELS
IN MADRID

MITRAILLEUSE ARRÊTANT LES REBELLES
DEVANT MADRID

LA DEFENSA DE MADRID
THE DEFENCE OF MADRID
DÉFENSE DE MADRID

CANSANCIO
WEARINESS
FATIGUE

UN ALTO EN LA LUCHA
A LULL IN THE FIGHTING
ACCALMIE

159

HAY QUE CONSERVAR
EN BUEN ESTADO LA
AMETRALLADORA.

THE MACHINE-GUNS
MUST BE KEPT IN
PERFECT CONDITION.

PREPARATIVOS PARA
VOLAR SOBRE EL
FRENTE ITALIANO.

GETTING READY FOR
A FLIGHT OVER THE
ITALIAN FRONT.

UN AVION ALEMAN DERRIBADO POR UN
APARATO REPUBLICANO SOBRE MADRID.

A GERMAN PLANE BROUGHT DOWN BY A
REPUBLICAN MACHINE OVER MADRID.

LA MUJER ESPAÑOLA EMPUÑA LAS ARMAS PARA DEFENDER
SU LIBERTAD : MILICIANAS DEL FRENTE DE ARAGON
THE WOMEN OF SPAIN HAVE TAKEN UP ARMS IN DEFENCE OF
THEIR LIBERTY : WOMEN MILITIA ON THE ARAGONESE FRONT
LA FEMME ESPAGNOLE A PRIS LES ARMES POUR LA DÉ-
FENSE DE SA LIBERTÉ : MILICIENNES DU FRONT D'ARAGON

¡HACIA EL FRENTE !
TO THE FRONT !
AU FRONT !

CAMPESINOS DE SIGÜENZA
PEASANTS IN SIGÜENZA
PAYSANS DE SIGÜENZA

160

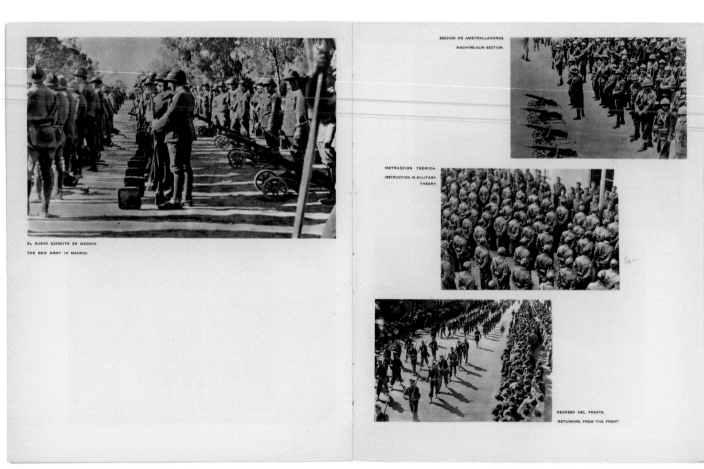

EL NUEVO EJERCITO EN MADRID.
THE NEW ARMY IN MADRID.

SECCION DE AMETRALLADORAS.
MACHINE-GUN SECTION.

INSTRUCCION TEORICA.
INSTRUCTION IN MILITARY
THEORY.

REGRESO DEL FRENTE.
RETURNING FROM THE FRONT.

a cohesive group, which could easily rein-
force the Spanish Republic's propaganda.
In a book accompanying the publication of
these photos, the academic Carlos Serrano
writes, "This collection is undoubtedly
one of the best demonstrations of the role
Robert Capa played during the Spanish
civil war and of his conception of photog-
raphy that aims to be both a document and
a weapon, or more accurately a weapon
because it is a document." The book also
suggested that the photos in this collec-
tion could have been published in 1937 in
London in *La lucha del pueblo español por su
libertad*. While that hypothesis is seductive,
it is inaccurate.

In 2000, an English book dealer
traveled to Barcelona to sell about one
hundred large-format photos mounted on
cardboard, including about thirty by Capa,
a dozen by Chim, and several by Walter
Reuter. They were eventually purchased by
the Spanish National Library. These were
some of the original photos published
in the London volume—in which they
appeared heavily touched up. The prints
feature the same captions as those accom-
panying the photos in the book.⊕

OPPOSITE: The photos on the top
are by Capa. Below is spread of
photos by Taro taken from *Work
and War in Spain*.
ABOVE: A photo by Capa.

...Moscow

A book entitled *Spain* appeared in two
volumes in Moscow early in 1937. Its author
was Ilya Ehrenburg, a Soviet journalist
and writer living in Europe. Each of the
carefully made volumes featured about one
hundred and fifty photos, accompanied by
short captions and brief introductory texts
taken from the pieces Ehrenburg had filed
from Spain since early 1936.

The first volume, which was completed
in August 1936, featured "photos and texts
on the beginning of the Spanish Revolu-
tion." The photos were by Ehrenburg
himself, but also Eli Lotar, Hans Namuth,
Georg Reisner, and especially Chim—
including that of a woman looking up at
the sky as she breastfed her child, which
would become one of the emblematic

Долорес Ибаррури, которую народ прозвал «Ла Пасионария» — «Неистовая»

Восемнадцатого февраля в тюрьме Овиедо находилось свыше девятисот заключенных. Рабочие собрались вокруг тюрьмы. Они кричали: «Амнистию!» Коммунистка Ла Пасионария, дочь шахтера и жена шахтера, шла впереди толпы. Стража выставила пулеметы. Ла Пасионария направилась к губернатору: «Тотчас же освободите заключенных!» Губернатор ответил: «Я признаю только закон. Если толпа не разойдется, комендант скомандует — пли». Толпа не расходилась. Ла Пасионария скомандовала коменданту «вольно», комендант повторил «вольно!» Ла Пасионария вошла в тюрьму. Сначала из тюрьмы вышли приговоренные к смерти, потом — к вечному заключению, потом остальные. Когда из ворот выбежал последний узник, жмурясь от солнца и счастья, появилась Ла Пасионария, в ее руке был огромный ржавый ключ, она показала его толпе: «Тюрьма пуста»

Освобожденные шли по улицам города, который в октябре 1934 года они отстаивали от гвардейцев и легионеров, шли и пели «Интернационал». Толпа в ответ кричала «UHP» «Уачее!»

Слушают

«UHP!»

Старая испанская песня восхваляет мужество:
«Мое украшение — оружие.
Мой отдых — сражаться.
Моя кровать — жесткие скалы.
Мой сон — всегда бодрствовать».
Когда гвардейцы стреляют в испанских рабочих, испанские рабочие не разбегаются — нет, товарищи сбегаются на выручку тех, в кого стреляют.
Крохотный мальчик, сын испанского рабочего, сказал мне: «UHP!»

164

Здесь она жила

165

Уносят свое добро

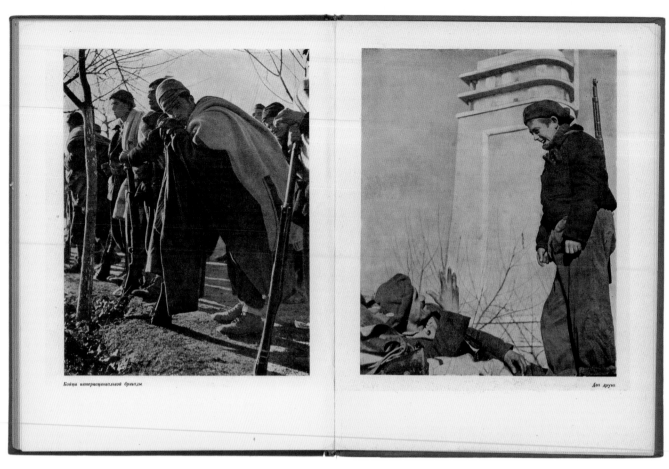

Бойцы интернациональной бригады

Два друга

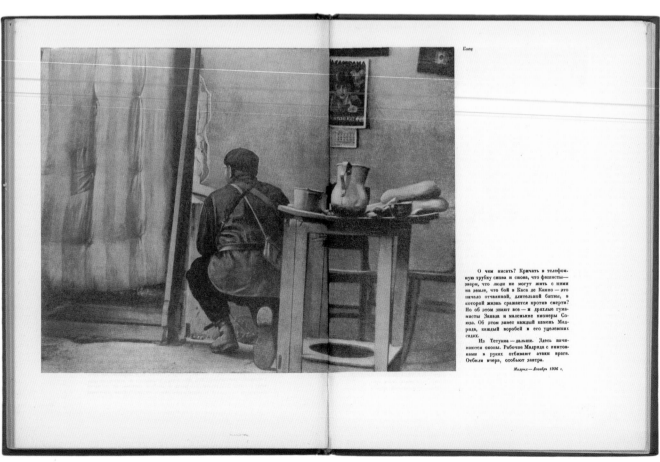

Боец

О чем писать? Кричать в телефонную трубку снова и снова, что фашисты— звери, что люди не могут жить с ними на земле, что бой в Каса де Кампо — это начало отчаянной, длительной битвы, в которой жизнь сражается против смерти? Но об этом знают все — и дряхлые гуманисты Запада и маленькие пионеры Союза. Об этом знает каждый камень Мадрида, каждый воробей в его уцелевших садах.

Из Тетуана — дальше. Здесь начинаются окопы. Рабочие Мадрида с винтовками в руках отбивают атаки врага. Отбили вчера, отобьют завтра.

Мадрид — Декабрь 1936 г.

166

В метро Мадрида

В кафе стояло тридцать чашек. Возле каждой лежала булочка. Старый официант сказал мне: «Мы ждем детей из Мадрида. Они должны приехать часа через два». Они не приехали. Старый официант собрал чашки и салфеткой вытер глаза. На большой белой дороге, среди реклам мадридских гостиниц и хересского коньяка, сметались санитары: они подбирали крохотные трупы. Фашистский самолет из пулемета обстрелял детей Мадрида. Это было 19 ноября.

Дети Москвы, веселые, счастливые дети! В Испании люди борются и умирают. Они не хотят, чтобы фашисты расстреливали ваших сверстников. Они сражаются за прекрасное детство, за него они умирают в Университетском городке и в парке Каса де Кампо.

Мадрид.—Декабрь 1936 г.

136

Защитники Мадрида

137

images of the Spanish civil war though it was taken long before the conflict erupted. The second volume devoted a considerable amount of space to Capa, reproducing the most beautiful photographs he took in Madrid during his second trip to Spain. It also included photos by Chim, Agustí Centelles, the Mayo brothers, and, once again, Namuth and Reisner. The second volume was designed by the Russian constructivist El Lissitzky.

Ilya Ehrenburg scoured Spain with his colleague Mikhail Koltsov, gathering material for the books, and was a fervent supporter of the Spanish Republic. He was a central player in the propaganda network that distributed texts and photos throughout the world from Agence Espagne (Spain Agency) in Paris.⊕

илья эренбург

испания

...And Barcelona

Published by the Generalitat of Catalonia in February 1937, the photo book *Madrid* is one of the most beautiful volumes about the Spanish civil war. Its uncredited photos by Capa and Chim show the destruction of a country subject to indiscriminate bombings. Some images (pages 170–171) were used in colorized photomontages by the Catalan designer Josep Sala. The only text with a credited author was by Andrée Viollis, then a journalist for *Vendredi*. The captions were in Catalan, Castilian, French, and English.

The last major volume containing a significant selection of photos by the trio of Capa, Taro, and Chim was published in Barcelona under the title *Madrid*. Once again, the cover featured Chim's photo of the woman breastfeeding a child, threatened by a Nazi bomb. Published by the press services of the Generalitat of Catalonia, the book was designed by the Catalan designer Josep Sala. The texts in Catalan, Castilian, French, and English were by Andrée Viollis, a then-famous French journalist, who wrote, "The Spanish soil is the stage for a struggle on which the world's destiny is at stake. Who will win? The fascist fury or the people's enthusiasm?"

The hundred or so photos—half of which are by Capa—show apartment buildings destroyed by the German air force, refugees in the subway and on the roads, casualties in the morgue, and children safely removed from the front. The dramatic progression of the layout and colored photomontages makes this one of the most impressive photo books. Jaume Miravitlles, head of propaganda for the Generalitat and a close friend of Capa's, was particularly proud of it. As with the other books discussed, this volume makes no mention of the photographers' names.⊕

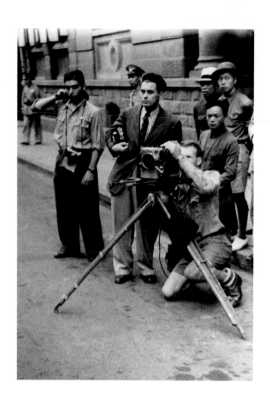

The crew of the documentary film *The 400 Million* in the streets of Hankow in April 1938. From left to right, Robert Capa, Joris Ivens, and John Fernhout operating the camera. Behind them, Madame Chiang Kai-shek's censors closely watch the frame.

In China with Joris Ivens

On Friday, January 21, 1938, Robert Capa arrived at the ferry port of la Joliette in Marseille. He boarded the ocean liner *Aramis* bound for Hong Kong via Saigon with John Fernhout, the Dutch director of photography who regularly worked with filmmaker Joris Ivens. Capa and Fernhout were both twenty-four years old and were longtime friends. Johannes Hendrik Fernhout had studied photography at the Agfa company's school in Berlin in 1931. He was married to Eva Besnyö, Capa's Budapest neighbor and childhood friend. The two men had spent time together in Madrid in the spring of 1937, during the shoot of Ivens's *The Spanish Earth*. The photographer Germaine Krull, Joris Ivens's wife, was in Marseille the day of their departure. She photographed them from the dock, leaning on the rail of the second-class deck. With his arms crossed, the tall Fernhout smiles, while Capa rests his face against the palm of his hand and seems pensive, which is no surprise when we consider that he had planned to make this trip with Gerda Taro.

Two British writers were aboard the same ocean liner: the poet W. H. Auden and the novelist Christopher Isherwood. In their collaborative book *Journey to a War*, published in 1939, the two British writers wrote about Capa and Fernhout: "We had got to know them both during the voyage from Marseilles to Hongkong. Indeed, with their horse-play, bottom-pinching, exclamations of 'Eh, quoi! Salop!' and

endless jokes about *les poules*, they had been the life and soul of the second class. Capa is Hungarian, but more French than the French; stocky and swarthy, with drooping black comedian's eyes. He is only twenty-three [*sic*], but already a famous press-photographer. [. . .] Fernhout is a tall, blonde young Dutchman—as wild as Capa, but slightly less noisy."

Joris Ivens, who was living and teaching film in San Francisco, traveled to Hong Kong aboard a Pan American Airways hydroplane. With excellent ties to the Comintern and a close friendship with Willi Münzenberg, whom he had met in Berlin, Ivens was, at thirty-nine years old, one of the most influential directors of political films. In China, the Nationalists in the Kuomintang suspected him of sympathizing with the Communists and criticized him for his ties with their representative Zhou Enlai, whom Capa would photograph standing before a photo of Karl Marx.

Many years later, Ivens would claim he wanted to "put Capa back to work" after the death of Gerda Taro by inviting him to accompany him to China as an assistant camera operator. Yet the director's interest in Capa was largely due to his being under contract with *Life* since the fall of 1937. Close to Chiang Kai-shek and the Chinese Nationalists, and thus hostile to the Communists, Henry Luce's magazine aimed to mobilize American public opinion in favor of the Nationalist camp defending the independence of China against Japan. *Life*'s calling card made it easier for Ivens to approach Chiang Kai-shek and Madame Chiang Kai-shek, who would make his film possible.

Before his departure, Capa had made arrangements with several periodicals. *Life* would be his first client, but he also made agreements with *Ce soir* and *Regards* in France and the *Picture Post* and *The Illustrated London News* in Great Britain. He asked them for an advance to cover his ticket and expenses. It is said that Hemingway also helped him by sending him two hundred dollars. More than ever before, Capa felt a stirring of independence and attempted to develop his studio on rue Froidevaux into a distribution cooperative to bypass the agencies and their steep commissions on the sale of photos. It was with this in mind that he wrote from Paris to his friend Peter Koester, an editor with the Pix agency in New York, on November 24, 1937: "We've organized the office here in order to speedily distribute the entire production of all the photographers in Spain. Chim's work, Cartier's, and my own will naturally be gathered here, and we will of course also be able to send you the most interesting work we produce for *Ce soir*."

The notebook discovered on rue Froidevaux and kept at ICP. This precious work document, which allowed the Capa studio to organize the archive and to prepare orders, was made by Csiki Weisz, then in charge of the studio's darkroom. Legend has it that this page of contact sheets made in a Hankow hospital in 1938 shows Madame Chiang Kai-shek (photos 17 and 18) helping doctors treat the wounded.

Zhou Enlai—future prime minister of China, from 1949 to 1976—standing in front of the portrait of Karl Marx at the general headquarters of the Chinese Communist Party's Central Committee in Hankow, photographed by Robert Capa in July 1938. At the time, Zhou Enlai was Mao's representative with Chiang Kai-shek.

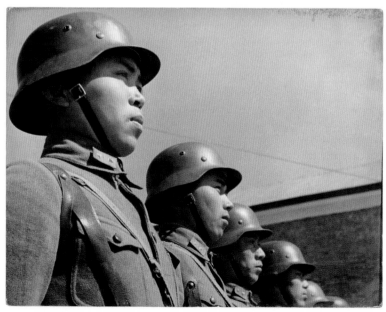

Very young Chinese soldiers of the Kuomintang's military forces in March 1938 in Hankow, before their departure for the front. In June 1938, one of these young soldiers would make the cover of *Life* under the title "A Defender of China."

This photograph, found at rue Froidevaux, is in an album of the Pix agency of New York, on page 9, contact number 7.

Robert Capa had visited the Pix agency on his first trip to the United States in September 1937. It had been founded by great German photographers in exile—Alfred Eisenstaedt, George Karger, Hans Knopf—and their former editor in chief at Dephot, Léon Daniel. A close collaborator with Simon Guttmann, Léon's brother Henri Daniel had been one of Capa's agents in Paris since 1935. Everyone at Pix knew Capa. He arranged for his brother, Cornell, to be hired in the agency's darkroom. He took Léon Daniel with him to *Life*'s offices in the Chrysler Building as his English

interpreter to negotiate his contract. Capa had decided to break his agreement with Alliance Photos in Paris, which distributed his work in the United States through the Black Star agency. Pix would now be his only distributor.

In Hankow, which had temporarily become the new capital of China since the Rape of Nanking by the Japanese in December 1937 (which historians estimate resulted in ninety thousand to three hundred thousand casualties), Joris Ivens's film crew was under the total control of the Nationalists. Madame Chiang Kai-shek had

Robert Capa landed in Hong Kong to join Joris Ivens on February 16, 1938, after twenty-six days at sea. The shoot began along the Pearl River, in the direction of Canton. This photograph, found at rue Froidevaux, shows a Kuomintang recruitment office. The number of shadows on the walls is probably due to special lighting, which indicates this may have been one of the first sequences shot for the film *The 400 Million*. Five photographs of this military office in the prefecture of Guangzhou (Canton) make up the first page of the famous notebook (see page 173). This photo is number 5.

Robert Capa Paris, den 24. November 1937.
 37, rue Froidevaux

Lieber Koester,

ich habe ziemlich lange geschwiegen, aber es war ein bischen
kompliziert, meine Geschaefte hier zu ordnen. Inzwischen habe
ich alles erledigt und zwar genau so, wie wir es uns vorge-
stellt hatten.

Wir haben das Bureau hier organisiert und zwar werden wir die
gesamte Produktion von allen spanischen Photographen zu vertrei-
ben haben. Die Produktion von Chim, Cartier und mir wird na-
tuerlich auch hier zentralisiert und wir werden natuerlich
auch alle interessanten Sachen aus der CE-SOIR-Tageszeitungs-
Produktion verschicken.

Ich fahre wahrscheinlich in einer Woche nach Spanien und nach
meiner letzten Verabredung mit Ivens eventuell am 26. Dezember
nach China.

Die ersten Photos aus dieser Produktion und einen ganz ausfuehr-
lichen Brief wirst Du ungefaehr in 14 Tagen bekommen.

Ich hoffe, dass dort alles in Ordnung ist. Gruess Pix von mir.

 Herzlichst

 Dein

 Capa

OPPOSITE: A letter written in German by Robert Capa, from 37, rue Froidevaux and addressed to Peter Koester of the Pix agency in New York. It is dated November 24, 1937, and is now in ICP's archives. Before his departure for China, Capa offered his "studio's" services as a "photographers' cooperative," giving a hint of what Magnum would become ten years later. He explained that he was "syndicating" his work and that of Chim and Cartier-Bresson for coverage of the Spanish civil war. "We have organized the office here in order to distribute the entire production of all the photographers in Spain as quickly as possible."
RIGHT: A parade for the thirteenth anniversary of the death of president Sun Yat-sen, founder of the Republic of China in 1912 and of the Kuomintang, in Hankow on March 12, 1938. On this print found at rue Froidevaux, a young boy holds up a flag bearing the word IMMORTAL!

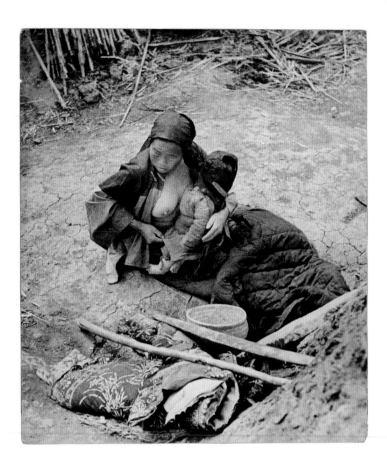

Refugees from the Battle of
Taierchwang, April 1938. This print
found at rue Froidevaux does not
seem to have been published in
the press. This "Chinese Pietà"
effectively illustrates Capa's
desire to bear witness to the
suffering of civilian populations
during wartime no matter
where he was.

grasped how useful the film could be for
her. Though the Communists and Nation-
alists had signed a military alliance against
Japan, Madame Chiang Kai-shek spied on
the shoot and ensured that the Communist
forces, Mao's famous Eighth Route Army,
never appeared in the film. Thus, while
waiting to travel to the front lines, Capa had
to make do with photographing the civilian
population, the military parades of young
Nationalist soldiers and the Kuomintang's
general staff. Meanwhile, back in Paris,
Gerda Taro's friend Ruth Cerf was working
at rue Froidevaux, preparing and typing
French captions based on the German text
Capa wrote in China.

During the eight months he spent in
China, the photographer wrote assiduously
to Koester. The two men had met in Berlin,
where Koester served as financial director
at the Dephot agency. Born in Budapest like

Capa, Koester was a discreet Communist
activist. His real name was László Fekete, but
he often changed names (he was also known
under the pseudonym Ladislaus Glück). He
died suddenly of tuberculosis in New York
in July 1938. On April 17, 1938, Capa wrote
him: "Overall I'm the 'poor relative' on this
expedition... They are very nice, but they
consider the film to be their personal busi-
ness (and are sure to let me know that); for
them the photos are totally secondary...
The photos of Taierchwang aren't bad, but
it really isn't easy to photograph with a big
camera on your back, four censors around,
and when on top of everything else you have
to help the camera operator."

From March 24 to April 7, 1938, a
battle raged between the Japanese and
Nationalist forces in Taierchwang, a
village on the Xuzhou front in northeast
China. For the first time, the Nationalist
forces were victorious, but the village was
totally destroyed by the Japanese. Capa
arrived immediately after the battle and
took striking photos that would be seen
around the world. *Life* called the village
the "Chinese Verdun." Back in Hankow,
he photographed the first Japanese aerial
attack on the Nationalist capital. As in
Madrid, Capa photographed civilians,
looking up toward the danger from above.
He also showed the devastating effects on
millions of farmers of the destruction of
the Yellow River dikes, which the National-
ists had decreed to slow the progress of
the Japanese infantry. In 1938, with Tokyo
deciding to form an Axis with Rome and
Berlin, it was becoming clear that Hankow
was the next battle for freedom after Spain.
In Paris, *Regards* titled a September 1, 1938,

photo story by Capa, "Hankow Will Be China's Madrid."

After filming a bombing scene in Canton in mid-August, Ivens and Fernhout, both eager to edit their film, left China. Finally liberated from this "cinematic expedition," which, as he wrote, "prevented him from taking photos," Capa decided to stay on. He would later say that his stay in China was more beneficial to his English than to his handling of a camera, through the time he spent with British and American journalists and military personnel. He also trained six young Chinese photographers, creating the "Capa gang." In another letter to Koester, he spoke of his projects: "I'd like us to start a kind of organization, which would certainly not be an agency. The Paris workshop is my personal headquarters... Currently all I can do is teach a few young people how to do good work."

Capa wanted to wait for the fall of Hankow, but exhausted by the climate and suffering from dysentery, he decided to fly back to Paris on September 22. The city fell to the Japanese on October 25. In one of his last letters to Koester, Capa wrote, "I am slowly becoming increasingly convinced that I am a vulture... The war correspondent's greatest wish is to be unemployed."⊕

The photographs from Robert Capa's time in China (see pages 172–181) are from Bernard Matussière's collection. Matussière discovered them in the attic of 37, rue Froidevaux, with the famous notebook, in which the photographer listed most of his work in China over dozens of contact sheets. This precious document is now in ICP's archives.

ABOVE: Robert Capa with Chinese children dressed as pioneers. This small-format photo was found at rue Froidevaux. Its back bears a mysterious inscription: "For Pierre, honorary Chinese man..." The handwriting is not Capa's, and the history of this print is unknown. But being a record of the photographer's smile and easy rapport with children ensures that it remains interesting.

BELOW: Walking shoes, multipocket jacket, reporter's bag, Contax 24 × 36 in hand: This is probably the picture that most contributed to creating the legend of Robert Capa as the inventor and father of modern photojournalism. The photographer is unknown, and to our knowledge this photo was not published at the time it was taken. On the turret of a Japanese tank captured at the Battle of Taierchwang, Capa sits near Joris Ivens and John Fernhout (both off frame in this shot). This tank appears in the film *The 400 Million*.

Bien que le photographe ait, pour un instant, distrait et fait sourire cette foule de Hankéou, elle n'en a pas moins entendu l'appel pour la défense que lui adresse ce jeune ouvrier. Chacun verse son obole : qu'elle soit de 5 cents ou de 5.000 dollars, 1.200.00 dollars vont être collectés pendant les manifestations pour la défense du pays.

180

HANKEOU SERA LE MADRID DE L

REPORTAGE de Robert CAPA

L A Chine rivalise d'héroïsme avec l'Espagne pour défendre son territoire et son indépendance. Ce que Madrid a fait, Hankéou, devenue capitale, le fera.

A l'occasion du premier anniversaire de la guerre, le général Chen Cheng, commandant militaire d'Hankéou, a appelé la ville à la résistance.

En quatre jours, 1.500.000 dollars ont été réunis pour la défense.

Chacun donne pour la défense selon ses moyens, de 5 cents à 5.000 dollars.

Trois minutes de silence pour les morts.

Un chanteur populaire qui vient de réciter la « Ballade de Shanghai » donne, pour la défense, l'argent, produit de sa collecte et qu'il vient de recueillir dans son vieux chapeau.

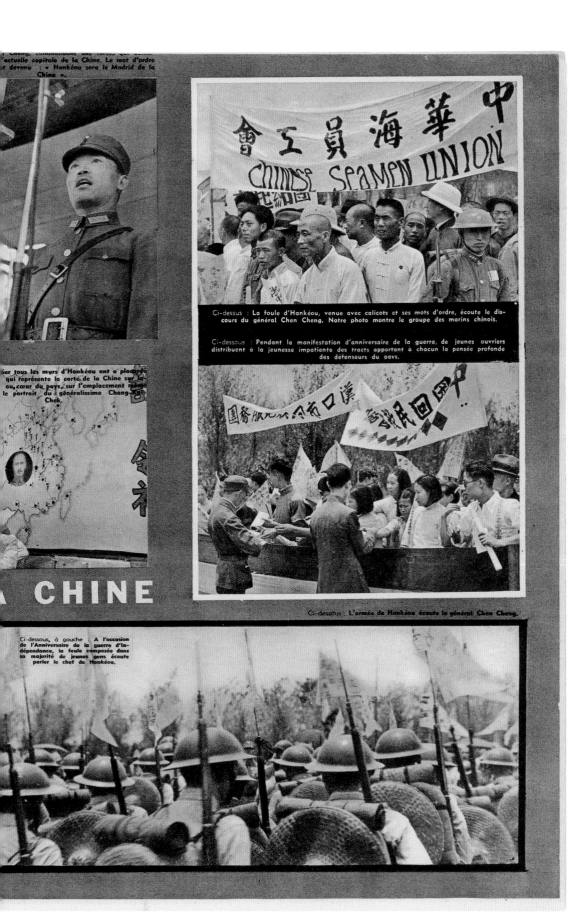

Cheng, commandant des forces qui actuelle capitale de la Chine. Le mot d'ordre t devenu : « Hankéou sera le Madrid de la Chine ».

Chinese Seamen Union

Ci-dessus : La foule d'Hankéou, venue avec calicots et ses mots d'ordre, écoute le discours du général Chen Cheng. Notre photo montre le groupe des marins chinois.

Ci-dessous : Pendant la manifestation d'anniversaire de la guerre, de jeunes ouvriers distribuent à la jeunesse impatiente des tracts apportant à chacun la pensée profonde des défenseurs du pays.

sur tous les murs d'Hankéou ont a placardé qui représente la carte de la Chine sur au, cœur du pays, sur l'emplacement le portrait du généralissime Chang-Kaï-Chek.

A CHINE

Ci-dessous : L'armée de Hankéou écoute le général Chen Cheng.

Ci-dessous, à gauche : A l'occasion de l'Anniversaire de la guerre d'Indépendance, la foule composée dans sa majorité de jeunes gens écoute parler le chef de Hankéou.

At the same time as *Life* in the United States, the French magazine *Regards* published dozens of pages of photographs taken by Robert Capa while he was in China. *Regards*, which had done so much to make Capa famous, treated him like a star. The June 9, 1938, issue read, "We are happy to be able to share with our readers the unique documents we are receiving from the intrepid photographer Robert Capa, who has made a sensational photo story we will soon publish."

In November, while Robert Capa was already back in Spain, Hankow, China's new capital since the fall of Nanking, was besieged and bombed by Japanese forces. *Regards* ran the headline "Hankow Will Be China's Madrid" and explained, "China is as heroic as Spain in defending its territory and independence ... The military commander of Hankow has called for the city to resist." But unlike Madrid, which never surrendered, Hankow fell to the Japanese forces on October 25, 1938.

181

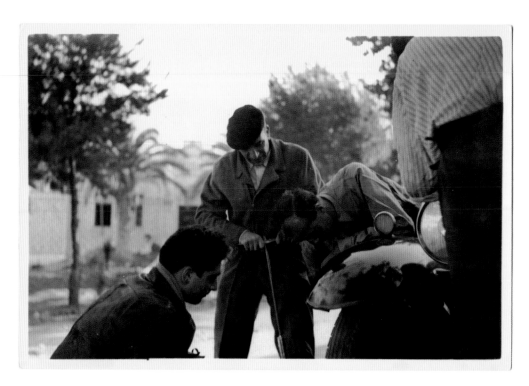

On the Way to the Ebro Front

After his return from China, Capa rushed to Spain, where the battle of Ebro was taking place. During the Spanish civil war, journalists traveled in groups in cars provided by the Republican government's press services. The same was true on the Francoist side. As is always the case in wartime, reporters' work was closely monitored and subject to authorization. Texts and photos had to be approved by the censor.

Robert Capa regularly traveled with Henry Buckley, a British journalist for *The Daily Telegraph*. Buckley also took photos. Though he was merely an amateur, his photos are a moving record of a journalist's work. Among other things, they show Robert Capa watching a tire be repaired in a Catalan village with *New York Times* reporter Herbert Matthews. It was October 25, 1938, and the two journalists were headed to the farewell ceremony for the International Brigades near Tarragona. Joseph Kessel was riding in the same vehicle.

In the other photo, Capa serves what appears to be sparkling wine, probably Spanish, to a group of reporters, including Ernest Hemingway (standing) and, seated left to right, Hans Kahle, commander of the International Brigades; Herbert Matthews; and Vincent Sheean of the *New York Herald Tribune*. The journalists have traveled from Barcelona on the way to the Ebro front. They have stopped for lunch with Henry Buckley, who is coming from Sitges. They are preparing to make an acrobatic river crossing to meet General Lister. The date is November 5, 1938; the Battle of the Ebro is nearly over. It was to be the last major Republican offensive. Despite auspicious beginnings, it turned into a fiasco.⊕

On January 15, 1939, Capa was
still in Catalonia as the Francoist
troops gained ground. He made
a dramatic photo story on the
retreat of the civilian population
from Tarragona to Barcelona
under the merciless machine-gun
fire of the Italian air force.

184

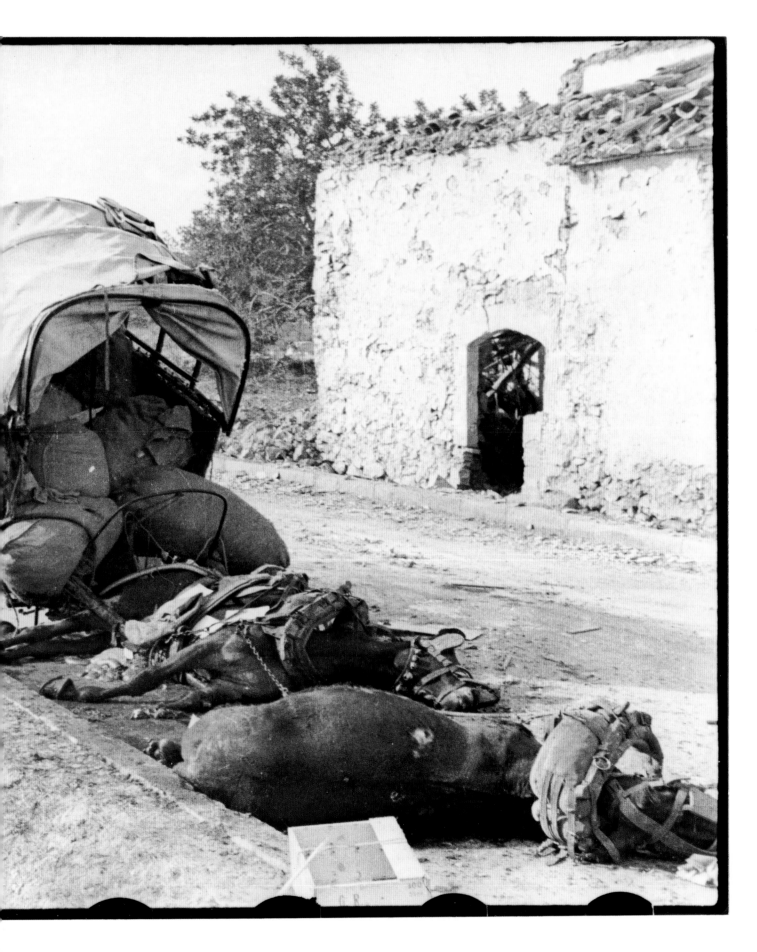

Photographers and Brigadiers

His whole life long, Capa would remain nostalgic for the Spanish civil war, which he covered from beginning to end. His brother, Cornell, wrote that he was part of an "International Brigade of Photographers" committed to the Spanish Republic. During the battles from Madrid to the Ebro, Capa rubbed shoulders with French, German, and American volunteers. Some became friends, like Milton Wolff, the commander of the Abraham Lincoln Brigade; Alfred Kantorowicz; and Gustav Regler.

In October 1938, several ceremonies were held in Catalonia to bid the International Brigades good-bye. This photograph was taken on October 15, 1938. Kneeling on the left, Robert Capa watches one of the ceremonies and takes pictures. Chim can be recognized above one of the banners hanging from the gallery. The location of the event was kept secret until the last moment to avoid bombing. The journalists and photographers traveled by bus from Barcelona to Espluga de Francolí, a little village near Montblanc in the province of Tarragona.

ABOVE: Spanish prime minister
Juan Negrín speaks to the
international volunteers
photographed by Juan Guzman.
OPPOSITE: An issue of *L'humanité*
featuring Capa's photos of
the farewell ceremony for the
brigadiers, uncredited.

In the photo above, we can glimpse
Capa's face behind the row of photog-
raphers. During this same good-bye
ceremony, reporters photographed
Spanish prime minister Juan Negrín deliv-
ering a farewell speech to the volunteers.
The same day, Capa took one of the most
famous pictures of the Spanish civil war,
a head-on portrait of an Italian brigadier
with his fist raised. Many journalists
and photographers were present: Ernest
Hemingway, Joseph Kessel, and Jean
Moral, among others. The brigadiers' final
parade was met in Barcelona with armfuls
of flowers; Capa and Chim immortalized
the scene.⊕

Les combattants de la liberté ont changé de FRONT

Un aspect de leur défilé inoubliable à travers Paris. On reconnaît, vivement acclamé par la foule, de gauche à droite : Marcel Sagnier, commandant de la brigade la « Marseillaise » ; André Marty ; Yves Tanguy, commissaire politique

Sous une pluie de fleurs, les volontaires de la liberté défilèrent dans Barcelone. L'Espagne saluait ceux qui l'avaient aidée à résister...

APRÈS 24 mois d'une lutte terrible, où souvent — la non-intervention odieuse jouant — ce furent les poitrines nues qui durent arrêter les engins d'acier du fascisme bestial, ils ont quitté — ou s'apprêtent à le faire — la terre espagnole, après les adieux poignants que leur a faits le peuple d'Espagne, de Madrid à Valence, de Barcelone à Port-Bou.

Pourra-t-on dire jamais ce que furent, ce que firent les volontaires internationaux, ces hommes d'épopée, venus de 53 pays — 28 % d'entre eux étant arrivés de France — et qui sont symbolisés par la grande figure d'André Marty, qui fut au milieu d'eux depuis les jours héroïques de novembre 1936 à Madrid jusqu'à ceux, témoignages de la vitalité de la jeune armée espagnole, de juillet-septembre 1938 sur l'Ebre ?

Ils sont partis, sûrs de la victoire finale de l'armée populaire aux bataillons ardents, aux chefs jeunes et capables, aux commissaires fiers de leur rôle grandiose et périlleux, ils sont partis confiants dans le triomphe de l'héroïque peuple espagnol, uni derrière son gouvernement de Front populaire et son chef, le docteur Negrin.

Le peuple de Paris les a vu défiler, l'autre dimanche, glorieux et simples et a fait l'ardent accueil qui convenait à ces vaillants fils de France qui ne quittent le combat dans les tranchées et les armes que pour entreprendre une autre forme de lutte. Mais c'est toujours le même ennemi ! Sans prendre de repos, sans connaître de trêve, ils prennent tout de suite place dans les rangs des millions de syndiqués, d'antifascistes, mettant toute l'expérience qu'ils ont si héroïquement acquise — au prix de tant de douloureux sacrifices ! — au service de la grande lutte humaine pour la liberté et la paix.

Gloire aux combattants de la Liberté !

Dimanche 13 novembre... le Paris des travailleurs est venu en foule immense accueillir ses héros

(De droite à gauche) Marcel Gitton, Maurice Thorez, Marcel Cachin, Jacques Duclos, accueillant André Marty, chef aimé des Brigades Internationales

Deux volontaires de la liberté parmi tant d'autres. Ils ont versé leur sang, ils ont souffert, ils pensent à leurs frères d'armes qui sont tombés, mais ils pensent aussi à la grandeur de leur œuvre ; ils ont barré la route aux troupes d'invasion du fascisme

Leaving France
at Any Cost

Robert Capa's exit visa was dated
September 19, 1939, and signed
by Chilean consul Pablo Neruda.
The document, which is kept at
ICP in New York, provides the
following information regarding
its holder: black hair, single, no
religious affiliation, photographer,
Hungarian, last residence known:
37, rue Froidevaux in Paris, object
of the trip: commercial.

After the end of the Spanish civil war in April 1939, Capa continued shooting photo stories for the press. In July, he followed the Tour de France for the weekly *Match*, a high-quality illustrated magazine that had already published his photos of the Battle of Rio Segre in Spain in 1938 as well as those of the Spaniards' retreat to France in early 1939. He also continued to work for *Regards*. Chim left France in the spring of 1939 aboard the *Sinaïa*, headed for Veracruz. The ship carried one thousand Spanish refugees to Mexico, which had agreed to receive them. For Chim, who was covering the journey, it was the road to exile.

In September 1939, France and England declared war on Hitler's Germany. Like the thousands of refugees from Germany and Central Europe, Capa was caught in a trap. He had everything to fear from the Nazis (from whom he had escaped in 1933), but also from the French, who imprisoned "undesirable foreigners" in the same camps that had held the retreating Spaniards. But he needed a visa from a host country in order to leave France and join his family in New York. Meanwhile, the staff of *Life* magazine worried about his fate. In a letter dated January 31, 1939, Capa's employers wrote him: "We were very worried about you here when Franco's troops were approaching Barcelona and during the taking of the city. It came as a great relief when Mme Chambers wired us 'Capa safe in Perpignan.' You could have lost your life, as I feared that after the photographic work you carried out in Loyalist Spain, you would not have been well treated by the Loyalists' enemies if you had fallen into their hands. *Life* was very satisfied with your photos of Spain and China. I hope your modesty won't suffer if I tell you that today you are the number one war photographer."

Capa didn't have any attainable options for getting out. On September 6, 1939, he made himself available to the French military authorities as a photographer. Pierre Lazareff of *Paris-soir* and *Match* tried to get him a visa, in vain. Finally, the Chilean consul, Pablo Neruda, provided him with the document he desperately needed, and his employers with *The March of Time* found him a place on a ship. Neruda was heavily involved in supporting the Spanish Republicans; he succeeded in getting thousands of them out of France. In 1937 he also published a collection of poems in Chile entitled *Spain in My Heart*, illustrated with photomontages, including at least one photo by Capa. Capa's exit visa, dated September 19, 1939, would allow him to embark on a ship for the United States. He left Csiki Weisz and his archives in rue Froidevaux behind.⊕

Cédula Consular Visación Nº 1212/2755 Fecha 19 de septimbre, 1939.

Consulado General de Chile en Francia, París

Nombre y apellido paterno y materno André Friedmann

Hijo de Desiderio y de Julia Profesión Fotógrafo

Lugar y fecha de nacimiento Budapest- 22-Octubre- 913 Nacionalidad húngaro

Origen húngaro Estado Civil soltero Nombre del Cónyuge

Nombre y edad de los hijos

Ultimo domicilio Rue París. Froidevaux 37

Religión no tiene Lee y escribe sí

Estatura 1m62 Color cutis moreno

Color cabello negro

Señas particulares x

Impresión dígito pulgar erecha

VISACION "EN VIAJE COMERCIAL"
Válida por seis meses

Nombre y domicilio de dos personas : 1º que acrediten sus antecedentes ante el Consulado

2º de su conocimiento en Chile

Fecha de salida _____ Lugar de salida _____ Vapor, Ferrocarril, Avión.

Objeto del viaje viaje comercial a) En visita por _____ meses a la ciudad de _____

con pasaje pagado, de ida y vuelta. b) En viaje comercial por _____ meses. c) Sujeta a contrato

que lo cumplirá en la ciudad de _____ d) En Tránsito a _____

con estada máxima de _____ días en Chile.

Certificado con indicación de procedencias y fecha :

Judicial

De moralidad

De Médico y vacuna Dr Urrutia. 19 de Septiembre, 939. París

Observaciones Antecedentes dados por el Enc. de Neg. Sr. Manuel Arellano y

Cónsul Sr. Neruda

André Friedmann

Firma del interesado

Arnaldo

Firma del Cónsul

BOB

In April 1941, Bob Capa embarks
from New York on a Liberty ship
to cross the Atlantic in a military
convoy and rejoin the theater of
military operations in Europe. The
cargo ship, owned by the British
company Cunard, is transporting
arms to Great Britain and twelve
passengers who traveled "at their
risk and peril," including Capa.
Here, the lookout communicates
in visual Morse code with the
warship that provides the
convoy's escort, while the battle
of the Atlantic is raging. This is
one of the first color photographs
taken by Capa during World War II.

195

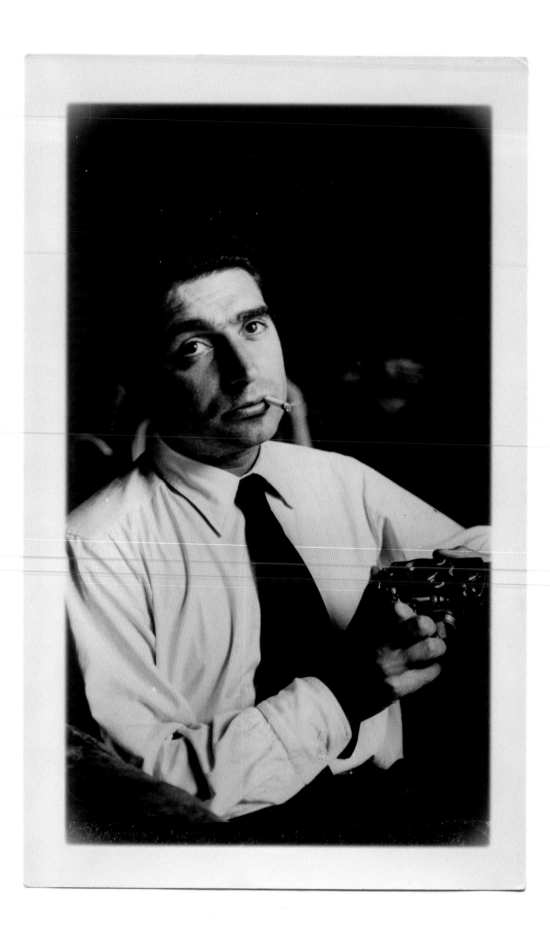

The American

He was the most Parisian of Americans and, of course, the most American of Parisians. Throughout his career as Robert Capa, he had only two home bases: Paris and New York. Paris to live and make his art, New York for his family and business. It was in Spain that he made lasting ties with American journalists: Ernest Hemingway, but also Jay Allen, Herbert Matthews, and many others. In 1937, he "Americanized" his career by signing a contract with *Life* magazine and making a distribution deal with the Pix Publishing agency. It was also in New York that Capa set up his first book deal, with a perfectly American title: *Death in the Making*. In June 1937, his mother, Julia, and his brother, Cornell, permanently settled in New York, first with an aunt in the Bronx, then on West Ninety-fourth Street. Yet Capa kept his phone number in the Paris phone book: "CAPA Robert, Danton 75 21." He was an American war correspondent with a map of Paris in his mind.

He probably came to be known as "Bob" deep in the bars and cafés of liberated Paris, at a time when anything American set the tone. *Match* photographer Michel Descamps wrote, "Okay, Bob," when he recounted his last encounter with Capa in Indochina. Even his old Communist buddy, *L'humanité* journalist Georges Soria, with whom he covered the Spanish civil war starting in 1936, referred to him as Bob in his letters to Cornell Capa. "Bob had a very peculiar manner of showing he was amused," wrote American director Noël Howard in his memoirs. "With his eyes half-open, his mouth stretching from one ear to the other and gripping a cigarette, he chuckled softly in little jolts. You kept waiting for him to burst out laughing, but he never did. But you could feel an intense inner joy behind his discreet purr."

In 1947, Capa became independent by registering Magnum with the New York Chamber of Commerce. The company only had a registered capital of two thousand eight hundred dollars. In the spring of that year, Capa launched his famous agency—whose so-French name was inspired by a large (one-and-a-half-liter) bottle of champagne—at MoMA's restaurant on East Fifty-third Street with all his friends: David Seymour (Chim); Henri Cartier-Bresson, of course; but also the Brit George Rodger, whom he had met in Italy during the war; William "Bill" Vandivert of *Life*; Vandivert's wife, Rita, who would be appointed head of the agency; and finally Maria Eisner, the founder of Alliance Photo, who took over as the head of Magnum's Paris office. Paris–New York, New York–Paris, forever.

This portrait of Bob Capa with his Rolleiflex is dated March 1948. It is published in *This Is Israel* (Boni and Gaer, New York) along with several other protagonists of the book, photographers Jerry Cooke and Tim Gidal, and authors I. F. Stone and Bartley C. Crum, in the preface. The author of this photo is unknown.

American soldiers in Tunisia, on a
Sherman M4 of the Second Army
Corps of General Patton, posing
for Capa after the victory of the
battle of El Guettar in March 1943.
They hold a Nazi flag, recovered
from a tank of the Tenth Panzer
Division of the Afrika Korps.

199

Waiting for D-day in London

It was in a tiny room crammed with folders in the offices of the Magnum agency in New York that in 2002 a researcher opened a drawer and chanced upon old photo boxes bearing the inscriptions, "Life at front, Pix Publishing, Kodachrome" and "From Robert Capa to *Collier's*." The boxes contained color photographs from World War II. Before the war, Capa had crossed the Atlantic on ocean liners: He first embarked in Le Havre on the ocean liner *Lafayette* in August 1937; he headed into exile aboard the *Manhattan* in October 1939. But late in April 1941, it was a warship that he boarded in New York: a Norwegian cargo ship chartered by the Cunard Steamship Company to transport planes and weapons to England. The ship was one of forty-four in a navy convoy. It reached Liverpool without incident. While color press photography had existed since 1938, it remained exceptional at the time. Capa—who had already experimented with color in China—took this photo of the lookout communicating in Morse code with one of his Contax IIs, which he had loaded with Kodachrome film. Two of these color photos were published in *The Saturday Evening Post*, while others appeared in *The Illustrated London News*.

In the United States, Capa felt frustrated being on the wrong side of the ocean. He was in a hurry to get to the theater of operations in Europe. But to do so, he needed a military accreditation. This was no easy task: While he had recently obtained his permanent American resident card, Capa remained a native of Hungary, a nation allied with Germany. He also needed an assignment from a newspaper, and *Life* had refused to send him to Great Britain because it considered the staff in the London office adequate to cover the unfolding events. Thanks to his friends—Martha Gellhorn, Léon Daniel of the Pix agency, and Vincent Sheean, who was preparing a book on the Blitz entitled *The Battle of Waterloo Road* with his wife, Diana Forbes-Robertson—Capa first succeeded in crossing the Atlantic back to Europe in 1941, then a second time in 1942, aboard an arms convoy again. On his second trip, Capa traveled from London to North Africa for the American magazine *Collier's Weekly* and the British newspaper *The Illustrated London News*. From March to May 1943, he covered General Patton's US II Corps' Tunisian campaign, including its victory over the Afrika Korps at the Battle of El Guettar. On March 23, 1943, in the south of Tunisia, Capa witnessed the first American victory over the Third Reich. He photographed GIs brandishing their war booty—a Nazi flag—in front of a Sherman tank. But the photos taken in El Guettar reached *Collier's* New York office so late—three months after the victory—that Capa lost his contract with the magazine.

He returned to *Life*, which hired him to cover the Sicilian and Italian campaigns from July 1943 to February 1944. These long months in the ranks of the United States Army gave Capa an opportunity to befriend general Theodore Roosevelt Jr., the son of the former president, and General Ridgway, US Army commander in Naples. Both men would later help him obtain American citizenship.

Back in London, the photographer was welcomed as a hero by his friends at *Life*, which had set up its offices in the heart of Soho, at 4 Dean Street. A party

was held in his honor on the evening of his return. In the photo above, taken by "Crocky"—Elizabeth Crockett Reeve, deputy to *Life*'s bureau chief—John Morris holds the flash while Capa rests his head on the paperweight on the desk, near a bottle of whiskey, his favorite drink. Crocky's husband, Alan Reeve, is sitting next to him. Time-Life photographer Hans Wild holds his arm against the lamp.

With D-day drawing near, *Life*'s war correspondents gathered in London to prepare to cover Overlord, the biggest military operation of all time. As John

Dean Street, London, in the offices of Time-Life, February 1944. After seven months of covering the war in Sicily and in Italy, Bob Capa returns to England, where his colleagues celebrate his return. In the forefront, at left, seated: Capa, tired, his head resting on a postal scale sitting on the desk. Next to him, John Morris, his boss.

RIGHT: In London, in the park at Grosvenor Square, close to the US Embassy, *Life* magazine photographers and their boss pose on the eve of D-day. From top to bottom and left to right: Bob Landry, George Rodger, Frank Scherschel, Robert Capa, Ralph Morse, John Morris, and David Scherman. Capa, at Omaha, and Landry, in the area of Utah Beach, were the only ones to land on June 6, but all Landry's photos disappeared during their travels to London.

OPPOSITE: Pinky—Elaine Justin—Capa's London girlfriend, opens the gown of patient Ernest Hemingway, who had injured his head during a drunken evening. Royal London Hospital, May 1944.

Morris later explained, a group photo was taken in Grosvenor Square, home to the US embassy, in May 1944. All the buildings around the square were occupied by the US Army. Capa—second row, right—is not in uniform like the others: He wears a Burberry raincoat and the legendary commando hat he would wear all the way to Berlin. Standing with him holding their own cameras are (top to bottom, left to right) Bob Landry, George Rodger, Frank Scherschel, Ralph Morse, and David Scherman, all gathered around their twenty-eight-year-old boss. Capa was the only one among them who would succeed in landing on Omaha Beach.

During the lead-up to D-day—the date of which was kept secret—the mood was devil-may-care. People took advantage of every moment as if it were their last. Capa cut loose at the Hotel Dorchester with his girlfriend, "Pinky"—Elaine Justin, whom he had met in February 1943. She

was married to John Justin, an Anglo-Argentine actor and pilot with the Royal Air Force. Even after the Justins' divorce, Capa remained committed to his freedom and did not marry the beautiful English-woman. In April, he invited his friend Hemingway to a last party. A drunk chauffeur drove Hemingway back to his hotel, hit a water tower, and sent the writer flying through the windshield. The next day Capa visited "Papa" at the Royal London Hospital with Pinky and took his picture. The accident did not prevent Hemingway from participating in the D-day landings from the bridge of a warship. But, contrary to legend, it was only on July 18—and not on D-day—that he landed in Normandy, on Utah Beach, with General Patton.⊕

With the
First Wave

Soldiers sheltered behind a Czech hedgehog. One of eleven images taken by Capa during the landing on Omaha Beach, the back of this photo indicates that *Life* photographers also worked for the United States Information Service.

Americans call them the "Magnificent Eleven": eleven unique photographs taken by Robert Capa on bloody Omaha Beach on June 6, 1944, the eleven negatives saved from the four thirty-six-exposure rolls that Capa sent to London by boat from Portsmouth—which were destroyed during developing. The photos were first published in *Life* on June 19, 1944. Today, only eight of the eleven original negatives remain, and they are kept at ICP. The best-known shot in the series, one of the most famous photos of the twentieth century,

is among the three images to have been lost: *The Face in the Surf*. It is the only one of the eleven photos to feature a close-up of a soldier. In 2007, on the occasion of the exhibition Robert Capa at Work, it was established that the subject of the photo was not Edward Reagan, as had long been believed, but Private First Class Huston "Hu" S. Riley. Riley, who now lives on an island near Seattle, still wonders what that "crazy photographer" was doing in such a hellish place.

The darkroom accident, which led to the loss of so many unseen photos of the D-day landings, has become an infamous

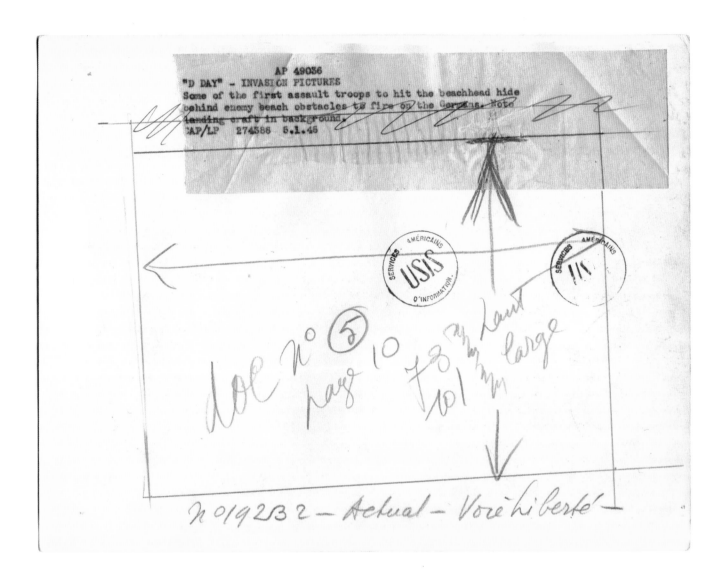

AP 49056
"D DAY" - INVASION PICTURES
Some of the first assault troops to hit the beachhead hide
behind enemy beach obstacles to fire on the Germans. Note
landing craft in background.
CAP/LP 274586 6.1.45

part of the history of photography. John Morris, then photo editor of *Life*'s British office, has often recounted the incident, reliving the heartrending experience as he goes through the painful details. He has assumed full responsibility, but was actually blameless. It was Dennis Banks, a young lab worker under pressure—and not the eighteen-year-old tea boy Larry Burrows, as has often been written—who closed the film dryer's door, leaving the electric heater in the cupboard to melt the film. The first of the eleven photographs John Morris found on the only usable roll is the one showing "Czech hedgehogs,"

antitank obstacles behind which American soldiers tried to shield themselves from German machine-gun fire. Capa is clearly kneeling in front of the obstacles, a little further up the beach. Using his Contax, he turns back and presses the shutter release. It is photo number 35 on the roll. The landing craft can be seen out at sea, their pilots having just turned back. It is early morning. The sea is rough. It is 6:30 AM. This is the first wave. The most poorly sheltered soldier, left, is one of the engineers (identifiable by the arch of a white circle on his helmet). Soldiers of the 16th Infantry of the 1st Division, the famous

The most famous of the "Magnificent Eleven," *The Face in the Surf*. The soldier was identified in 2007 as Private First Class Huston Riley.

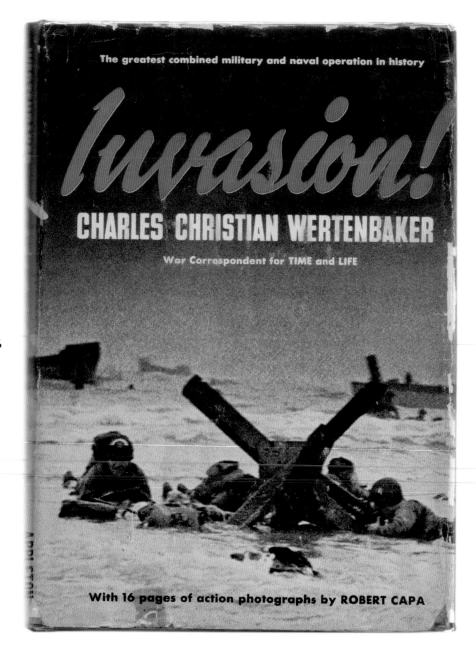

The greatest combined military and naval operation in history

Invasion!

CHARLES CHRISTIAN WERTENBAKER

War Correspondent for TIME and LIFE

With 16 pages of action photographs by ROBERT CAPA

"Big Red One," hide behind the steel cross-piece. They are all members of E Company, which Capa had previously encountered in Tunisia and Sicily.

Life photographers, who had a front row seat of the war on the front lines, gave their photos to the AP, UPI, and Reuters agencies pool, and also to the American government's propaganda services. Having been subject to military censorship by the Office of Censorship, this collector's print bears the stamp of the United States Information Service (USIS) press office on its back. At the time, the USIS was part of the Office of War Information, a special department of the administration created in 1942 and directly attached to the President of the United States. The US Army's photographic services and the Signal Corps' specialized units provided free (but controlled) images to the press and film industries in allied countries.

Capa wrote about the difference between a soldier and a journalist in wartime in his memoirs: "I would say that the war correspondent gets more drinks, more girls, better pay, and greater freedom than the soldier, but that at this stage of

Vierville-sur-Mer, Omaha Beach sector, June 12, 1944, during the religious ceremony held for the inauguration of the first provisional American military cemetery. The military chaplain is Reverend William Dempsey of New York. In this still from a newsreel, Robert Capa is clearly identifiable standing at right reloading his Contax. This rare document was discovered in the ECPAD archive by a crew working for director Patrick Jeudy, on the occasion of the release of his film *Robert Capa: The Man Who Believed His Own Legend* in 2004.

The inscription on the back of the photo reads: "Somewhere in Normandy, August 1944, photo John Morris." These German officers surrendering to Americans could have been photographed in la Manche. Given the date, it is also likely that the scene took place in Ille-et-Vilaine, at La Ballue, near Antrain, on the road between Mont-Saint-Michel and Rennes. Indeed, according to his biographer, Richard Whelan, on August 8, 1944, Capa photographed a group of Germans here who surrendered without putting up a fight after a single announcement from a loudspeaker on an American military truck.

the game, having the freedom to choose his spot and being allowed to be a coward and not be executed for it is his torture. The war correspondent has his stake—his life—in his own hands, and he can put it on this horse or on that horse, or he can put it back in his pocket at the very last minute. I am a gambler. I decided to go in with E Company, in the first wave."

After his first, ill-fated delivery of film to England, Capa—whose friends believed he had been killed during the landings—returned to Omaha Beach on June 8. Here he photographed a religious ceremony for the inauguration of the American cemetery. There were four thousand casualties in

this sector alone, including more than one thousand dead. Later, France gave the land to the United States and the Colleville-sur-Mer Cemetery—the final resting place of 9,386 soldiers killed in the Battle of Normandy—became famous. A camera operator from the French Army Cinema Service was also present at the ceremony and photographed Capa reloading his camera.⊕

On the Front Lines in Normandy

During the three months of the Battle of Normandy, Capa worked for *Life* in the field with the brilliant writer Charles Christian Wertenbaker. Capa called him "Charlie," or "my boss." This great reporter was one of *Time*'s London bureau chiefs. He joined Capa in Bayeux, the first city in metropolitan France to be liberated. Wertenbaker had left London with the wild idea of being first to publish a book about the D-day landings. His dream came true in September 1944 with the New York publication of *Invasion!*, a 184-page volume featuring 16 photographic plates by Capa. The period covered extends from the D-day landings to the liberation of Paris on August 25, 1945. As Wertenbaker wrote, that day "at 9:40 and 20 seconds AM by my watch, we passed the Porte d'Orléans with the driver of our jeep, Private Hubert Strickland of Norfolk, Virginia." He and Capa were the first American war correspondents to enter the capital with Général Leclerc's Second Armored Division. "Sitting in a café in Bayeux on the evening of June 12," Wertenbaker wrote in *Invasion!*, "his accent thickened by the Calvados, Capa" told him the end of his adventures on June 6 on Omaha Beach: "I shoot for an hour and a half and then my film is all used up. I saw an LCI behind me with a lot of medics getting out and some getting killed as they got out. . . . Then I climbed aboard and started to change my film. I felt a slight shock and I was covered with feathers. I thought: 'What is this? Is somebody killing chickens?' Then I saw that the superstructure had been shot away and the feathers were the stuffing from the Kapok jackets of the men who were blown up. . . . Then things get slightly confused. I was, I think,

exhausted. An LCVP came for the wounded and I went with them."

A few weeks later in London, Capa learned the terrible news about the darkroom accident. His "best photos had been destroyed," he wrote to his mother. "The little that remains publishable is nothing next to the material that was ruined." As consolation, he was permanently hired by *Life* as a photographer, with an annual bonus of $9,000 (about $90,000 dollars today).

On June 8, Capa left the following note in the guest book of a Bayeux hotel, also signed by Charlie and the great Ernie Pyle, whom Capa had met on the front lines in Tunisia and Italy: "At the Lion d'Or, in this picturesque and comfortable city, I could take a hot bath and have a bed with clean sheets. Delicious cooking and good wine." Then Capa spent a few days at the Château de Vouilly, south of Isigny-sur-mer, where the first press center for American correspondents had been set up. The Signal

Robert Capa, holding a flask of whiskey and a cigarette, his Rolleiflex around his neck and his commando hat on his head, rests his hand on the shoulder of Olin Tomkins, the driver of Ernest Hemingway's jeep. The writer, who was then playing the "strategist" in the hedged farmland of Normandy, always had his binoculars. According to two veterans' accounts, this photograph was taken in the south of la Manche, in le Pont-Brocard in the district of Dangy, on July 30,1944, at the end of the Cobra operation which led to the Avranches breakthrough and opened Brittany to American troops.

Corps had installed "Belinograph" stations to transmit photographs to London, as well as powerful radio equipment with which correspondents could reach the United States. John Morris joined Capa there. In August 1944, somewhere in la Manche, which they explored together from Cherbourg to Mont-Saint-Michel, or in Brittany, near Rennes and Saint-Malo, during the liberation of those cities by American troops, Morris took a photo of Capa, crouching and facing away from the camera, as he photographed German officers surrendering. This photo has never previously been published. Ernest Hemingway landed on Utah Beach on July 18 with General Patton's 3rd Army and was reunited with his friend Capa during what was called "the Hedge War" in the hedged farmland of la Manche. They traveled together in a jeep provided to "Papa" and, with "Charlie" Wertenbaker, witnessed the Battle of Saint-Sauveur-le-Vicomte, in which parachutists of the 82nd American Airborne Division participated. The man on crutches in Capa's photos is Lieutenant-Colonel Benjamin Vandervoort (played by John Wayne in *The Longest Day*), one of the heroes who fractured an ankle landing by parachute on June 6. On the right, Robert Capa crouches along a wall in the ruins of Saint-Sauveur, reloading his camera. This photo was taken by an unidentified soldier of the Signal Photographic Company (SCP) a specialized section of the Signal Corps.⊕

213

Saint-Sauveur-le-Vicomte, June 16, 1944, with the 505th Parachute Regiment of the American 82nd Airborne Division. On the right, Robert Capa reloads his camera (Rolleiflex or Contax). Claude Demestre of the PhotosNormandie website was the first to identify him in early 2008. The print has a "Signal Corps – US Army" stamp.

Lunch Stop at Mont-Saint-Michel

On the road to Brittany over the weekend of August 6 and 7, 1944, Robert Capa and his friends—Charles Wertenbaker of *Time*, Charles Collingwood of CBS radio, A. J. Liebling of *The New Yorker* and John Morris—stopped at the just-liberated Mont-Saint-Michel. A sign on the pier says: "Forbidden to soldiers, save generals and war correspondents." The famous La Mère Poulard hotel-restaurant was open. A crew shooting newsreels for the American army joined the group—and not any old crew! This was the Signal Corps' Special Coverage Unit, headed by George Stevens, the Hollywood director who served as a major in the US Army. The same crew would shoot color film of the liberation of the Dachau concentration camp near Munich on April 29, 1945. This color still from the newsreel shows Capa in his war correspondent outfit, his Rollei-flex in his hands, and, for once, wearing the regulation officer's cap rather than his usual "commando hat." He wears the insignia for photographers accredited by the American army both on the hat and on his shoulder. Ernest Hemingway is also in the photo, having apparently made up with Capa at Mont-Saint-Michel. The two men had had a falling out a short time before, in Saint-Pois. The novelist had an accident while traveling in a sidecar. Capa jumped to photograph him in an unflattering position before helping him. Hemingway accused him of trying to get the "scoop" of his death.⊕

Paris, My City

On Friday, August 25, 1945, Robert Capa finally reached Paris. After the terrible Battle of Normandy, he did not want to miss this major event, which he would later describe in his book *Slightly Out of Focus*. Perched on a tank in Général Leclerc's Second Armored Division—a Sherman named *Teruel* and operated by a crew of Spanish fighters—Capa crossed the place Denfert-Rochereau in the fourteenth arrondissement. "I felt that this entry into Paris had been made especially for me. On a tank made by the Americans who had accepted me, riding with the Spanish Republicans with whom I had fought against fascism long years ago, I was returning to Paris—the beautiful city where I first learned to eat, drink, and love. The thousands of faces in the finder of my camera became more and more blurred; that finder was very, very wet. We drove through the *quartier* where I had lived for six years, passed my house by the Lion of Belfort. My concierge was waving a handkerchief and I was yelling to her from the rolling tank: '*C'est moi, c'est moi!*' "

Though Capa would later say it was the most beautiful day of his life, his memoirs embellish the episode. The *Teruel* actually entered Paris the previous evening. And it was not a tank, but a half-track that was part of the legendary Ninth Company headed by Captain Dronne. Dronne was the first to enter the capital: At ten PM on August 24, he was in front of the Hôtel de Ville.

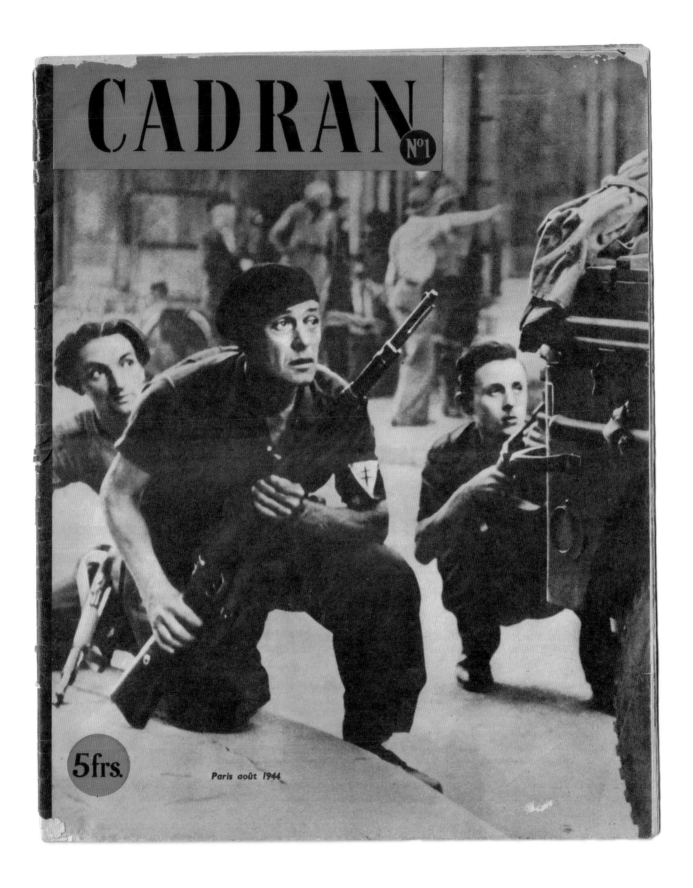

CADRAN

Nº1

5frs.

Paris août 1944

In his own way, Capa was paying tribute to his Spanish friends, the forgotten soldiers of the liberation army. Though he does not mention her name, he also refers to Gerda Taro and their love affair. As for his concierge, there were indeed concierge's quarters at 37, rue Froidevaux, but there is nothing to indicate that she was among the Parisians who welcomed the liberators on the morning of August 25, as Capa claims. It is possible, however, for rue Froidevaux opens on place Denfert-Rochereau. While the concierge's presence cannot be proven, Émile Muller, the building's "heart and soul" and an early Resistance fighter who briefly served as mayor of the fourteenth arrondissement in the liberated capital—with his pistol through his belt—did indeed witness these events.

As soon as he arrived, Capa photographed the surrender of the Germans occupying the Chamber of Deputies, but also the Battle of the Senate, during which the Free French and Général Leclerc's troops struggled to overcome the entrenched enemy. The next day, he photographed the crowd in front of the Hôtel de Ville trying to take cover while snipers unleashed a final battle from the rooftops.⊕

ABOVE AND RIGHT: These are three photographs of the liberation of the Chamber, the last fight from the rooftops, August 25, 1944. FFI and soldiers of the Second Armored fight in the rue de Bourgogne near the place du Palais Bourbon, where the back entrance of the Chamber is located. Soon, the German officers occupying the place, came, white flag in hand, to negotiate with a French officer. Then came the surrender and the increase of prisoners in the rue de Bourgogne. These vintage photos, credited to Keystone, are unsigned. The first two are clearly by Capa, and probably the other two as well.
OPPOSITE: Meanwhile, at the fourteenth arrondissement city hall, the photographer at 37, rue Froidevaux, Émile Muller, pistol in his belt, joins the Liberation Committee with his comrades in the Communist Party.

Friends at the Scribe Bar

In August 1944, the general staff of the Second Armored Division and the American command in Paris chose the Hôtel Scribe near the Opéra to put up war correspondents in Paris. The Scribe was chosen over the Ritz due to the quality of its wine cellar, but also—and especially—due to its proximity to the famous Harry's New York Bar on rue Daunou. The Hôtel Scribe bar— the first American bar founded in Paris, in 1860—was made famous by the writers of the Lost Generation, the American interwar literary movement. Hemingway, the emblematic figure of the Lost Generation, is in the foreground of the painting shown on the following pages, standing out from the other figures with his powerful (and slightly ridiculous) stature.

This extraordinary painting, which is only missing the usual hubbub of the Hôtel Scribe bar, is by Floyd MacMillan Davis. Along with his wife, Davis was the only painter war correspondent sent by *Life* to Great Britain, then France, to cover the military operations. This oil on canvas painted in Paris in August 1944 was first reproduced in the January 1945 issue of *Life* on a double-page spread. Six months after the liberation of the French capital, the magazine's Parisian bureau chief, Charles Christian Wertenbaker, wrote an article about the sadness of Paris faced with the deprivations of the postwar era, so far removed from the euphoric atmosphere of the days of August 1944. The article was illustrated with Floyd Davis paintings.

In the painting shown on the following pages, Charlie Wertenbaker and Robert Capa are to the left of the Nazi flag, which is held up like a war trophy by another *Life* photographer, the young Ralph Morse. Standing apart, his face somber and poorly shaven, Capa wears the hat he loved, the lining of a GI helmet used to cushion soldiers' skulls from the weight of the metal. Below him, his boss Wertenbaker sports a mustache and a beige scarf. Facing Wertenbaker, we find a typically British colleague smoking a pipe. Davis depicts this historical moment in a satirical manner, as can clearly be seen in the figure representing Lee Miller, preening behind Hemingway like a Hollywood platinum blonde. As if in a modern vanitas, death is represented to the left, behind the bar, in the guise of an old woman. Strangely enough, this gathering of an unusually large number of photojournalists in a single place was never photographed.⊕

220

RIGHT AND FOLLOWING PAGES: Depicting a gathering of photojournalists, who are identified on the right, the painting by Floyd MacMillan Davis was published in *Life* in January 1945. It is now part of the collection of the National Portrait Gallery in Washington, D.C., where it is listed as *Bar in Hotel Scribe*.
ABOVE: In addition to painting journalists and photographers, war correspondents such as Floyd MacMillan Davis and his wife also painted World War II battle scenes.

RICHARD DE ROCHEMONT
(1903–1982), *THE MARCH OF TIME*, PARIS

DAVID SCHERMAN
(1916–1997), PHOTOGRAPHER, *LIFE*

WILL LANG
(1914–1968), JOURNALIST, *LIFE*

CHARLES WERTENBAKER
(1901–1955), JOURNALIST, *TIME* AND *LIFE*

NOEL BUSCH
(1906–1985), JOURNALIST, *LIFE*

RALPH MORSE
(B. 1917), PHOTOGRAPHER, *LIFE*

ROBERT CAPA
(1913–1954), PHOTOGRAPHER, *LIFE*

FLOYD DAVIS
(1896–1966), ARTIST-REPORTER, *LIFE*

JANET FLANNER
(1892–1978), JOURNALIST, *THE NEW YORKER*

WILLIAM SCHIRER
(1904–1993), JOURNALIST, CBS RADIO

ERNEST HEMINGWAY
(1899–1961), WRITER AND JOURNALIST, *COLLIER'S*

LEE MILLER
(1907–1977), PHOTOGRAPHER, *VOGUE*

222

THE SCRIBE HOTEL BARROOM is the headquarters and the hangout of correspondents in France. Here Artist Floyd Davis found old acquaintances of the *Time* and LIFE European staff: (*standing, second from left*) *March of Time* movies' Producer Richard de Rochemont; (*right, with camera*) Photographer David Scherman; (*center, staring starkly ahead*) Will Lang; (*under de Gaulle's portrait, facing right*) Charles Wertenbaker; (*at right, holding Nazi flag under Noel Busch's pipe*) Photographer Ralph Morse; (*at bar, behind Morse*) Photographer Robert Capa. At table in left foreground are Floyd and Gladys Davis;

223

table in center, *The New Yorker*'s Janet Flanner, Broadcaster William Shirer, ovelist Ernest Hemingway; at far right, H. V. Kaltenborn. Every other day he bar served brandy and then the place was crowded with correspondents ho drank the brandy, they insisted, just to keep warm. The Scribe was a confused place, which will appear in innumerable future war books, plays, movies. Spruce correspondents rushed out to the front to get stories. Disheveled correspondents rushed back from the front to file their stories. At any time reporters could be heard complaining about censors, brass hats, editors.

A meeting of the National Spanish Union in Toulouse, then capital of the Republic in exile. After having fought in the ranks of the French Resistance, the Spanish Republicans want to continue the fight on the other side of the Pyrenees in order to overthrow the Franco regime and institute a democracy.

Back with the Spaniards

Life **published** the photo opposite in December 1944 accompanied by a short article entitled "The Spaniards," which noted that "the most heroic Communists in Europe are Spaniards but today they are everywhere except Spain." The shot was taken in Toulouse—then the capital of the Spanish Republic—during a meeting of the Spanish National Union, which gathered all the political players, from Communists to Catholics. A Catalan Communist leader is speaking from the rostrum; the man in uniform is Colonel Paz, head of the *guerilleros* who fought next to the French maquis.

Pierre Gassmann was at this meeting along with Robert Capa and remembers, "In 1944, immediately after the Liberation, a congress of Spanish Republicans in Toulouse had a significant impact. Suddenly someone tapped me on the shoulder—it was Capa disguised as an American officer. Henri Cartier-Bresson was standing next to him in a leather jacket. At night, back at the hotel, we told each other stories. I had heard he had landed in Sicily, that he had parachuted in. He had never done a parachute jump but he told me how to do it: 'You pull on the cable and afterward the hardest part is getting rid of your parachute and your soiled pants.' That's the real Capa, who always poked fun at himself."

Capa wasn't satisfied with simply attending the meeting. The Spaniards wanted to take back their country and overthrow Franco. On October 19, 1944, several thousand of them invaded Spain by the Val d'Aran in the Pyrenees, but the more heavily armed, better informed Francoists fended off the attack. Capa accompanied his Republican friends to the border and photographed the wounded in the hospitals of Toulouse. He told an embellished version of this adventure in his book *Slightly Out of Focus*.⊕

Photographing Cinema

The excellent French magazine *Photo monde* published this Capa photo of a French cancan dancer on the cover of its February 1953 issue. The issue ran six of Capa's photos taken on the shoot of his old friend John Huston's film *Moulin Rouge*, starring José Ferrer, Colette Marchand, and Zsa Zsa Gabor. The shots were published with reproductions of Toulouse-Lautrec paintings representing cabaret stars of Montmartre such as La Goulue, Valentin le Désossé, and Grille d'Égout. The editor wrote, "In Robert Capa's photo story, we recognize the capture of movement through the same out-of-focus effect, but we see the appearance of a new element specific to photography: the capture of real movement."

Capa had always been drawn to cinema. As far back as Spain, he had used a film camera for reportage. But it was his 1945 affair with Ingrid Bergman that truly revealed his love for cinema. In her memoirs, the actress tenderly and humorously recounted their meeting at an eccentric dinner in Paris, followed by their trip through the ruins of Berlin. Having become Bergman's lover, Capa joined her in Hollywood and tried his hand at cinema, without much pleasure or success, on the shoot of Alfred Hitchcock's *Notorious*. But Capa did not want to marry the actress, and in 1947 their relationship came to an end. Back in Europe, the photographer covered the masterpiece of Italian neorealism *Riso amaro* (*Bitter Rice*), which notably launched Silvana Mangano, the wife of the great producer Dino De Laurentiis. The shoot took place in Piedmont, using the rice fields of Vercelli, and featured Raf Vallone,

LEFT: Capa used an elegant artistic blur to capture La Goulue, as played by Katherine Kath, on the shoot of *Moulin Rouge* in 1952. As the magazine pointed out, he was inspired by Toulouse-Lautrec's paintings.
BELOW: The March 11, 1950, issue of *Picture Post* devoted its cover to actress Silvana Mangano for the British release of *Riso amaro* (*Bitter Rice*). Though the photograph is unattributed, it may be by Capa.

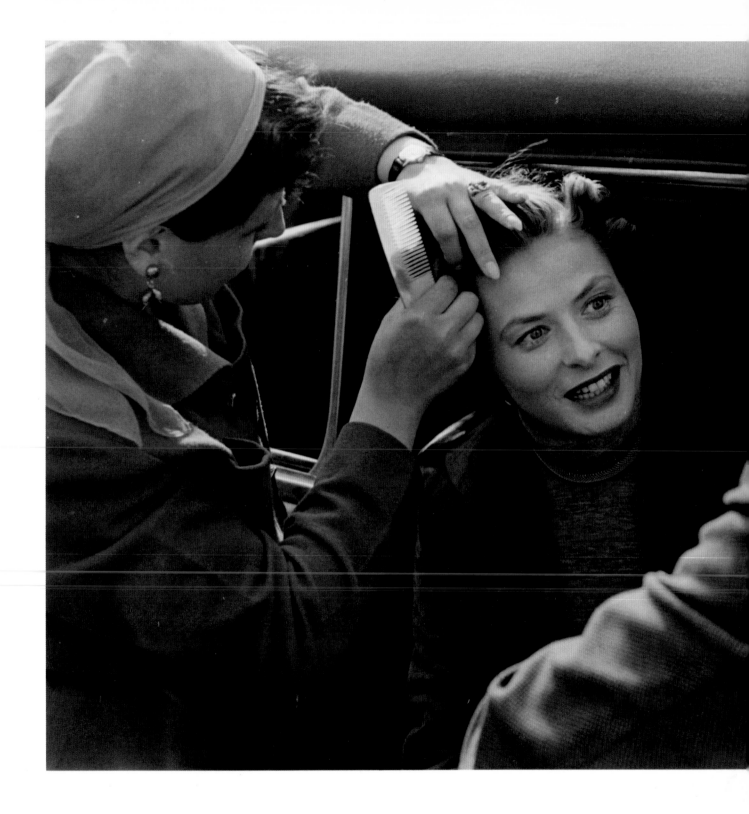

228

ABOVE: A tender photograph of Ingrid Bergman taken by Capa on the shoot of *Beat the Devil*.

OPPOSITE: Capa at the bar, after the shoot.

Vittorio Gassman, and the American Doris Dowling (Capa's girlfriend at the time). The photos appeared in November 1948 in *The Illustrated London News* and in March 1949 in *This Week*, the *New York Herald Tribune*'s Sunday supplement.

In 1953, Capa was reunited with John Huston and Ingrid Bergman on the shoot of *Beat the Devil* in Ravello, near Naples. The film's other stars were Gina Lollobrigida and Humphrey Bogart, another close friend of Huston's. The director liked to tell how he fleeced Capa and Truman Capote, the film's scriptwriter, at poker in the evenings. Two other photographers were on the shoot: Ted Castle and Chim. Though not particularly fruitful, Capa's experience in Hollywood allowed him to make ties with many people in the industry. He had also gotten to know members of military newsreel crews in London and France during World War II, including some of the greatest Hollywood directors such as John Huston, Alfred Hitchcock, and George Stevens. After Magnum was founded in 1947, these connections allowed Capa to get his friends with the agency hired on film shoots to take advantage of magazines' seemingly insatiable appetite for this kind of photo. In 1950, lured by the financial incentive in this kind of work, Capa negotiated with John Huston and Howard Hawks to secure exclusive coverage of their films.⊕

John Steinbeck's book *A Russian Journal* was published in the United States in 1948 with seventy-five photos by Robert Capa, while the French edition published by Gallimard in 1949 featured only sixteen. *Ladies' Home Journal* was the first publication to run Capa and Steinbeck's story.

Capa in the Land of the Soviets

They first met during the war in London, then ran into each other again in Normandy. In 1947, John Steinbeck, forty-five, and Robert Capa, thirty-four, met at the bar of the Hotel Bedford in New York. The novelist and winner of the 1940 Pulitzer Prize for *The Grapes of Wrath* was going through a difficult time. Steinbeck

asked Capa to join him for a journey to the USSR to see what had changed since his first trip there in 1936. Capa had just founded Magnum Photos and needed money. The *New York Herald Tribune* financed the trip and published the account of it in the paper from January 14 to 31, 1948. John Morris, then photo editor of *Ladies' Home Journal*, ran it as a cover story in the February 1948 issue, with sixteen full pages of color and black-and-white photos by Capa with captions by Steinbeck. Their account was considered the first "free" reportage from inside the USSR. Capa, an American citizen since 1946, managed to obtain a visa because Steinbeck, who had been invited, refused to go without him. At the time, the Soviets were deeply fearful of the presence of a foreign photographer. The writer and the photojournalist flew to Russia from Paris on July 31, 1947. They spent forty days behind the Iron Curtain, traveling from Moscow to Stalingrad via Georgia and the Ukraine. Capa took four thousand photographs of farmers, workers, and daily life (about one hundred were censored by the Soviet authorities).

John Steinbeck's book of the journey, *A Russian Journal*, appeared in the United States in 1948. He wrote about Capa's anxious personality in Russia, hidden underneath a relaxed demeanor. "Our films had to be developed and inspected, every single one of them, before they could leave the country . . . [Capa] paced about, clucking like a mother hen who has lost her babies. He made plans, he would not leave the country without his films . . . Half the time Capa plotted counter-revolution if anything happened to his films, and half the time he considered simple suicide." The Soviets responded to the book's publication by calling its authors "hyenas" and "gangsters." Yet in the heart of the cold war, the conservative American press saw it as a tribute to Stalin's USSR. ⊕

Ladies' Home

JOURNAL

The Magazine Women Believe In February, 1948 25¢

Women and children in
SOVIET RUSSIA

A report in pictures by
ROBERT CAPA
Text by
JOHN STEINBECK

Capa Arrives in Tel Aviv

Capa arrived in Tel Aviv on May 8, 1948. He wanted to witness the birth of a nation to which he was no stranger. But the first Israeli-Arab War broke out unexpectedly on the 14th, the evening of Israel's declaration of independence. As *The Illustrated London News* reported, "Once again the violence of war has caught up with Robert Capa." Inevitably empathetic with his subject, Capa took an approach best exemplified by this quote reported by his friend the journalist Martha Gellhorn. "In a war," he told her, "you must hate somebody or love somebody. You must have a position or you cannot stand what goes on." Over the course of his three trips to Israel (in 1948, 1949, and 1950), the photographer shot seven hundred rolls of film. Pierre Gassmann's lab in Paris took a year to develop Capa's orders on the subject. Yet these photos did not include any images depicting the suffering of the Arab population forced into exodus. In the photos Capa took in Israel and the film he directed, *The Journey*, those who chose to stay after the war of 1948 appear occasionally, as if by chance. Only once did Capa choose to photograph one of them, a middle-aged Arab man standing behind barbed wire in traditional garb. The image was published on a full page in the August 27, 1949, issue of *The Illustrated London News* with the caption, "The wandering Arab: a new tragic figure."

In France, *Regards* published images of the Battle of Jerusalem reminiscent of those of the Battle of Madrid taken in 1936. As Capa would later write, he found "the same enthusiasm, the same political divergences, the same variety of professions and ages," in the ranks of this Jewish army as he had experienced in Spain; he encountered veterans of the Spanish brigades, French Resistance members, and Hungarian émigrés.

With the road connecting Tel Aviv to Jerusalem blocked by the Arab Legion, Capa witnessed the construction of a supply road crossing the mountains and opened by force under the command of David "Mickey" Marcus. This former colonel of the United States Army, a hero of Guadalcanal and the Battle of Normandy in 1944, would be killed during the Battle of Jerusalem. *Regards* published a portrait of him with the caption, "Capa was beside him when he was killed, ten minutes before the cease-fire." A close friend and acolyte of Capa's, Marcus remains one of the legends of the Israeli war of independence, immortalized by actor Kirk Douglas in the 1966 Hollywood film *Cast a Giant Shadow*.

Capa witnessed the fratricidal combat between the partisans of Menachem Begin's Irgun and those of David Ben Gurion's Haganah on the beaches of Tel Aviv in June 1948. The Irgun hoped to shatter the truce and blockade imposed by the Haganah by delivering weapons clandestinely imported on the cargo ship *Altalena*. Capa was struck by a bullet during the battle. Wounded, he was forced to return to Paris, where he furiously told anyone who would listen that "being killed by Jews would take the cake!" This didn't prevent him from coming back as soon as January. In 1949, Pierre Gassmann, Magnum's film developer, also traveled to Tel Aviv to see his mother and do a story for UNICEF (the United Nations Children's Fund). He reported, "It was too hard to go to Israel after Capa; he had done everything." ⊕

Regards had the exclusive rights to publish Capa's story on the siege of Jerusalem in its July 2, 1948, issue. Over three pages illustrated with "extraordinary documents," the paper hailed "the silencing of weapons" after "a dramatic month."

Les dernières heures du siège de Jérusalem

PREMIÈRE
EXCLUSIVITÉ

ROBERT CAPA nous envoie aujourd'hui de Palestine ces extra-ordinaires documents sur les derniers jours de combat dans Jérusalem. Capa est un reporter de classe internationale, le premier sans doute des photographes contemporains. La qualité de ses images, l'émotion, en un mot la vie qu'il parvient par son talent à y garder présente font de lui un artiste incomparable.

« REGARDS » s'honore d'avoir été à l'origine de sa notoriété. C'est en effet comme envoyé spécial de notre journal en Espagne qu'il se révéla au grand public. Nombreux sont sans doute nos lecteurs qui n'ont pas oublié les bouleversantes images de guerre que « REGARDS » publiait alors chaque semaine et qui constituaient le plus saisissant témoignage de l'héroïsme des républicains espagnols.

Depuis, Capa a fait bien d'autres reportages sensationnels, en Chine, à Bikini, en U.R. S.S. (où il accompagnait récemment le célèbre écrivain américain John Steinbeck). Ses photos sont publiées dans les plus grands hebdomadaires mondiaux. Et Capa est resté un fidèle ami de « REGARDS ».

« SI JE T'OUBLIE, O JÉRUSA-LEM, que l'on me tranche la main droite... » chantait jadis le prophète. Quand les troupes d'Abdullah pénétrèrent dans le vieux Jérusalem, la parole n'avait pas perdu de son actualité bi-millénaire et il leur fallut arracher littéralement les civils juifs de leurs demeures. La nuit précédent le « cessez le feu! » des volontaires de la Haganah réoccupèrent les quartiers arabes entourant la vieille ville, et ces deux instantanés dramatiques donnent l'exacte physionomie de la bataille. Après l'infiltration maison par maison, ruine par ruine, on défend les positions.

THE JOURNEY

Directed by ROBERT CAPA

UNITED JEWISH APPEAL presents

A Legendary Film on the Birth of Israel

Robert Capa was in Israel from early October to mid-November 1950. Over those six weeks, he shot a twenty-six-minute-long documentary about Holocaust survivors who had emigrated through the port of Haifa and become Israeli citizens and then kibbutzniks in the Negev Desert. In *The Journey*, he filmed the long exodus of the European émigrés at the request of the United Jewish Appeal (UJA), the powerful American Jewish organization. The Frenchman Jacques Letellier was his camera operator, and the American Millard Lampell, his screenwriter. After a long truck trip across the country, the "pioneers" settle in a precarious kibbutz at the southern end of the Dead Sea. Everything remained to be cleared; everything remained to be built. Pita Wolff, Capa's girlfriend in Israel, was on the trip; she played the part of a kibbutz leader. The film was edited in Paris by Françoise Diot, with original music by Maurice Thiriet, and was screened in the United States in 1951. Though the UJA's fundraising campaign was a failure, *The Journey* is considered by the Jerusalem Cinematheque to be "an irreplaceable and legendary historical documentary about Israel's difficult beginnings."⊕

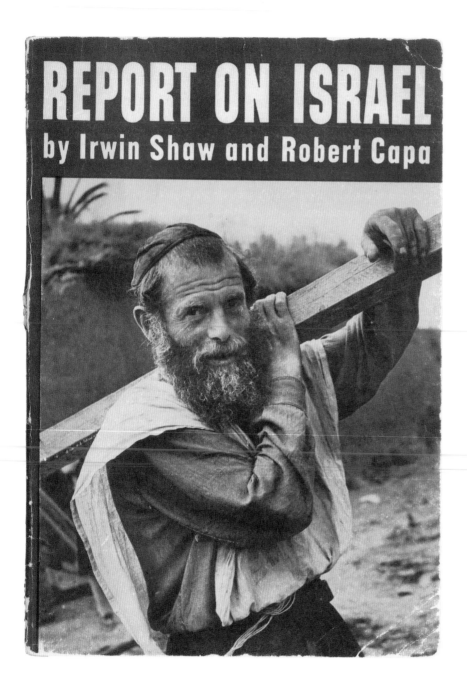

A Masterpiece of Reportage

The playwright and journalist Irwin Shaw, whom Capa had met in Great Britain and in Paris during the Liberation, visited Israel in May 1949 to write a series of three long articles for *The New Yorker*. Before leaving together for Jerusalem, Capa and Shaw met in Tel Aviv for the new state's first anniversary. Their collaboration was not used by *The New Yorker,* which did not feature photos. But Robert Capa convinced Irwin Shaw to prepare a book as soon as they returned to the United States. The book, *Report on Israel*, was published in New York in April 1950 by Simon & Schuster and was considered an absolute success and a masterpiece of reportage. It consisted of Shaw's *New Yorker* pieces, along with an article written for *Holiday*. With the addition of Capa's photographs, Shaw could tell the story of the birth of Israel in 1948. He wrote the 109 captions of this 144-page book. The text does not conceal its author's doubts and questions regarding the future of Israel; it expresses more distance than the empathetic photographs. Shaw notes the extent to which "Palestinian Arabs [as they were then known] have suffered from the creation on their land of this national home for the survivors of the Holocaust." In a review titled "Warm and Insightful," the *New York Times* emphasized that "Capa's camera, trained on the different facets of this country and its inhabitants, tried to photograph its human qualities as well as the milestones of its history."⊕

The girl on the left came from Bulgaria to do Monday's chores for the settlement of Kafar Giladi in Galilee. The young man below came from America and was naturally put in charge of a machine.

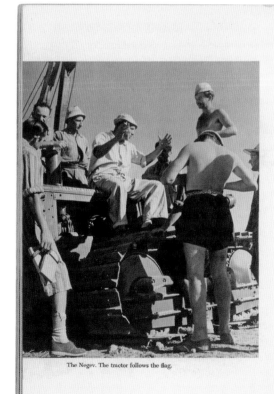

The Negev. The tractor follows the flag.

An ex-French Maqui terraces a stony hillside near Jerusalem. Naturally, he is going to plant grapes.

The Good Life

Back in Paris early in 1948, Capa took more interest in Monsieur Dior, master of the New Look, and his star models, Bettina Graziani and Suzy Parker, than in existentialism, political tensions, or even the genius of bebopper Charlie Parker. Spending his time on the Right Bank between the Bar des Théâtres, the Hôtel Lancaster (where he was staying), and Magnum's offices on rue du Faubourg Saint-Honoré (where he worked), Capa was on the lookout for assignments from American magazines (*This Week*, *Holiday*, *Harper's Bazaar*) and threw himself into fashion photography. His poker partner, Dmitri Kessel, a photographer for *Life*'s Paris bureau for thirty years, immortalized him in Dior's grand reception room on avenue Montaigne. Wearing an elegant custom-made suit, his Rolleiflex around his neck, Capa poses before the fashion show and directs model Suzy Parker on how to present her dress.

Capa still saw his longtime friends. He advised Pierre Gassmann to start the Pictorial Service lab, which would print Magnum's photos; Taci Czigany worked there and lived in the studio on rue Froidevaux. Capa also supported Ata Kando, who was back from Hungary and trying to make a living as a photographer. But Capa's childhood friend Eva Besnyö, who visited Paris in the early fifties and had opened Capa's path to photography in Berlin, did not have the same support: When she came to ask him for work, he deemed that her style was not "journalistic" enough!

Upon his return from the USSR, Capa, who was much impressed by television's influence in the United States, founded a production company called World Video. Henry White, a former head of United Artists, was its chairman and sales manager; John Steinbeck, its vice-chairman and script supervisor; and Bob Capa, officially named associate vice-chairman, its director. Based on Capa's idea, a series of twenty-nine

fifteen-minute film portraits of Parisian designers was launched under the catchall title *Paris, Cavalcade of Fashion*. The films were televised in the United States on CBS from June 4, 1948, to January 20, 1949. The first episode naturally featured Christian Dior. He was followed by Robert Piguet, Jacques Fath, Lucien Lelong, Elsa Schiaparelli, Edward Molyneux, Pierre Balmain, Jean Patou (shot in Deauville), and the house of Lanvin. The shooting and production crew in Paris consisted of cameraman Paul Martellière and scriptwriter Frances Healy Geyelin. The head of World Video in Paris was none other than Anne Buydens, former assistant to John Huston on *Moulin Rouge*. The films in question have vanished; they were allegedly left at the Chambre syndicale de la haute couture (Trade Union for Haute Couture) in Paris. The endeavor would end in financial disaster, probably due to Capa's extravagant expense account. Without the help of models Suzy Parker, who worked at Magnum in 1953, and her sister Dorian Leigh, Capa would have never pulled off these shoots.

At the time, the writer Romain Gary was also a regular on avenue Montaigne. In *La nuit sera calme* (*The Night Will Be Calm*), a book of interviews with François Bondy, he remembered, "At the time the Hôtel des Théâtres [was] frequented by the most beautiful models in the world, Dorian Leigh, Assia, Maxine de la Falaise, Bettina [Graziani] of course, Nina de Voght, and Suzy Parker, among others. The hotel had a tiny elevator and when you were lucky enough to step in and happen upon one of these goddesses you went straight up to heaven… Capa, the famous *Life* photographer who photographed the landings in Normandy and would later blow himself up on a mine in Indochina, reigned over the scene, along with Irwin Shaw, Peter Viertel, and Ali Khan, and marvelous things took place in the rooms, which I barely dare to imagine, for moral reasons and due to lack of experience."⊕

238 **Capa poses wearing a custom-made suit at the house of Christian Dior on avenue Montaigne.**

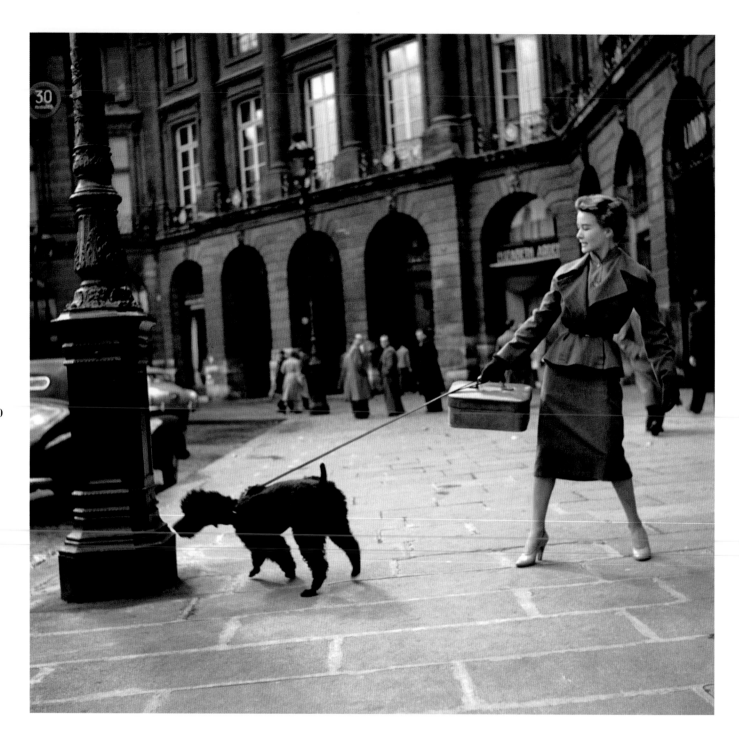

240

Models for the House of Dior wear a New Look suit, Place Vendome in Paris, spring 1948. Around mid-January 1948, Bob Capa left New York for Le Havre on the ocean liner RMS *Queen Elizabeth*. He traveled with Richard Avedon, already the master of fashion photography, and Carmel Snow, the editor in chief of *Harper's Bazaar*. Both of them gave him advice on how to approach and work with the Parisian haute couture houses. Capa published three style portfolios in 1948 in *The Illustrated London News*, *Look*, and *This Week*.

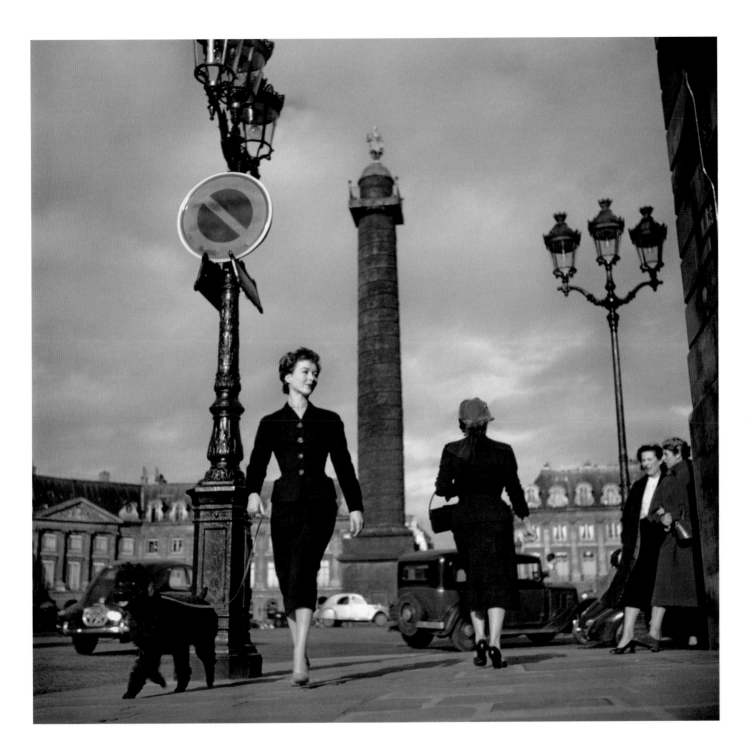

241

Ten years after his first color photographs, taken
in China and published in *Life* on October 17, 1938,
Capa tried fashion photography with his Rolleiflex
in Paris.

The blithe story (with pictures)
of a top-notch cameraman whose work
keeps interrupting a wonderful romance

Robert Capa

Slightly
out of Focus

Robert Capa

Slightly out of Focus

With photographs by the author

SLIGHTLY OUT OF FOCUS is a contradiction in terms, being the natural climax of a special kind of publishing achievement at the same time that it is a completely different sort of book. With it Henry Holt and Company will have published the three top reporters of World War II; Ernie Pyle, who wrote the war, Bill Mauldin, who drew it, and now Bob Capa, who photographed it and wrote about it too.

This is *not* a book of photographs with captions. These are the hundreds of pictures Bob Capa took throughout the fighting in the ETO. They have been made into chapters and they alternate with the frank, airy, true story of a fabulous young man, Bob Capa, whose romance with a girl called Pinky kept getting involved with his trips to the fighting fronts.

You know the story — or some similar story — of a hundred people who participate in a battle and come out of it with a hundred different reports. Each report may be true; all may be contradictory. "This," Mr. Capa points out, "goes for poker games, drinking parties, and love. Writing the truth being obviously so difficult, I have in the interests of it allowed myself to go sometimes slightly beyond and slightly this side of it. All events and persons in this book are accidental and have something to do with the truth."

This, certainly, is obvious about life and writing — even writing about oneself, as Mr. Capa has done. But though his words may be slightly, occasionally, and riotously out of focus, his pictures never are.

(Continued on back flap)

$3.50
SOF

"The blithe story (with pictures) of a top-notch cameraman whose work keeps interrupting a wonderful romance." This description on the cover of *Slightly Out of Focus*, published in 1947, sets the tone for the book.

Memories of the War

Everything is in the details. Most first editions of this rare book, published in New York in the spring of 1947 by Henry Holt and Company, have lost the famous dust jacket so prized by bibliophiles. Without it, the book loses some of its significance. The inner flap states, "Robert Capa, *Slightly Out of Focus*, With photographs by the author." This is a key specification for the man who had battled against uncredited pictures, photos used as mere illustrations, and inaccurate captions. He had been through hell when publishing his work in periodicals and now cherished the freedom to personally write the text that completed his photographer's point of view above any other.

The title of this account of his life during World War II—the book only covers the period from 1942 to 1945—referred to the publication in *Life* of his surviving photographs of the D-day landings. The lab accident in London not only reduced his work on Omaha Beach to eleven shots, but left the few surviving pictures out of focus. In the June 19, 1944, issue of *Life*, the photos were published with the caption, "Immense excitement of moment made Photographer Capa move his camera and blur picture." This pure fabrication by an editor safe and sound back in New York inspired the title *Slightly Out of Focus*. On the dust jacket's inner flap, the author warns, "Writing the truth being obviously so difficult, I have in the interests of it allowed myself to go sometimes slightly beyond and slightly this side of it. All events and persons in this book are accidental and having something to do with the truth." Each page is full of cheeky humor, and emotion. But ultimately what is most striking is Capa's rage at being alone on every front; he, a stateless man

243

born in an enemy nation—Hungary—was the only photographer with the United States Army. Capa constantly had to woo and convince the military administration to allow him access and be braver than anyone else in order to capture images of the heat of the action, accepting the risk of being a part of the first wave of assaults and doing parachute jumps. His English mistress Pinky is undoubtedly the book's other leading figure. This slice of private life slipped into a war narrative appealed to reviewers. In his article "The Man Who Invented Himself," published in '47 magazine, Pulitzer Prize–winner John Hersey wrote, "Despite all his inventions and postures, Capa has, somewhere at his center, a reality. This is his talent—which is compounded of humaneness, courage, taste, a romantic flair, a callous attitude toward mere technique, an instinct for what is appropriate, and an ability to relax. At the core, he even has modesty. He has the intuition of the gambler . . . He has humor. He has a clear idea of what makes a great picture: 'It is a cut of the whole event,' he says, 'which will show more of the real truth of the affair to someone who was not there than the whole scene.' "

This unique volume, largely dictated to an English-speaking typist in Turkey (which goes a long way toward explaining its tone) is fascinating, though the inaccuracies scattered throughout will continue to feed the debates of those who study Capa professionally for years to come. The quality of the original version's photo section, which contains 121 shots (a few pages are reproduced here), and the relationship between the photos and the text make this a model photo book. It was published in Japan nine years after its publication in the United States and in France fifty-six years later. It has never been reprinted in the version conceived by Capa.⊕

244

ROBERT CAPA was born in Budapest in 1913. Due to disagreement with a Mr. Horthy (then dictator, now Admiral retired) he left Hungary at the age of 18 and became a photographer in Germany. In 1932, due to disagreement with a Mr. Hitler (then dictator, now suspected retired) Capa left Germany and found his way to Spain. Due to disagreement with a Mr. Franco (not retired) he left Spain in 1939 and came to America, going back to cover World War II with the U. S. Army. He has been the only enemy alien to be a war photographer and war correspondent with the U. S. Army; he got involved with secret bombsights, a pink girl, high and low poker, and too many invasions. After the war Capa went out to be a movie producer in Hollywood, ended up playing an Egyptian heavy, directed a March of Time film in Turkey, and proceeded to get fired; one wonders what Mr. Capa (not retiring) will be doing by the time this book comes out.

HENRY HOLT AND COMPANY
257 Fourth Avenue, New York 10

Chicago *San Francisco*

SLIGHTLY OUT OF FOCUS
ROBERT CAPA
HENRY HOLT

RIGHT: The back cover and back flap of *Slightly Out of Focus*.
PAGE 246: Faces of Resistance fighters and German prisoners.
PAGE 247: The liberation of France, July 1944.

There was absolutely no reason to get up in the mornings any more. My studio was on the top floor of a small three-story building on Ninth Street, with a skylight all over the roof, a big bed in the corner, and a telephone on the floor. No other furniture — not even a clock. The light woke me up. I didn't know what time it was, and I wasn't especially interested. My cash was reduced to a nickel. I wasn't going to move until the phone rang and someone suggested something like lunch, a job, or at least a loan.

I rolled over and saw that the landlady had pushed three letters under the door. For the last few weeks my only mail had been from the phone and electric companies, so the mysterious third letter finally got me out of bed.

The third letter was from the editor of *Collier's* magazine. He said that *Collier's*, after pondering over my scrapbook for two months, was suddenly convinced that I was a great war photographer, and would be very pleased to have me do a special assignment; that a reservation had been obtained for me on a boat leaving for England in forty-eight hours; and that enclosed was a check for $1500 as an advance.

Here was an interesting problem. If I'd had a typewriter and sufficient character, I would have written back to *Collier's,* telling them that I was an enemy alien, that I could not go even to New Jersey, let alone England, and that the only place I could take my cameras was the Enemy Aliens' Property Board down at City Hall.

I had no typewriter, but I had a nickel in my pocket. I decided to flip it. If it came up heads, I would try to get away with murder and go to England; if it came up tails, I would return the check and explain the situation to *Collier's.*

I flipped the nickel, and it was — tails!

The subway accepted the nickel. The bank accepted the check. I had breakfast at Janssen's, next to the bank — a big breakfast that came to $2.50. That settled it. I couldn't very well go back to *Collier's* with $1497.50, and *Collier's* was definitely in for trouble.

247

3. Due
dicta-
at the
n Ger-
a Mr.
etired)
Spain.
not re-
merica,
e U. S.
to be a
t with
bomb-
nd too
out to
led up
arch of
t fired;
g) will

PANY
10
rancisco

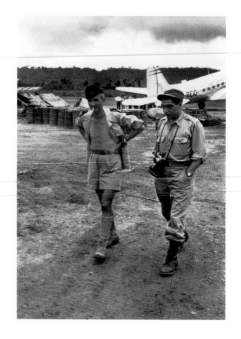

OPPOSITE: Bob Capa on the streets of Tokyo in April 1954 with his first Nikon S. Years later, during a trip to Japan, his brother, Cornell, gave the camera to the Japan Camera Industry Institute (JCII), then headed by the man who took this picture, Kakugoro Saeki. The camera, one of the two with which Capa was killed, is still exhibited there.

The Last Mission

The Marunouchi district, Tokyo, mid-April 1954: With an American newspaper in his pocket and a camera slung around his neck, Bob Capa scours the streets around the train station. Suddenly, he frames a vertical shot with his brand-new Nikon S and pushes the shutter release. Standing nearby, Kakugoro Saeki, editor in chief of the photography magazine *Camera Mainichi*, snaps an on-the-fly shot of Capa. This previously unpublished photograph was discovered in Tokyo by Bernard Matussière. In 1954, the forty-year-old Capa spent three weeks in Japan and was welcomed as a hero and national living treasure. "I've been given five still cameras, fifteen lenses, and thirty bouquets of flowers in just a few days," he wrote to the Magnum office in Paris, which he had left on April 11. As soon as he touched down at the airport in Japan, he was reunited with his friend Hiroshi Kawazoe. Kawazoe had been a student in Paris from 1934 to 1939, living in the Cité internationale universitaire de Paris (Paris International University campus), along with Seiichi Inoue, a future director and the co-translator of *Slightly Out of Focus* into Japanese (1956). A wealthy man, Hiroshi Kawazoe had done a great deal to help André and had even brought him his first raincoat from London. Capa and Kawazoe were the same age and had not seen each other since 1939.

But the Indochina War raging nearby soon interrupted Capa's stay. The French military garrison in Dien Bien Phu was on the verge of falling. Howard Sochurek, an American photographer for *Life*, was covering the battle but asked for a month's leave after his mother suffered a heart attack. *Life* asked Capa to replace him; Capa hesitated. John Morris called him from New York: "Bob, you don't have to do this job, it's not our war!" But Capa had made up his mind. On May 1, he wrote to John Morris, "Be assured that I did not accept this assignment out of a sense of duty, but because I really wanted to . . . I know that Indochina will probably only lead to frustration, but that still deserves a story. So I'm going."

Capa arrived in Hanoi on May 9, two days after the fall of Dien Bien Phu. He put up at the Modern Hotel and took his meals at la Bonne Casserole, a restaurant in the heart of the old city. A few days later Capa flew to Luang Prabang, a city on the banks of the Mekong in northern Laos, with *Life* reporter Don Wilson. It was on Luang Prabang's French military airfield that Michel Descamps of *Match* took the last known picture of Robert Capa alive, between May 13 and 17, 1954. The photo shows Capa walking in front of a Dakota aircraft in his war correspondent outfit, his Contax over his shoulder, accompanied by an air force major. ⊕

A Photographer at Work

One week after the fall of Dien Bien Phu,
General Giáp, head of the Viêt Minh forces,
authorized the first transfer of the French
Army's critically wounded personnel. From
May 15 to 26, 1954, 858 of the wounded
were evacuated with their nurse, Geneviève
de Galard. Helicopters shuttled between
Dien Bien Phu—where more than eleven
thousand French soldiers were taken pris-
oner on the evening of the surrender on
May 7—and the military airfield of Luang
Prabang (Laos). A field hospital had been
set up headed by professor Pierre Huard,
the dean of Hanoi's medical faculty. From
this medical base, planes transported the
wounded to Hanoi. It was the first oppor-
tunity for the press to get the stories of
the French soldiers who had been under

Établissement cinématographique et
photographique des armées (Cinematic and
Photographic Establishment of the Armies
[ECPA]) was also at Luang Prabang, with
Lucien Millet as a camera operator. He was
with Capa until the last day, when Capa
traveled to the Red River Delta. Soldiers
on stretchers—*Match* ran the headline
"After Dien Bien Phu, the Tragedy of the
Wounded"—were the principal subject of
this story. While Capa tried to take a low-
angle shot of a wounded soldier's face,
Millet's camera filmed him. This precious
document, which belongs to the Établisse-
ment de communication et de production
audiovisuelle de la Défense (Defense
Department Establishment for Audiovisual
Communication and Production [ECPAD]
and kept at the Fort de Vincennes under the
reference ACT 2617, was found by the crew
working under Patrick Jeudy, the director
the film *Robert Capa: The Man Who Believed*

252

The Last Image

French soldiers, seen from behind as they walk along the dike of a rice paddy; in the distance, we can see a tank and a village. This is the last color photo taken by Bob Capa, on the road to Thai Binh, on May 25, 1954, around 3 PM. Like many American war correspondents since the Korean War (1950–1953), Bob Capa took color versions of his black-and-white shots.

In Indochina, he seemed to have permanently given up his faithful Rolleiflex to work with two 35 mm cameras with range finders: a Contax IIa made by Zeiss Ikon, loaded with black-and-white film, and the Nikon S (which was unusual for still being a 34 × 24 mm), made by Nippon Kogaku (a Japanese optics company) and given to him in Tokyo, loaded with Kodachrome film.⊕

RIGHT: An article by John Martin Mecklin in the June 7, 1954, issue of *Life*, on Capa's death.

BELOW: Then a correspondent for a local paper, seventeen-year-old Dirck Halstead was the only one who dared to take a few photos of his role model's funeral. The writing on the military coffin brought home from Hanoi was in French: "Restes Mortels, CAPA Robert, Reporter Photographe, décédé le 25-5-1954, NORD VIETNAM." (Mortal remains, CAPA Robert, photojournalist, died on 5-25-1954, NORTH VIETNAM.)

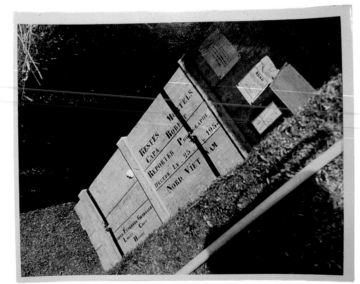

HE SAID: 'THIS IS GOING TO BE A BEAUTIFUL STORY'

by JOHN MECKLIN

TIME-LIFE correspondent who was with Capa on his last mission

HANOI

In the bug-ridden room of a Nam Dinh establishment which calls itself the Modern Hotel (in English), Bob Capa sucked a glass of warm cognac and soda and made a pronouncement: "This is maybe the last good war. The trouble with all you guys who complain so much about French public relations is that you don't appreciate this is a reporter's war. Nobody knows anything and nobody tells you anything, and that means a good reporter is free to go out and get a beat every day."

Capa and I had been touring French outposts in the besieged Red River Delta with General René Cogny, French commander in northern Vietnam. Next day we were going out with a 2,000-man task force which was to relieve, then evacuate, two garrisons some 50 miles south of Hanoi. Capa prepared for the mission with professional finesse: a thermos of iced tea, a jug of cognac, a jeep promoted from a French colonel, everything except matches. Capa never had matches, presumably because other people could be counted on for such obvious items.

When the jeep appeared at 7 a.m. May 25 we climbed in along with Scripps-Howard Correspondent Jim Lucas. Waiting for the Red River ferry just outside Nam Dinh, Capa announced, "This is going to be a beautiful story. I shall be on my good behavior today. I shall not insult people and I shall not even mention the excellence of my work."

On his delta tour Capa had got the idea of a picture story to be entitled "Bitter Rice." His plan was to dramatize the contrast of tanks next to peasants working in paddies, of men dying in the struggle for the rice harvest. All morning he worked to photograph peasants carrying rice to market in straw baskets, plodding along the edges of vehicle-clogged roads. Once a French motorcyclist playfully rode close to the roadside as he passed lines of peasants, forcing them to jump off. Said Capa, "Look at that s.o.b. making new Vietminh." When the column was stopped by ambushes, mines and trenches across the road, Capa was everywhere but always showing an expertness in calculated risk that only a man in his fifth war could know. He was cautious about crossing exposed areas, but if he saw a good picture which could only be made with risk he took the risk. A colonel invited us to lunch at Dong Qui Thon, but Capa kept poking around for pictures and failed to show up. We found him dozing under a truck and asked how his film was holding out. Said Capa, "That's what I'm doing here, saving film."

A few minutes later we heard that French Union elements had reached Doai Than, the first of two posts the column was to relieve. We got there in about 10 minutes, arriving at 2:25 p.m. Capa wanted to press on, saying: "The story's almost done, but I need the fort blowing up."

A couple of hundred yards beyond Doai Than the column was stalled again by a Vietminh ambush. We turned into the field and talked to the sector commander, Lieut. Colonel Jean Lacapelle. Capa asked, "What's new?" The colonel's reply was a familiar one: "*Viets partout*" ("Vietminh everywhere"). As the column began moving again Capa climbed on the jeep hood for a shot. A truck loaded with infantry behind us tooted vigorously but Capa took his time. "That was a good picture," he said as he climbed down. But the column halted again almost immediately. This was at a point one kilometer past Doai Than and three kilometers short of the final objective, Thanh Ne. The road was three or four feet above the paddies and here served as a dike for a little stream which ran along the right side. About 50 yards ahead the road bent to the left, forming a V with the stream, now contained by an independent dike.

The sun beat down fiercely. There was firing in every direction: French artillery, tanks and mortars behind us, the chatter of small arms from woods surrounding a village 500 yards to our left, heavy small arms fire mixed with exploding French shells in another village 500 yards ahead and to our right, the sporadic ping of slugs passing overhead, the harrowing *curr-rump* of mines and enemy mortars.

A young Vietnamese lieutenant approached us and began practicing his English, which was limited to a labored "How are you sir? I am good." Capa was exquisitely bored and climbed up on the road, saying, "I'm going up the road a little bit. Look for me when you get started again." This was about 2:50 p.m. The lieutenant switched to French and asked if we liked Vietnam.

At 2:55 the earth shook from a heavy explosion. Behind us spouted up a column of brown smoke and flames: the French were blowing up

CONTINUED ON NEXT PAGE

"It Was 3:10 PM"

John Martin Mecklin was the last writer
to team up with Bob Capa. In the June 7,
1954, issue of *Life*, he described the
circumstances of Capa's death. The title of
the article: "He Said: 'This Is Going to Be a
Beautiful Story.'" Early on May 25, 1954, a
French army jeep picked up Capa, Mecklin,
and the journalist Jim Griffin Lucas at their
hotel. In Nam Định, a city fifty-five miles
to the southeast of Hanoi, they joined a
long convoy of two hundred French foreign
legion vehicles. They crossed the river on a
ferry, then headed for Thái Bình. From the
dikes, Capa photographed farmers leading
their buffalo through the rice paddies. At
8:40 AM, the convoy was attacked. "Capa
was everywhere," Jim Lucas wrote. "Once
he transported a wounded Vietnamese
soldier to the jeep under mortar fire and
drove him to a safer place in the rear."
Later, Capa grew impatient and jumped
out of the truck: "I'm going up the road a
little bit. Look for me when you get started
again." According to Mecklin, it was
2:50 PM. Capa photographed the patrols
moving through the fields. "Bitter rice!"
Capa had told his colleagues about his
project to make a book about the people of
this country waging war in the rice paddies.
Suddenly, an explosion. An antipersonnel
mine. Mecklin ran over to discover a
severely wounded Capa, still holding his
Contax. He called to Capa several times.
"The second or third time his lips moved
slightly like those of a man disturbed in
sleep. That was his last movement. It was
3:10 PM." At the hospital, the doctor asked,
"Is this the first American correspondent
killed in Indochina?" Mecklin told him he
was. The doctor added, "It is a harsh way
for America to learn."

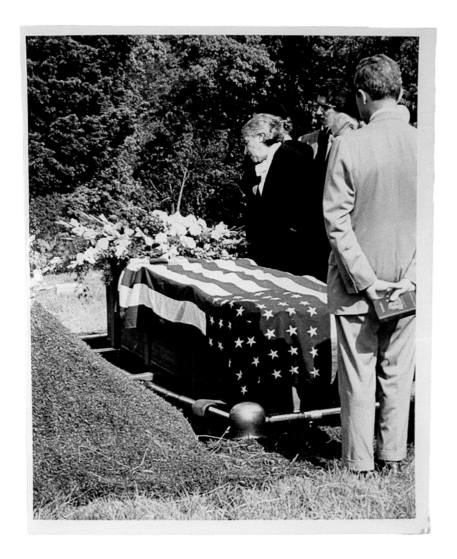

Two weeks after receiving military
honors from the French Army in Hanoi,
Capa was buried in New York, in the small
Quaker cemetery in Amawalk. The two
photographs of the ceremony show the
military coffin with French inscriptions,
draped with an American flag. The man
with seventy thousand negatives was forty
years old. He was the first *Life* photogra-
pher and the second of the Magnum agency
to die on assignment. Werner Bischof had
died in a car accident in South America
on May 16, 1954, but his death was not
reported until the 25th—the very morning
of the day Bob Capa died.⊕

Quaker cemetery at Amawalk, in
Westchester County, New York,
early June 1954: Julia Friedmann,
leaning over her son's coffin; to
her right, Cornell Capa and his
aunt; seen from behind, John
Morris, head of the Magnum
agency and Capa's friend for
a decade.

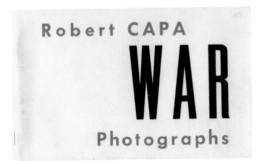

Catalogs of Robert Capa
photograph exhibitions of the
1960s–1970s.

Fifty-seven years after his death, Robert Capa's work and life can be likened to the pharaohs' tombs: something always remains unexplored. There is no shortage of archeologists—or rather Capalogists. Their passionate interest can be measured on the Internet. In an eighteenth of a second, a search engine will display two million hits for the name Robert Capa.

On the web, Capaphobes and Capaphiles face off in a planetary cacophony, myth busters lining up against legend lovers. Did the man keep up the legend in his lifetime? Not necessarily. What follows is the account of Charles-Henri Favrod, a former Swiss reporter who was with Capa in Hanoi during the last few days of Capa's life: "What I also noticed is that unlike my fellow journalists, photographers don't talk about photography and their exploits much. Someone like Lucien Bodard, who I knew well in Indochina, was far more likely to go on and on about his daring feats than Capa ever was." We have tried to untangle the threads of legend and fact, but many remain to be separated.

This is not a legend. Capa was also a writer. Yet his articles, which are disseminated in many newspapers (*Ce soir*, *Picture Post*, *The Illustrated London News*, *Look*, and starting in 1949, especially *Holiday*), remain little known and practically inaccessible. For example, take this story on Deauville, recently discovered by Philippe Normand and originally published in the United States in *Holiday* in September 1953: "Aside from the sea and the beautiful and opulent natural attractions of Normandy, August in Deauville offers: two days of sun out of seven, a tennis tournament for masters, a golf tournament for the less masterful, a song contest for the ambitious, clay pigeon shooting for those who like outdoor games, and a casino to snag the suckers who like indoor games." This fourteen-page piece by Capa deserves to be published with other unseen pieces such as the one about his native city of Budapest, also written for *Holiday*, the two about the Israeli rebirth of 1948, and many others."

This is a legend. Capa's work was never exhibited during his lifetime (preface to the Bibliothèque nationale de France catalog, 2004). In fact it was: His Spanish photos were exhibited as early as 1938 at the New School in New York and at MoMA in 1952 (the Picasso photos) and again in 1953. "The Falling Soldier" was even invited to Paris by the Musée d'art moderne as part of MoMA's traveling exhibition of fifty years of art in the United States in 1955.

This is not a legend. The number 1 contact sheet notebook on the Spanish civil war—covering the first trip taken with Gerda Taro in 1936, during which "The Falling Soldier" was taken—remains unfound. The Paris national archives own eight of the notebooks, which were probably seized during a police raid. The French state returned these to the ICP so they are kept with the negatives found in the "Mexican suitcase." A ninth notebook was discovered in New York among Cornell Capa's belongings and is now at the ICP. But the tenth still hasn't been found. The 4,500 negatives found in the Mexican suitcase do not cover the entire range of Capa's press publications. Of course, the ICP owns many original negatives, but these have not been cataloged in print. Others are scattered in public and private collections.

This is a legend. In *Comme dans un miroir* (page 144), Charles-Henri Favrod, founder and curator of the Musée de l'Élysée in Lausanne claims he has seen Capa's contact sheet featuring the famous photo of the Republican soldier. This is surprising, given he is the only one making such a claim. There is no contact sheet or negative for this legendary shot, and that's exactly the problem. Knowledgeable observers believe the mystery will be lifted when we uncover the photos taken immediately before and after. But even then it isn't certain that all our questions will be answered.

This is not a legend. Robert Capa was married. In his biography, Richard Whelan explains that Capa married the actress Toni Sorel, whose real name was Nona Teilenbogen, in March 1940 in the United States for administrative reasons to secure his passport. But according to the American website Find a Grave, it appears that Capa was also married to Hazel Louise di Fede, whose final resting place is in California. The mystery remains complete.

This is not a legend. Capa was nearly buried at the Père Lachaise. Near Gerda Taro, of course, who was buried in the 97th division of the Paris cemetery in the summer of 1937. But by the time Capa died, the cemetery was much too far from the other woman in his life; his mother, Julia, now lived in the United States. In the US, Arlington military cemetery was briefly considered. Julia Friedmann opposed the idea, insisting that her son hated war and was not a military man. According to Bob's close friends, he and Taro were not reunited in death because he had been with so many women since she died. By 1954, their love story was seen as ancient history and the feeling was that Capa had moved on. John G. Morris then suggested the Quaker cemetery in Amawalk, much closer to New York. The Capa family, which had no direct descendants, now rests there in its entirety.

This is a legend. Capa loved the Leica and became a precursor of modern photojournalism by using that particular camera. Not at all—he gave up on the Leica back in 1937, giving his to Gerda Taro and switching to the Contax and his beloved Rolleiflex.

This is not a legend. Capa also took color photographs. Since his Kodachromes were discovered in the bottom of a drawer at Magnum, only the Japanese have shown a real interest, by copublishing the excellent *Capa in Color* with Magnum-Tokyo on the occasion of an exhibition in 2005. But many color stories—starting with the first one shot in China in 1938—remain little known or completely unseen, including those about the USSR, Israel, and portraits of cities he shot for *Holiday*.

This is not a legend. After World War II, Capa directed a film in Turkey. He shot a documentary about the Westernization of the land of Ataturk for *March of Time* with French cameraman Paul Martellière for two months in the winter of 1946–47. The film has never been found.

This is not a legend. Robert Capa spent six months in Mexico in 1940, covering the electoral race between generals Camacho and Almazán for *Life*. But his broader work on Mexico has never been made truly available. Twenty thousand Spanish Republicans found shelter in this post-revolutionary country, and Trotsky was assassinated during the same period.

This is not a legend. Robert Capa appeared as an actor in a Hollywood movie. Thanks to his accent, Capa got a very short part as Hamza, an Egyptian porter on the platforms of Cairo's central station. His brush with movie fame came in the summer of 1946 in *Temptation*, directed by Irving Pichel in International Pictures' studios. Capa is hard to recognize in the part because his face is hidden by the hood of his burnoose. But if you listen closely, you can hear the sound of his voice.

This is not a legend. Caporal-Chef Pierre Schoendoerffer of the French army, then a twenty-four year old army filmmaker and a prisoner of the Vietnamese communists after the fall of Dien Bien Phu in May 1954, learned that Robert Capa had died from Soviet director Roman Karmen, who was filming a reenactment of the battle. Both filmmakers deeply admired Robert Capa. Karmen had met and spent time with Capa in Madrid during the Spanish civil war. He saved the prisoner Schoendoerffer from the worst by lobbying for his liberation—as well as that of Daniel Camus of *Match*—on August 24, 1954.

This is not a legend. Upon learning of Capa's death, a Magnum reporter immediately quit the agency, frightened by the dangers of the war correspondent's trade. The Zurich photographer Ernst Scheidegger, a close friend of Giacometti's, switched to photographing art and architecture and made the first book about Le Corbusier's constructions in Chandigarh, India, in 1956.

This is not a legend. Capa never won the Pulitzer Prize. Yet the most prestigious journalism prize in the United States, founded in 1917 by another Hungarian, Joseph Pulitzer, launched its photography category in 1942. In 1945, Joe Rosenthal of the Associated Press won for his famous photo "Raising the Flag on Iwo Jima." In 1944, Earl L. Buddy won for his photo of Major Bob Moor's return home, "Homecoming." Buddy, who never set foot outside of the United States, worked for the *Omaha World-Herald* in Nebraska. Capa's famous photos of the D-day landings were out of competition for a simple reason: The prize had to go to an American citizen. Capa would only receive citizenship in 1946.

This is not a legend. Bob Capa foretold the end of photojournalism. He told Marc Riboud, whom he recruited for Magnum in 1953, that press photography would be extinguished by television's enormous success in the United States. Which didn't stop generations of young photographers from following in Capa's footsteps and, for the best of them, from receiving the Robert Capa Gold Medal Award, a prestigious prize created in his memory by the Overseas Press Club of America in 1955. Chris Hondros received the medal for his work in Iraq in 2005. Chris said: "It is not photojournalism that is dead, but the way that it was practiced up until the nineties. Yet nothing has changed since Capa's time as far as the commitment required and the dangers faced by war correspondents."

Chris Hondros, the son of German and Greek parents who immigrated to the United States after the war, died on assignment in Misrata, Libya, on April 20, 2011. He had just turned forty-one. His friend and colleague Tim Handherington died by his side. He was forty years old.

APPENDICES

A letter Capa wrote to his mother from the the restaurant Le Marignan, at 27, rue des Champs-Élysées, Paris, on April 8, 1936.

My dear Mother,

As you can see, the stationery is prestigious, but that doesn't mean anything. I'm waiting for someone here and taking advantage of the nice paper and beautiful weather. I was happy to get your letter and just yesterday the one from my little brother, it made me laugh so hard I could barely breathe. The little one is growing up and becoming a remarkable man.

I've gotten to work. I'm hoping that at the end of this month I'll be able to settle my debts and I especially hope I'll be able to earn more because otherwise it is impossible. Of the 1,100 francs I make a month, I use 500 on expenses. I'd like to have 500 for expenses and 250 every week. It will probably work. I'm working under another name, I'm called Robert Capa and one could say that it is a rebirth (and this time it won't hurt anyone).

At the end of the month we'll leave our room and before we find a little apartment we'll live in a decent hotel. In any case, all that isn't important, the only thing that matters is that the work is succeeding because living on projects bores me to tears. Now I do three photo stories a week, you can imagine how I run all over the place. But we'll talk about all that soon.

Robert Capa, *Slightly Out of Focus* (pages 242–245), with photographs by the author
Front Flap

Slightly Out of Focus is a contradiction in terms, being the natural climax of a special kind of publishing achievement at the same time that it is a completely different sort of book. With it Henry Holt and Company will have published the three top reporters of World War II; Ernie Pyle, who wrote the war, Bill Mauldin, who drew it, and now Bob Capa, who photographed it and wrote about it too.

This is *not* a book of photographs with captions. These are the hundreds of pictures Bob Capa took throughout the fighting in the ETO. They have been made into chapters and they alternate with the frank, airy, true story of a fabulous young man, Bob Capa, whose romance with a girl called Pinky kept getting involved with his trips to the fighting fronts.

You know the story—or some similar story—of a hundred people who participate in a battle and come out of it with a hundred different reports. Each report may be true; all may be contradictory.

"This," Mr. Capa points out, "goes for poker games, drinking parties, and love. Writing the truth being obviously so difficult, I have in the interests of it allowed myself to go sometimes slightly beyond and slightly this side of it. All events and persons in this book are accidental and have something to do with the truth."

This, certainly, is obvious about life and writing—even writing about oneself, as Mr. Capa has done. But though his words may be slightly, occasionally, and riotously out of focus, his pictures never are.

Back Flap

Robert Capa was born in Budapest in 1913. Due to disagreement with a Mr. Horthy (then dictator, now Admiral retired) he left Hungary at the age of 18 and became a photographer in Germany. In 1932, due to disagreement with a Mr. Hitler (then dictator, now suspected retired) Capa left Germany and found his way to Spain. Due to disagreement with a Mr. Franco (not retired) he left Spain in 1939 and came to America, going back to cover World War II with the U.S. Army. He has been the only enemy alien to be a war photographer and war correspondent with the U.S. Army; he got involved with secret bomb-sights, a pink girl, high and low poker, and too many invasions. After the war Capa went out to be a movie producer in Hollywood, ended up playing an Egyptian heavy, directed a *March of Time* film in Turkey, and proceeded to get fired; one wonders what Mr. Capa (not retiring) will be doing by the time this book comes out.

Back Cover

Summer, 1942

There was absolutely no reason to get up in the mornings any more. My studio was on the top floor of a small three-story building on Ninth Street, with a skylight all over the roof, a big bed in the corner, and a telephone on the floor. I didn't know what time it was, and I wasn't especially interested. My cash was reduced to a nickel. I wasn't going to move until the phone rang and someone suggested something like lunch, a job, or at least a loan.

I rolled over and saw that the landlady had pushed three letters under the door. For the last few weeks my only mail had been from the phone and electric companies, so the mysterious third letter finally got me out of bed.

The third letter was from the editor of *Collier's* magazine. He said that *Collier's*, after

pondering over my scrapbook for two months, was suddenly convinced that I was a great war photographer, and would be very pleased to have me do a special assignment: that a reservation had been obtained for me on a boat leaving for England in forty-eight hours; and that enclosed was a check for $1,500 as an advance.

Here was an interesting problem. If I'd had a typewriter and sufficient character, I would have written back to *Collier's*, telling them that I was an enemy alien, that I could not even go to New Jersey, let alone England, and that the only place I could take my camera was the Enemy Aliens' Property Board down at City Hall.

I had no typewriter, but I had a nickel in my pocket. I decided to flip it. If it came up heads, I would try to get away with murder and go to England; if it came up tails, I would return the check and explain the situation to *Collier's*.

I flipped the nickel and it was—tails!

The subway accepted the nickel. The bank accepted the check. I had breakfast at Janssen's, next to the bank—a big breakfast that came to $2.50. That settled it. I couldn't very well go back to *Collier's* with $1497.50, and *Collier's* was definitely in for trouble.

Letter from Cornell published in *The Sunday Times Magazine* (page 109)

The following statement is included at the request of Robert Capa's brother, Cornell Capa.

For 39 years Robert Capa's "moment of death" has been subjected to the closest scrutiny of knowledgeable editors, reprinted time and time again, and viewed by millions throughout the world.

For 39 years Bob's reputation as a brave and honest photo-journalist has remained the highest in the Press community, the community of his peers. It would appear that Phillip Knightley rests his denigrating speculations on the purported conversations between my brother and a *Daily Express* correspondent, G.D. Gallagher, who was covering the Spanish Civil War. Is it conceivable that through the 39 years, including the period of Bob's own lifetime, Gallagher remained a silent witness to an alleged fraud? Why did he reveal what only he knew when Bob was alive to respond to his allegations?

It saddens me to think that Phillip Knightley would launch an attack on such a flimsy record on the credibility of the photograph and the integrity of the photographer.

ACKNOWLEDGMENTS

This book owes much to photographer Bernard Matussière,who "lived at rue Froidevaux and who guards traces of Robert Capa in Paris"; to Richard Whelan, author of the biography of Robert Capa referenced here; and Cynthia Young of the International Center of Photography, who opened New York's valuable archives to us. Thank you also to John G. Morris for his photographs and his advice, and Jimmy Fox for his generosity; to Anne Mathieu for the article "Ce soir"; to Csaba Morocz for his photographs, his knowledge, and his careful reading; to Jorge Amat for the collected interviews with Pierre Gassmann; to Kathrin Berg, daughter of Ruth Cerf, for her photograph in Capa's studio. Thank you to Ernest Alós, Ata Kando, and his son, Tom; Kristen Lubben of ICP; Claude Maire; Gérard Malgat; Jean-Mathieu Martini; Carol Naggar; Alex Novak; François Pillu; Serge Plantureux; Carles Querol; Pierre-Marc Richard; Jean-Luc Rosoux; Juan Salas; Irme Schaber; Ben Schneiderman of the David Seymour-Chim Estate; Peter Stein of the Fred Stein Estate; José María Susperregui; Georges Teboul; and Annick Tournier. Thank you to Laure Beaumont-Maillet, whose exhibition at the National Library in 2004, the fiftieth anniversary of the death of Robert Capa, showed that there remained a Capa "unknown" yet close to us, the Parisian Capa.

Thank you to Éditions de La Martinière for realizing our project, and Nathalie Mayevski, our editor, for her infinite patience and love of Spain and Capa, never wavering. Thank you to Sophie Malexis for her image research help and Philip Ghielmetti for the inspired design.

Bernard Lebrun dedicates this work to the memory of Teresa and Joaquim Roig who grafted "Spain to the heart" and would like to thank Nancy and Victor for their continued support. Michel Lefebvre dedicates this work to his father who brought him a piece of Spain, and thanks Dominique Seban, Anthony, and Camille for their attention.

BIBLIOGRAPHY

Books

• *50 Years of Art in the United States*, Collection of the Museum of Modern Art—New York, preface by Jean Cassou, April—May 1955. Catalog of the Musée d'art moderne—Paris exhibition.

• Asenjo, Mariano, Manuel Fernandez Cuesta, Victoria Ramos, and Lolo Rico. *Fotógrafo de guerra, España 1936–1939*. Fontarabie (Spain): Hiru Argitaletxea, 2000.

• Auden, Wystan-Hugh, and Christopher Isherwood. *Journal de guerre en Chine*. Monaco: Éditions du Rocher, coll. "Anatolia," 2003; original edition: London: Faber & Faber, 1939.

• Barrett, James Wyman. *The World, the Flesh, and Messrs. Pulitzer*. New York: The Vanguard Press, 1931.

• Beaumont-Maillet, Laure (ed). *Capa connu and inconnu*. Paris: French National Library, 2004.

• Bergala, Alain. *Magnum cinéma*. Paris: Cahiers du Cinéma, 1994.

• Bessie, Alvah. *Alvah Bessie's Spanish Civil War Notebooks*. Edited by Dan Bessie. The University Press of Kentucky, 2002, p. 262.

• Beurier, Joëlle. *Images and violences 1914–1918, Quand le Miroir racontait la Grande Guerre*. Paris: Nouveau monde éditions, 2007.

• Bondi, Inge. *Chim: The Photographs of David Seymour*. New York: Bulfinch, 1996.

• Borkenau, Franz. *The Spanish Cockpit*. London: Faber & Faber, 1937. Translated from the English by Michel Pétris under the title *Spanish Cockpit*. Recounts the social and political conflicts of Spain (1936–1937). Paris: Ivrea éditions, coll. "Champ Libre," 1979.

• Brinkley, Alan. *The Publisher: Henry Luce and His American Century*. New York: Alfred A. Knopf, 2010.

• Brothers, Caroline. *War and Photography: A Cultural History*. London: Routledge, 1997.

• Buckley, Henry W. *Life and Death of the Spanish Republic*. London: Hamish Hamilton, 1940.

• Capa, Robert. *Capa in Color*. Tokyo: Magnum Photos, 2005. Catalog of the exposition at the Mitsukoshi Gallery in February 2005 and at the Kobe Museum in May 2006.

• Capa, Robert. *Death in the Making*. New York: Covici-Friede, 1938.

• Capa, Robert. *Slightly Out of Focus*. New York: Henry Holt and Co., 1947; French edition: Paris, Delpire, 2003.

• Capa, Robert, and Irwin Shaw. *Report on Israel*. New York: Simon & Schuster, 1950.

• Carroll, Pander N., and James D. Fernandez. *Facing Fascism: New York & the Spanish Civil War*. New York: Museum of the City of New York, 2007.

• Cartier-Bresson, Henri, Ramón Esparza, Josep Vicent Monzó, John G. Morris, and Ben and Eileen Shneiderman. *David Seymour Chim*. Valence (France): IVAM, 2003.

• Cohen, Peter (dir.), Achim Heine, and Andréa Holzherr. *Magnum's First*. Ostfildern, Hatje Cantz Verlag, 2008.

• Denoyelle, Françoise. *La Lumière de Paris. Le marché and les usages de la photographie, 1919–1939*. Paris: L'Harmattan, 1997, vol. 2.

• Denoyelle, Françoise. *La Photographie d'actualité and de propagande sous le régime de Vichy*. CNRS éditions, 2003.

• Desquenes, Rémy. *Les Photographes de Magnum sur le front de la Seconde Guerre mondiale*, preface by James A. Fox. Rennes: Éditions Ouest-France, 2009.

• Dior, Christian. *Christian Dior et moi*. Paris: Bibliothèque Amiot Dumont, 1956.

• Eisner, Alexei. *La 12a Brigada internacional*. Valence: Promandeo, 1972.

• Elgey, Georgette. *Robert Capa, David Seymour Chim, Front populaire*. Paris: Chêne/Magnum, 1976.

• Faas, Horst, and Tim Page. *Requiem. Par les photographes morts au Viêt-Nam and en Indochine*. Paris: Marval, 1998.

• Favrod, Charles-Henri, and Christophe Fovanna. *Comme dans un miroir. Entrandiens sur la photographie*. Gollion (Switzerland): Infolio, 2010.

• Fontaine, François. *La Guerre d'Espagne. Un déluge de feu et d'images*. Paris: BDIC/BERG International, 2003.

• *Fotografías de Robert Capa sobre la Guerra Civil española*, Colección del ministerio de Asuntos Exteriores. Text by Carlos Serrano. Madrid: Ediciones el Viso, 1990.

• Gary, Romain. *La Nuit sera calme. Entrandiens avec François Bondy (France-Culture)*. Paris: Nouvelle revue française, coll. "L'air du Temps," 1974.

• Graziani, Bettina. *Bettina par Bettina*. Paris: Flammarion, 1964.

• Hallett, Michael. *Stefan Lorant: Godfather of Photojournalism*. Lanham, MD: The Scarecrow Press, 2005.

• Hemingway, Ernest. *En ligne*. Paris: Gallimard, 1970.

• *Israël: 50 ans. Par les photographes de Magnum*, photographs by Robert Capa, David Seymour, George Rodger, Inge Morath, Abbas, Don McCullin, Larry Towell, Raymond Depardon, James Nachtwey. Paris: Hazan, 1998.

• Jotterand, Franck. *J'aime . . . le cinéma*. Paris: Denoël, 1962.

• Kee, Robert. *The Picture Post Album, 1939–1959*. Preface by Sir Tom Hopkinson. London: Barrie & Jenkins, 1989.

• Kershaw, Alex. *Blood and Champagne: The Life and Times of Robert Capa*. London: Pan Books, 2003. Translated from the English by Daniel Roche under the title *Robert Capa. L'homme qui jouait avec la vie*. Paris: JC Lattès, 2003.

• Knightley, Phillip. *The First Casualty*. New York: Harcourt-Brace, 1975. Translated from the English under the title *Le Correspondant de guerre de la Crimée au Viandnam. Héros ou propagandiste*. Paris: Flammarion, 1976.

• Lacouture, Jean. *Robert Capa*. Paris: Nathan, coll. "Photo Poche," 2001.

• Lebrun, Bernard, and Michel Lefebvre. "Where does the 'Mexican suitcase' come from?," in *The Mexican Suitcase*, New York, ICP/Steidl, 2010, vol. 1, pp. 75–82; French version in La Valise Mexicaine, Arles, Actes Sud, 2011. Catalog of ICP.

• Lefebvre, Michel. *Kessel-Moral, deux reporters dans la guerre d'Espagne*. Paris: Tallandier, 2006.

• Lefebvre, Michel, and Rémi Skoutelsky. *Les Brigades Internationales. Images randrouvées*. Paris: Seuil, 2003.

• Le Goff, Hervé. *Pierre Gassmann. La photographie à l'épreuve*. Paris: Éditions France Delory, 2000.

• Liebling, Abbott J. *The Road Back to Paris*. New York: Doubleday, Doran & Co, 1944.

• Matussière, Bernard. *Muller: Mécanicien Photographe*. Preface by Erik Orsenna. Paris: Denoël, 2003.

• Miller, Russel. *Magnum: Fifty Years at the Front Line of History*. London: Secker & Warburg, 1997.

• Moorehead, Caroline. *Martha Gellhorn: A Life*. London: Vintage, 2004.

• Mora, Constancia de la. *Fière Espagne. Souvenirs d'une républicaine*. Translated from the Spanish by C. Dalsace and L. Viñes. Paris: Éditions hier et aujourd'hui, Paris, 1948.

• Morris, John G. *G and the Picture: A Personal History of Photojournalism*. New York: Random House, 1998. Translated from the English under the title *Des hommes d'images, Une vie de photojournalisme*. Paris: Éditions de La Martinière, 1999.

• Naggar, Carole. *George Rodger: An Adventure in Photography, 1908–1995*. New York: Syracuse University Press, 2003.

• Namuth, Hans, and Georg Reisner. *Spanisches Tagebuch 1936*. Berlin: Nishen, 1986.

• *Paris Magnum. Photographies 1935–1981*. Text by Irwin Shaw and Inge Morath. New York: Aperture, 1981.

• Preston, Paul. *We Saw Spain Die: Foreign*

Correspondents in the Spanish Civil War. London: Constable, 2008.

• Querol y Rovira, Carles. El darrer dia de la Tarragona republicana, el reportatge de Robert Capa del 15 de gener de 1939. Tarragona: Ajuntament de Tarragona, 2009.

• Querol y Rovira, Carles, and Oriol Querol. Henry Buckley, corresponsal britànic del The Daily Telegraph a la Guerra civil espanyola. Sitges: Ajuntament de Sitges, 2009.

• Quétel, Claude (ed.). Dictionnaire du débarquement. Rennes: Éditions Ouest-France, 2011.

• Quétel, Claude. Robert Capa. L'oeil du 6 juin 1944. Paris: Gallimard, "Découvertes" series, 2004.

• Schaber, Irme. Gerda Taro. Fotoreporterin im spanischen Bürgerkrieg. Marburg: Jonas Verlag, 1994; French edition: Monaco: Éditions du Rocher, coll. "Anatolia," 2006.

• Schaber, Irme, Richard Whelan, and Kristen Lubben. Gerda Taro. Steidl: 2007. Catalog of the International Center of Photography.

• Serrano, Carlos. Robert Capa, Cuadernos de Guerra en España (1936–1939). Valence: Sala Parpalló—Diputación Provincial de Valencia, 1987, 157 p. 86 photographs.

• Soria, Georges. Robert Capa, David Seymour-Chim. Les grandes photos de la guerre d'Espagne. Paris: Jannink, 1980.

• Steinbeck, John. A Russian Journal with photographs by Robert Capa. London: Penguin Books, 2000; original edition: New York: Viking Press, 1948.

• Steinbeck, John. Il était une fois une guerre. Paris: Del Duca, 1960.

• Steinbeck, John. Un Américain à New York and à Paris. Paris: Julliard, 1956.

• Steinbeck, John. Un artiste engage. Paris: Gallimard, 2003.

• Stone, J. F. This Is Israel: The Photographs of Robert Capa, Jerry Cook, Tim Gidal. New York: Boni and Gaer, 1948.

• Surreal Friends: Leonora Carrington, Remedios Varo and Kati Horna. Lund Humphries, 2010.

• Susperregui, José M. Sombras de la fotografía, Los enigmas desvelados de [. . .] Muerte de un miliciano [. . .]. Bilbão: Universidad del País Vasco, 2009.

• Walter Reuter, el viento limpia el alma, entrevista John Miraz y Jaime Vélez, textos de John Miraz, Michel Lefebvre, Luis Rius. Barcelona: Lunwerg, 2009.

• Weber, Eugen. La France des années 1930. Tourments and perplexités. Paris: Fayard, 1995.

• Weber, Olivier. Lucien Bodard, un aventurier dans le siècle. Paris: Plon, 1997.

• Wertenbaker, Charles Christian. Invasion! With photographs by Robert Capa. New York and London: D. Appleton-Century Co., 1944.

• Whelan, Richard. Robert Capa: The Collection. London: Phaidon, 2001.

• Whelan, Richard. Robert Capa. New York: Alfred A. Knopf, 1985; French edition: Paris: Mazarine, 1985.

• Whelan, Richard. This Is War: Robert Capa at Work. Steidl, 2007.

• Yokogi, Arao, Dernier jour de Robert Capa, Tokyo, éditions Shoseki, 2004.

• Young, Cynthia (ed.), The Mexican Suitcase: The Rediscovered Spanish Civil War Negatives of Capa, Chim, and Taro. Steidl, 2010, 2 vol. Catalog of the International Center of Photography.

Articles

• '47 The Magazine of the Year, vol. 1, no. 8, New York, October 1947. After a six-page article by John Hersey "The Man Who Invented Himself," published in September 1947, five letters about Capa are addressed to the newspaper by Irwin Shaw, Vincent Sheean, William Saroyan, Bill Graffis, and "Jumping General" James Gavin of the 82nd Airborne.

• "Adieu Capa," article by Louis Aragon, Les Landtres françaises, May 27–June 3, 1954.

• "A great war reporter and his last battle," Life, vol. 36, no. 23, June 7, 1954, pp. 27–30.

• Cornell Capa's appeal for finding his brother's missing negatives, Photo, no. 143, August 1979.

• "Capa's Camera," Time, February 28, 1938.

• "Espagne 1936: les inédits," article by Cornell Capa, Photo, no. 156, September 1980.

• "Press: Death Stops the Shutter," Time, June 7, 1954.

• "Robert Capa: 124 photos randrouvées," article by Jean-Jacques Naudet, Photo, no. 189, June 1983.

• "Robert Capa est mort en Indochine," Le Soir Illustré, no. 1145, June 3, 1954, p. 23.

• "Robert Capa, Gerda Taro, Paul Nizan, parcours croisés," article by Michel Lefebvre, Paris, Aden, no. 5, 2006.

• "Robert Capa, le chasseur d'images est mort comme il avait vécu, en première ligne," Match, no. 271, June 5, 1954.

• "Un photographe américain saute sur une mine dans le delta tonkinois," article by Lucien Bodard, France-Soir, May 26, 1954.

• "Vision of a New State: Israel as Mythologized by Robert Capa," article by Andrew L. Mendelson (Temple University, Philadelphia, PA) and Zoe C. Smith (University of Missouri, Columbia, MO), Journalism Studies, Routledge, April 2006, vol. 7, pp. 187–211.

Documentaries

• John G. Morris: Eleven Frames, 2010, 8 min., director: Douglas Sloan, United States (online on YouTube).

• Heros Never Die, 2004, 89 min., director: Jan Arnold, production: Marea Films and Co., distribution in France: Les Productions de la Lanterne (film about "The Falling Soldier", filmed in Spain).

• Robert Capa: In Love and War, 2003, 90 min., director: Anne Makepeace, production: "American Masters," PBS-TV (USA), distribution: Films transit, May 2003.

• Robert Capa, L'homme qui voulait croire en sa légende, 2004, 52 min., director: Patrick Jeudy, production: Point du Jour (France), DVD Naïve 2007.

• La Valise mexicaine, 2011, 90 min., director: Trisha Ziff, production: 21 BERLIN & co, (theatrical release, fall 2011).

Internet

• Elrectanguloenlamano.blogspot.com, Spanish, Javier Izquierdo Vidal and Joseba Bolot, in English and in Castilian, excellent articles by José Manuel Serrano Esparza devoted to John G. Morris, but also to Robert Capa and Cerro Muriano, Hans Namuth, and Georg Reisner.

• Flickr.com/photos/photosnormandie, crowd-sourcing site on the Battle of Normandy, founded in January 2007 by Patrick Pecatte and Michel Le Querrec, fundamental information on Capa in Normandy.

• "Robert Capa messa in scena di un mito," website of Luca Pagni (http://www.photographers.it/articoli/capa.htm), Rome, since 2003. Very useful information on Capa in Italy.

To contact the authors:
Bernard Lebrun
bernard.lebrun@francetv.fr

Michel Lefebvre
lefebvre@lemonde.fr

263

DESIGN Philippe Ghielmetti
IMAGE RESEARCH Sophie Malexis, Pauline Carlier

English-language edition:
PROJECT MANAGER Laura Dozier
DESIGNER Shawn Dahl, dahlimama inc
PRODUCTION MANAGER Jules Thomson

Library of Congress Cataloging-in-Publication
Lefebvre, Michel, 1955–
 Robert Capa : the Paris years 1933/54 / Michel Lefebvre and Bernard Lebrun ; in collaboration with Bernard Matussière.
 p. cm.
 Includes bibliographical references.
 ISBN: 978-1-4197-0062-0 (alk. paper)
1. Capa, Robert, 1913–1954—Homes and haunts—France—Paris. 2. Capa, Robert, 1913–1954—Friends and associates.
3. Photojournalism. I. Lebrun, Bernard. II. Matussière, Bernard. III. Title.
TR140.C28L44 2012
070.4—dc23
 2011035638

International Center of Photography
1133 Avenue of the Americas at 43rd Street
New York, NY 10036
www.icp.org

Magnum Photos
19, rue Hegesippe Moreau
75018 Paris, France
www.magnumphotos.com

Copyright © 2011 Éditions de La Martinière, a division of La Martinière Groupe, Paris
English translation copyright © 2011 ABRAMS, New York

Originally published in 2011 as *Robert Capa: Traces d'une légende* by Éditions de La Martinière,
an imprint of La Martinière Groupe, Paris, France

Published in 2012 by Abrams, an imprint of ABRAMS. All rights reserved. No portion of this book may
be reproduced, stored in a retrieval system, or transmitted in any form or by any means, mechanical,
electronic, photocopying, recording, or otherwise, without written permission from the publisher.

Printed and bound in Malaysia
10 9 8 7 6 5 4 3 2 1

Abrams books are available at special discounts when purchased in quantity for premiums and
promotions as well as fundraising or educational use. Special editions can also be created to
specification. For details, contact specialsales@abramsbooks.com or the address below.

ABRAMS
THE ART OF BOOKS SINCE 1949

115 West 18th Street
New York, NY 10011
www.abramsbooks.com

070.4
Lebrun Lebrun, Bernard.

 Robert Capa

DUE DATE 40.00
